PAINTING
WITH
OILS

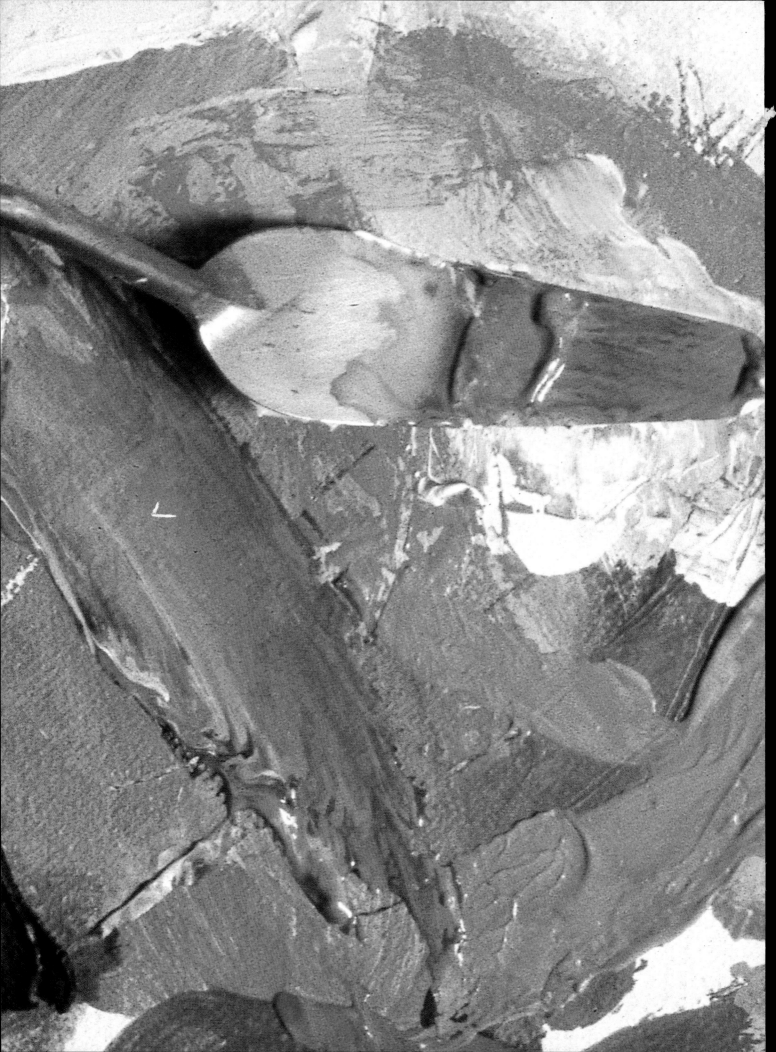

PAINTING
WITH
OILS

*32 oil painting projects, illustrated step-by-step
with advice on materials and techniques*

Patricia Monahan

CHARTWELL
BOOKS, INC.

Published by Chartwell Books
A Division of Book Sales Inc.
114 Northfield Avenue
Edison, New Jersey 08837
USA

Copyright ©1984 Quarto Publishing plc

A QUANTUM BOOK

This edition printed 2000

ISBN 0-7858-1249-0

QUMMOL

This book was produced by
Quantum Books Ltd
6 Blundell Street
London N7 9BH

Printed in Singapore by Star Standard Industries Pte. Ltd.

CONTENTS

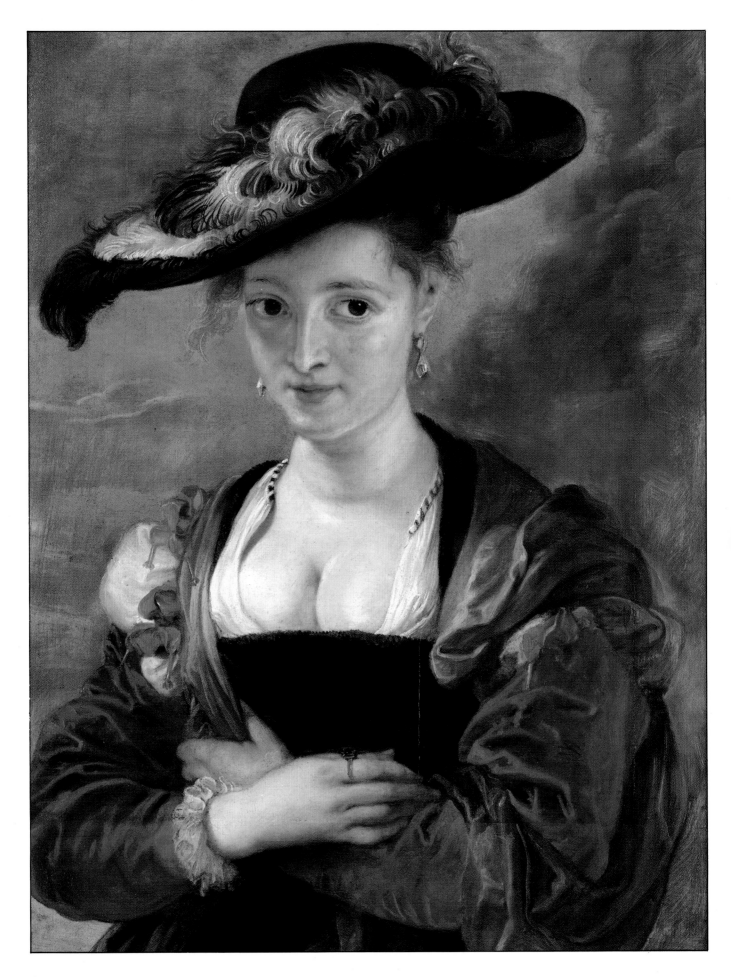

CHAPTER ONE

'A MOST
BEAUTIFUL
INVENTION...'

Today, when oil painting is such an important part of our visual experience, it is sometimes hard to remember that it is a relative newcomer to the artist's repertoire. Until the fifteenth century, tempera was the most commonly used painting medium, and to a great extent the way artists painted was dictated by its limitations. Tempera was sticky, difficult to manipulate and fast-drying, and artists worked with fine brushes, applying the paint slowly and methodically to one small area before moving to another. Unfortunately it was almost impossible to make any changes to the painting once the color was put down. For the artists of the Renaissance, the new method of binding pigments with oils meant that many of these limitations were swept away. Painters could work more freely, applying color in broad areas and blending tones on the support itself. Gradually a new approach to paint and technique evolved, and this is the basis of oil painting even now.

Portrait of Susanna Lunden née Fourment by Peter Paul Rubens (1577-1640), *left.* Rubens was a skilled exponent of the relatively new technique of oil painting and was admired for the assurance of his drawings and the virtuosity of his brushwork. His work influenced many artists of succeeding generations.

The Greek physician, Aetius, writing in the sixth century AD, mentions oils in connection with works of art, describing the way in which they dry to a hard film — a property exploited by gilders, who used walnut oil to protect their work. The use of a drying oil as a paint medium was first described by Theophilus Presbyter, whose book *De Diversis Artibus,* written in about 1100, is the most important source of information about the arts and crafts of the medieval world. Not much is known about the writer, but there is some evidence to suggest that he was a Benedictine monk. Theophilus gives many recipes for the preparation of oil colors and varnishes and recommends grinding pigment into linseed oil or walnut oil. From his account it is clear that the color was applied in layers which were dried in the sun before the next layer was applied. Other accounts from the thirteenth and fourteenth centuries show that oil was often used for panel painting and for wall painting, certainly in northern Europe.

The story that the Flemish painter Jan van Eyck (*c*1390-1441) was the inventor of oil painting can be attributed to Giorgio Vasari (*c*1511-74). Vasari was an Italian painter, architect and writer, whose most important contribution to painting was a series of biographies of the artists of his time, *Lives of the most excellent Painters, Sculptors and Architects*, first published in 1550. It is a lively and prejudiced account of artists whom he knew personally or by repute and whose work he had seen. In many instances his accounts must be taken with a pinch of salt, but his book is nevertheless a fascinating document and an excellent read. According to his story of van Eyck's 'discovery' of oil painting, a tempera panel had been varnished with oil and had, in accordance with traditional practices, been left to dry in the sun. The sun was so hot that the panel split, and van Eyck determined to 'devise means for preparing a kind of varnish which should dry in the shade, so as to avoid having to place the pictures in the sun'. Having found that linseed and nut oil answered the purpose admirably, van Eyck (so Vasari says) mixed this varnish with the colors and found that it 'lit up the colors so powerfully that it gave a gloss of itself', without an aftercoat of varnish.

Various oils were used as paint mediums long before van Eyck, but it is undoubtedly true that he improved the techniques of oil painting, achieving a minuteness and luminosity which surpassed anything that had gone before, and have rarely been matched since. He was certainly responsible for many technical developments in painting, and was recognized for these at the time. Fifteen years after van Eyck's death Bartolommeo Facio of Spezia described him as 'learned in those arts which contributed to the making of a picture, and on that account credited with the discovery of many things in the properties of colors, which he had learned from ancient traditions recorded by Pliny and other writers'.

TECHNIQUE IN NORTHERN EUROPE

Like the other early Netherlandish painters, Jan van Eyck painted on oak panels, on white chalk grounds. The ground was bound with animal-skin glue, or size. Vasari recommends 'four or five coats of the smoothest size', followed by a tinted *imprimatura*, or priming. The ground obscured the grain of the wood and, when polished, reflected light in a way that plays an important part in the final effect.

Oils have a particular optical effect on pigment, rendering it translucent and at the same time giving it a richly saturated appearance. Oil paintings at that time were developed in two basic stages. The first stage was an opaque underpainting in which the forms were modeled in monochrome in pale shades of gray. This was overlaid by layers of glazes in which pure pigment was mixed with a translucent, glossy oil medium which allowed the forms beneath to show through. The paint was thinnest in the highlight areas and thickest in the shadows so that less light was reflected. The technique was still, in many ways, medieval — the paint was laid on in flat, separate areas, pigments were rarely mixed and tonal transitions were very subtly blended.

ITALY AND THE VENETIANS

Oil painting took longer to gain a foothold in Italy than in northern Europe. Tempera and oil were used together in Italy in a mixed technique until well into the sixteenth century, and were often used in the tight, meticulous manner typical of the earlier tempera paintings. Even so, it was in the hands of the Italian painters, particularly the Venetians, that oil painting really came into its own. Antonello da Messina (*c*1430-79) appears to have

discovered the secret of painting in oil while on a visit to Flanders, and was responsible for the introduction of the new process to Venice in about 1475. There it was taken up by Giovanni Bellini (1430/40-1516) and other painters of the period. Bellini had a wonderful feel for the qualities of the medium and used oil paint with a freedom previously unknown. His *Doge Leonardo Loredano* in the National Gallery, London, shows one of the earliest attempts to use impasto (thick paint, heavily applied).

Giorgione (1475-1510) marked yet another turning point, both in the history of Venetian painting and in the development of painting in oil. He worked directly from nature and was considered by Vasari to have surpassed the achievements of the Bellini family and to rival the Tuscans, who were 'creating the modern style'. He was greatly influenced by the work of Leonardo da Vinci (1452-1519), and sought to emulate the way in which he modeled form by subtle transitions of color and tone. Giorgione's work is characterized by delicate and careful modeling, rich and evocative color and an interest in pure landscape painting.

Probably the greatest and certainly the most influential of all Venetian painters was Tiziano Vecellio (*c*1487-1576), known to us as Titian, who was born in Cadore, a hill town in the Veneto. He was sent to Venice as a child to work in the studio of a designer of mosaics and subsequently went to train with Giovanni Bellini and his brother, Gentile. His work is a synthesis of the achievements of the Bellinis and of Giorgione, to which he added his own unique vision and genius. In his early work he used strong, simple colors and often silhouetted dark figures against a light ground. His paintings are bold and imaginative, employing ambitious compositions to create dramatic effects.

In his late period Titian returned to the vigorous designs of his youth, and began to handle color with abandon. At last oil paints were liberated from the burden of precise imitation of the real world. Indeed, much of the power of Titian's paintings comes from the way he handled his brush, which was seen as an extra means of expression. The Venetians were the first painters to allow the marks of the brush to show and understood the importance of the way the paint was applied to the canvas.

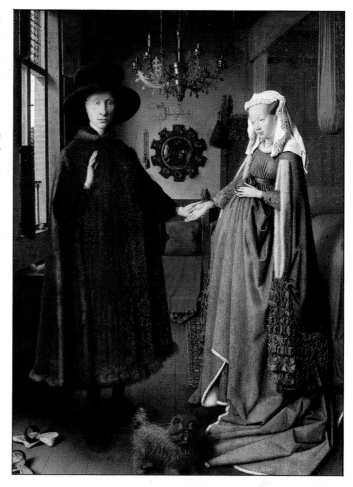

The Arnolfini Marriage by Jan van Eyck (active 1422-41). Van Eyck is credited with the invention of painting in oil, and undoubtedly this type of painting did emerge at this time. The artist used a layered technique, starting with a detailed underdrawing, followed by a pale, opaque underpainting, and a series of translucent layers. The artist was still working within a medieval tradition, in that the approach was meticulous and the paint laid down as such small, separate areas of color, that the brushmarks cannot be discerned.

MATERIALS AND METHODS

According to Vasari, oil paint was used on wood, walls, canvas and stone. The Venetians took to canvas, in particular, quickly and wholeheartedly — they used it for mural paintings because the moist atmosphere of Venice meant that frescos deteriorated rather quickly. Canvas was light, could be rolled up for transportation and could be used for much larger pictures than would be convenient in panel. Gesso was not used as a primer unless the painting was intended to remain *in situ*, because it is brittle and would crack and fall off if the canvas were rolled up. Instead, a paste 'of flour and walnut oil with two or three measures of white lead put into it' was applied to the canvas with a knife. Three or four coats were necessary, followed by one or two coats of size and a final priming. The underdrawing was made on this ground, which was then rendered impermeable with a thin layer of oil.

Vasari describes the way in which artists transferred their cartoons, or preliminary drawings, to the support, using a technique rather like carbon paper. The drawing was made on one sheet of paper and a second sheet of paper, with a black substance on one side, was placed between the drawing and the support. The artist then went over the lines of the drawing with a pointed tool, thus transferring the lines to the panel or canvas.

The pigments used were just the same as those used by the earlier tempera painters, but the oil gave them greater saturation and increased the range of effects possible. Paint could be made either more transparent or more opaque quite easily, and thus the range of techniques was much greater, enabling painters like Titian to use paint in an entirely new way.

THE SEVENTEENTH CENTURY

The next major advance in the use of oil paint came with Rubens (1577-1640). Sir Peter Raul Rubens was born at Siegen in Westphalia and studied painting in Antwerp. In 1600, at the age of 23, he went to Italy, where he made studies from the antique and copied the work of Michelangelo (*c*1475-1564), Titian, Jacopo Tintoretto (*c*1518-94) and Antonio Correggio (*c*1494-1534). Despite his sojourn in Italy and the undoubtedly important influence of his studies there, he remained at heart a Flemish artist in the tradition of van Eyck, Rogier van der Weyden (*c*1399-64) and Pieter Brueghel (*c*1325-69). The Flemish painters had always been fascinated by the appearance of things, by the difference, for instance, between a piece of fur and the metallic sheen of a goblet. Unlike the Italians, who were always searching for standards of beauty, the Flemish painters dealt with reality as they saw it and did not consider only certain subjects 'suitable'. This was the tradition in which Rubens was nurtured, and all his life he maintained a fundamental belief that the artist's concern was to depict the world around him.

By the time he returned to Antwerp, in 1608, at the age of 31, he had learned all there was to be learned about his art and had no rival north of the Alps. Although his predecessors in Flanders had mostly painted on a small scale, Rubens came back to Antwerp with a taste for the huge canvases popular in Venice and eminently suitable for the decoration of churches and palaces. These pleased his patrons enormously, and by 1611 Rubens was so popular that he was inundated with pupils and, indeed, had to turn many down. He made full use of his assistants in preparing his paintings but always added the finishing touches himself.

To an even greater extent than Titian before him Rubens used the brush as his main instrument. His paintings are no longer drawings carefully modeled in color, they are an explosion of color and energy which exploits and delights in the quality of the paint, the way it moves on the canvas and relates to the picture surface.

His work is characterized by brilliant colors, which obviously refer back to the Flemish masters but are also influenced by the later works of Titian and Tintoretto. The way in which he juxtaposed primaries and complementaries anticipated the French painters of the nineteenth century. He worked from a white ground with a thin gray wash, laying down his tonal and linear design in a golden umber, on top of which he used cool, semi-opaque half-tones, allowing the underpainting to show through. The half-tones gave him a key against which he could work the other colors. He worked up from the half-tone toward the darks, developing them with strong and varied colors, and then worked back toward the lights and the local color with solid, opaque

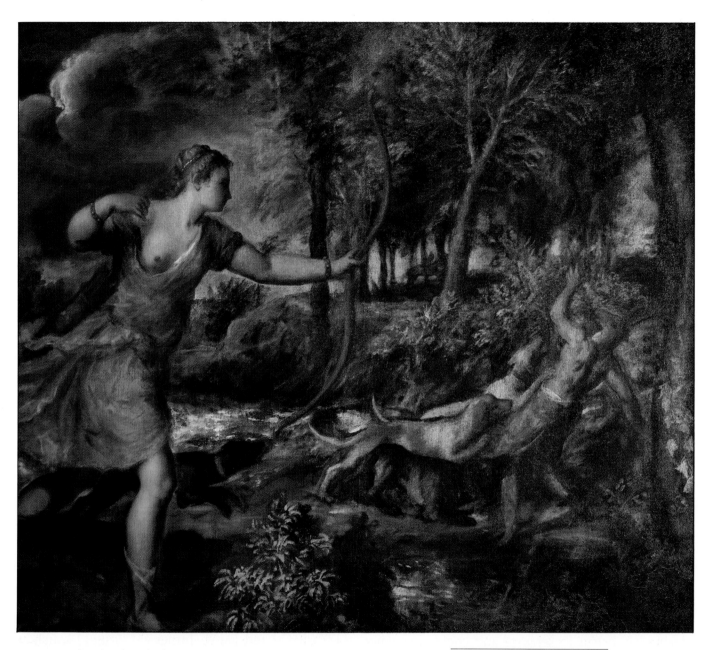

paint. He finished with thin transparent glazes of color which unified the areas of color.

Rubens' method is historically important, for he was enormously successful and had a large studio with many pupils and assistants who emulated his style. The procedures he developed were followed by generations of painters. Rubens influenced both Velásquez (1599-1640), whom he met in Madrid, and that master handler of paint, Rembrandt (1606-69). His influence can also be seen much later in the work of Eugène Delacroix (1798-1863) and, later still, in that of Pierre Auguste Renoir (1841-1919).

The Death of Actaeon by Titian (1487-1576) is in the artist's mature style. The paint is handled with a vigor and freedom that allows the mark of the brush to make an important contribution to the finished painting. Titian broke up areas of color by varying the way in which he applied paint, from thin washes to thick impasto.

THE CONTRIBUTION OF REMBRANDT

Of all the painters of the Baroque age it is probably Rembrandt who can most truly be recognized as Titian's heir. Rembrandt left no sketches or preliminary studies. His compositions, including the distribution of light and shade, were mapped out in a monochrome underpainting over which he then applied solid colors, working from background to foreground, and leaving the figures at the front as monochrome silhouettes until quite a late stage. He completed a painting by applying highlights in stiff impasto.

Later painters admired Rembrandt's work for its rich chiaroscuro. The term, which combines the Italian words for light and dark, refers to the balance of light and shadow in a painting, and is mainly used to describe the work of painters such as Caravaggio (1573-1610) and Rembrandt, whose work was generally rather dark in tone. Unfortunately, by the nineteenth century the term had acquired a new ideological meaning, synonymous with certain academic ideals of truth and beauty, but for Rembrandt himself chiaroscuro had a purely practical role in describing form.

Rembrandt's subtle and descriptive handling of light and shade was combined with a richly saturated palette which demonstrated an understanding of, and delight in, color and paint. By the mid-1630s he had completely abandoned conventional Dutch smoothness and often worked areas of his painting in a single solid color which was later covered with glazes and opaque strokes of brushwork. In places he used a heavily loaded brush — where others needed five touches he used one. The brushtrokes began to separate and could sometimes only properly be read from a distance. The exact imitation of life practiced by lesser artists was replaced by the suggestion of it, causing some of his contemporaries to think that his paintings looked unfinished. He worked in complex layers, and the paint surface betrays his purely sensual delight in the physical qualities of the paint, to which he gave a significance which is almost independent of the image.

THE EIGHTEENTH AND NINETEENTH CENTURIES

By the mid-seventeenth century France had become the artistic capital of the world, and the French Academy of Painting and Sculpture, set up in 1648, very quickly assumed responsibility for imposing moral and aesthetic standards on art. Until the end of the nineteenth century the Academy exercised a stultifying control on artists, and most of the creative movements took place outside the art establishment. Art teaching was rigorous and strictly controlled. Students had first to prove themselves proficient in drawing before they could progress to using color, and they could not work from a line model before they had copied the Old Masters. The painting technique itself was equally rigid. They began by laying in the first underpainting (*ébauche*), using thinned paint to establish the lines, broad masses and half-tones of the subject. They then prepared their palettes, using mainly earth colors, plus Prussian blue, black and lead white. The contours of the forms were first laid in with charcoal, then reinforced with a thin, transparent earth color, which was then used for the shadows, laid in with a large hog's-hair brush. The highlight areas were laid in with thicker paint, and attention was then directed to the half-tones, between the lights and the darks. The transitions between the tones were carefully blended, and the artist sought to achieve a convincing illusion of form in space by a smooth and subtle handling of the tonal changes. The thickly painted highlights contrasted with the flat shadow areas so that the paint surface was given texture in low relief, thus mimicking three-dimensional form.

By the end of the eighteenth century many artists were beginning to find this prescribed technique rather restricting. Painters like Thomas Gainsborough (1727-88), Francisco Goya (1746-1828), John Constable (1776-1837) and J.M.W. Turner (1775-1851) sought a more direct approach. Their techniques of working, laying on patches of color as they were meant to appear (a method now known as 'alla prima') instead of building up layer by layer, were not new, but the freedom of their paint application and the way they handled their brushes was. The freshness of their technique can most easily be seen in the sketches made by Constable and Turner, which were painted directly from nature, and were to have a considerable influence on the French Impressionists' approach to their work.

Turner, one of the most inventive painters of his time, was fascinated by the scientific ideas of his age and studied the theory of color and light avidly. In his early

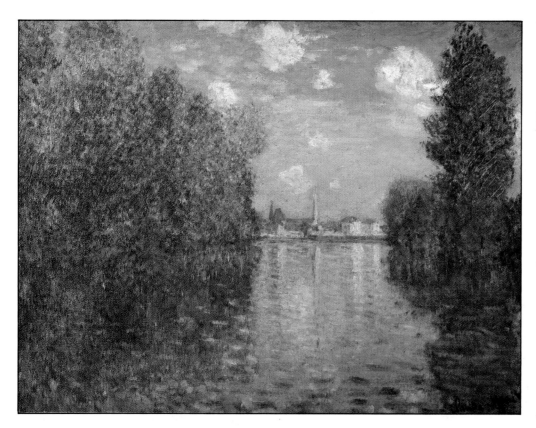

Autumn at Argenteuil by Claude Monet (1840-1926), painted in 1873, illustrates the artist's concern with the fleeting effects of light on the landscape. Monet often worked out-of-doors, but few of his paintings were completed at one sitting because the light would usually change before he could finish. The broad outlines of the subject were roughly blocked in using diluted opaque colors. Over this he developed thick, buttery impastos, building up a complex web of color and texture.

work he used dark, warm grounds, but later these became paler, and his mature works were generally executed on a white ground which enhanced and extended the brilliance of his palette. He adopted a broad underpainting, using a range of pale, washed colors instead of the more usual monochrome. The pinks, blues and yellows that predominated in his underpainting not only established the composition, they also created a mood which affected subsequent paint layers. Many of Turner's color effects depended on paint overlaid on the canvas rather than mixed on the palette. He used both scumbling — the technique of working opaque paint over another layer of a different color — and glazing, and applied paint with great freedom, in thin washes and thick, scrubbed and scraped impasto.

TECHNICAL ADVANCES

By the eighteenth century professional colormen were already putting ready-made oil colors in skin bladders — forerunners of the metal tubes of the mid-nineteenth century — which were a boon to artists who wanted to paint outdoors. Some artists and art historians regretted the move away from total control of the medium, but the increasing range, flexibility and availability of prepared colors allowed more direct techniques and new standards of craftsmanship. Paint bladders were replaced by metal cylinders, which were emptied by means of a piston and could then be returned to the artist's colorman for refilling. The collapsible metal tube with a screw top came on the market in the 1830s, and the manufacture of paint moved away from the studio to the factory.

The character of the paint changed because a more solid consistency was required to pack into the new containers, and various additives were mixed with the oils to ensure that the pigments remained in suspension. This, in turn, affected the way the paint was handled — artists had to use shorter, stiffer brushes and diluents such as turpentine. Painting away from the studio became much easier, and artists, freed from the necessity to mix paint, were encouraged to use a much wider range of the ready-mixed colors.

The year 1869 is commonly regarded as the turning point in the development of the Impressionist style. That summer Claude Monet (1840-1926) and Renoir worked side by side along the banks of the River Seine at La Grenouillière, one of the new leisure spots outside Paris.

With their portable easels and paint boxes they made rapid studies in free sketchy brushwork, attempting to capture the transient effects of light on the landscape. Their methods and palette colors were to change considerably in the following decade, but the basis for the new Impressionist techniques had been established. They had to learn to 'see' the natural world for themselves rather than with the artificial eye of European painting, and in order to do so rejected the conventional academic concern with line and chiaroscuro.

Not only did Impressionism radically alter the way artists saw, but it also gave rise to quite new ways of handling paint. Thinly applied glazes and scumbles built layer upon layer were rejected in favor of thick opaque color applied in rich impasto with brush or knife.

The chief characteristic of the Impressionists, including painters such as Monet, Camille Pissarro (1831-1903) and Alfred Sisley (1839-99), was their use of broken color. In this technique strokes or dabs of varied opaque colors were laid side by side to merge into the correct tones in the eye of the viewer. The aim of the Impressionists was to achieve a greater naturalism than before by exact analysis of tone and color and by trying to describe the way light played on surfaces, changing the color of both light and shadow areas. They felt that the traditional palette and ways of handling paint were inadequate to capture this natural light.

Their interest in color and light was partly due to the researches of Michel-Eugène Chevreul (1786-1889) into the physics of color. The artists experimented with the effects of color contrasts, and this led them to use complementary contrasts to enliven their shadow areas and create atmospheric effects. For example, a cream ground might be allowed to show through a loosely painted blue sky to create the effect of warm, glowing light. The warm cream would be enhanced by the adjacent blue, which would in turn appear cooler. They exploited the way in which warm colors advance and cool colors tend to recede to create form without recourse to conventional tonal modeling.

The public and critics were outraged by the apparent carelessness of their work — by the freedom of their brushwork and the dashes of unblended colors. They were used to the firmly established forms, carefully handled paint, 'finished' images and 'suitable' and ennobling subjects of the academic painters. Impressionist paintings, with their small brightly colored dabs of color and images which lacked any firm outline, seemed strange and provocative.

OIL PAINTING TODAY

Our century has seen a proliferation of art movements, and artists have felt free to work in whatever way they wished. New media such as acrylic and alkyd have come onto the market and have found favor with many painters, but oil paint has lost none of its attraction — rather, its possibilities have been extended beyond anything that could have been imagined by previous masters of the medium. Salvador Dali (b 1904) sought a kind of photographic realism, applying oil paints in a way which was obviously derived from the Flemish masters. In his search for minute accuracy he often worked with a jeweler's glass, resting his arm on a mahl stick. The Abstract Expressionists worked on large canvases which demanded quite another way of applying paint. Jackson Pollock (1912-56), for example, laid his unstretched canvas on the floor and, dispensing with the brush, dipped, dribbled and splashed his paint onto the surface, the physical qualities of the paint and the dynamics of the artist's movements dictating the quality of the line and the finished paint surface.

Since the time of the Impressionists the range of oil pigments on the market has greatly increased, largely because of the abundance of chemically manufactured tints available. Manufacturers have created all sorts of mediums to modify the behavior of paint, and the commercially available pigments are now fairly consistent and therefore predictable. While all these developments undoubtedly remove much of the uncertainty and drudgery from painting, they can create their own problems, particularly for painters who are inexperienced or who have not had the benefit of several years at art school. For such people the shop selling artists' materials can be a daunting place indeed, albeit an exciting one. The artist can learn about a medium by study, by looking at the work of other painters from all periods, but most importantly by experiment and experience.

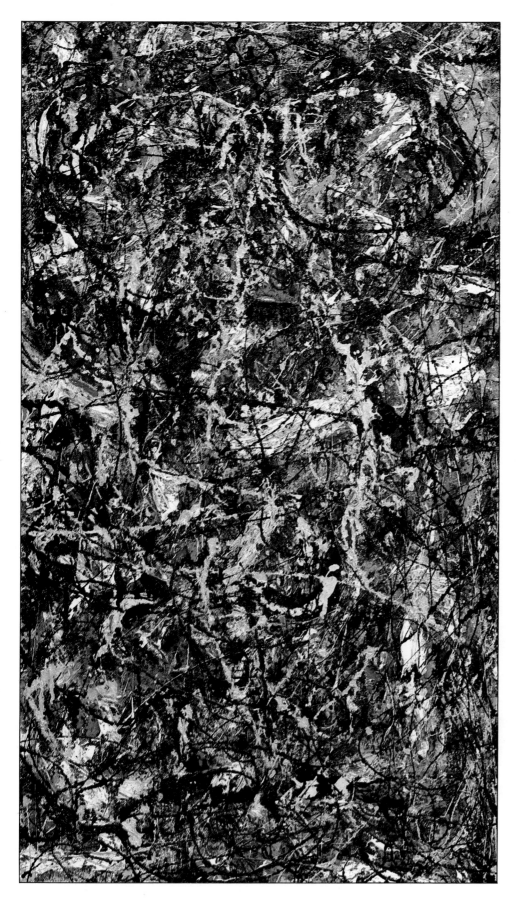

Full Fathom Five (1947) by Jackson Pollock (1912-56). Pollock started as an easel painter, but for this painting, one of the earliest examples of his drip technique, he removed the support from the easel and laid the unstretched canvas on the studio floor. Abandoning the brush in favor of a more direct method of application, he diluted his paint and applied it by pouring it from a can, with a stick placed inside the can controlling the direction of flow. He moved around the painting so that the paint was applied from all sides, the final effect being determined by such factors as the angle and speed at which the paint was poured, its viscosity and the way in which the artist moved. Onto this dominant mesh of 'dripped' color the artist flicked and dabbed other colors and enriched the impasto effect by introducing materials such as buttons, coins, nails, tacks and cigarettes.

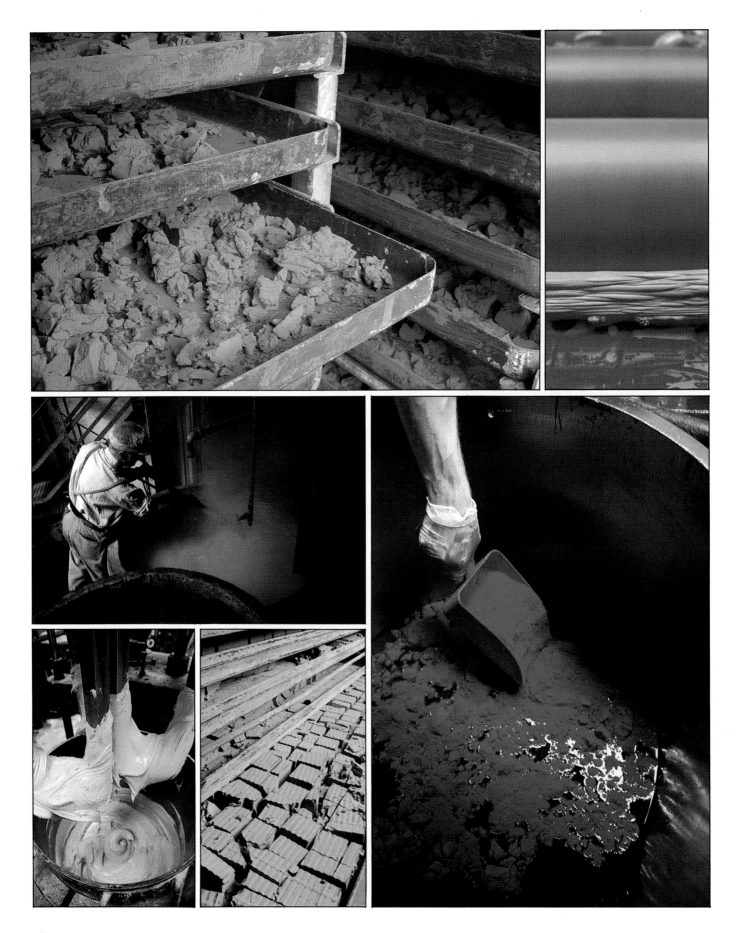

GETTING STARTED

For the beginner a visit to an artist's materials shop can be either a thrilling or a daunting experience because the range of materials and equipment is quite bewildering. You do not need to spend a great deal of money to start with, however, and a few brushes and six or seven colors — black, white, yellow ocher, cadmium red, cadmium yellow light, cobalt blue and raw umber — would be quite sufficient. As you experiment with subjects and techniques, you will find that you need to expand your range of colors.

Until the eighteenth century most artists either prepared their own materials and tools or relied on their apprentices and pupils to do so. Today, most materials are bought ready-made. These pictures *left* show modern paint manufacturing at the factories of George Rowney and Co. (established 1789) and Winsor and Newton (established 1832).

Choosing a place to paint is the first and often the most difficult requirement for the artist, whether a professional or a serious amateur. The spaces that artists use vary from large, purpose-designed studios, often at some distance from their home, to a corner of the living room, or at very worst a corner of the kitchen table when the rest of the family is out or has gone to bed. In fact this may be quite adequate if your chosen medium is watercolor or if you work on quite a small scale — you may not need a great deal of space and may be able to carry the tools of your trade in a small box or bag and set up to work almost anywhere. The problems arise when you start to work on a larger scale and use more complicated media.

Oil paint can be a problem for this very reason. Many artists who work with oils find that they are happiest working on anything from 30in x 20in to supports that measure a yard or more. The ideal working environment allows the artist to leave work in progress on the easel so that it can be returned to at any time. Oil paint dries slowly, and while this means that the artist is free to work on the painting over a considerable period of time, it also means that if space is at a premium and cannot therefore be allocated exclusively to painting, the artist has a possibly large and probably very wet object to deal with. Unless you are very neat and organized, bits of oil paint have a thoroughly irritating habit of appearing in all sorts of unlikely places — on furniture, clothing and even on the underside of coffee cups — and can creep into every part of the house, to the great annoyance of family and friends.

SUPPORTS FOR OILS

Having considered, albeit briefly, the place in which you will paint, you now turn to the material, known as the support, upon which you will paint. The support is a very important aspect of any painting. The first supports were the walls or ceilings of prehistoric caves, which were superseded by manmade walls covered with a layer of mortar and followed with plaster walls. Easel paintings — those that could be moved from one place to another — enabled a much greater variety of materials to be used: not only the traditional canvas but also wood, parchment, metals, fabric and, more recently, composition boards such as hardboard, particle board and plywood.

A support for oil painting must not absorb the oil in the paint and must have sufficient 'tooth' to hold the paint. The texture is a matter of personal taste and will be influenced by the way you work. In general, artists who use fairly thin paint and small brushes, and work on a small scale will probably prefer a surface with a relatively fine grain, whereas those who work with thick paint and on a larger scale, will prefer something coarser.

CANVAS

The range of supports available to the oil painter is enormous. Even so, canvas is the one most often used for oil painting. The popularity of canvas as a support dates back to the early fifteenth century and coincides with the beginning of oil painting itself. Fabric had been used as a support even before that, as had wood panels. The latter proved to be most suitable for tempera, which needed a firm support to prevent the pigment from cracking and separating from it. Wood was easily obtained, durable, could be carved and was an excellent surface for the gilding beloved of religious painters (and their patrons); but as the fifteenth century progressed,

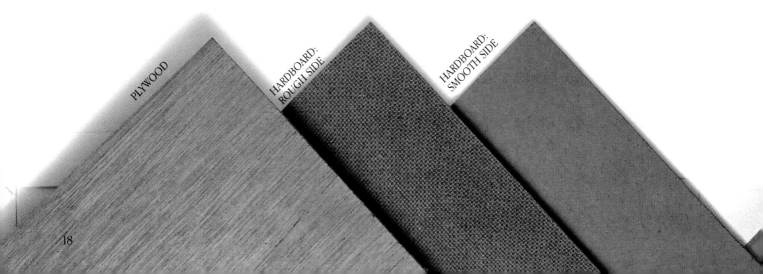

PLYWOOD

HARDBOARD: ROUGH SIDE

HARDBOARD: SMOOTH SIDE

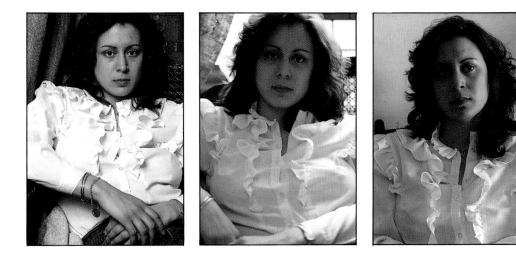

Light contributes to the mood of a composition and affects the way you perceive the subject and the colors of your pigments. The place where you paint should have adequate lighting, either natural or artificial. *Left*, the artist experiments with the lighting for the portrait on p.102.

artists increasingly turned to canvas. The advantages were obvious. Canvas was light and easily transported. Large paintings which previously could have been done only *in situ* as murals or on very large and heavy wooden panels could now be tackled as easel paintings.

Although there are various alternatives, many artists still find canvas the most pleasing support for oil painting. There is nothing to match the responsiveness of the stretched fabric and the way its natural tooth holds the paint; there is also a great range of textures and finishes available.

Various fibers are used for canvas, linen being the best — and the most expensive. It is produced from the stalks of the flax plant (linseed oil is extracted from the seeds of the same plant). Linen canvas, which retains the dark, gray color of the natural linen, is produced in a variety of weights and weaves. The differences are a matter of taste rather than of quality. Cotton canvas is popular, and it too is available in a range of weights and textures. It is less stable and softer than linen, but is considerably cheaper and favored by many artists. Linen and cotton mixtures

are not recommended because the materials absorb oil and pigments in different ways, which can cause the weave to distort. Hessian is a cheap, coarse surface which requires a lot of priming.

Only by trial and error will you be able to decide which surface suits your requirements and your pocket best, so it is important to experiment, and every now and then to try something new. To some extent you will be limited by the resources of your local suppliers, although you can obtain some materials by mail order. Another way of broadening your experience is by noting what your friends use and, at exhibitions, by examining paintings in detail to find out what the artist used.

STRETCHING CANVAS

Canvases can be bought ready-stretched and primed, but is is much cheaper to buy the fabric by the yard and stretch it yourself. This is less difficult than you might think. Wooden stretchers can be bought in pairs from art suppliers, who also stock canvas pliers, which are very helpful. Select the dimensions of the canvas you want

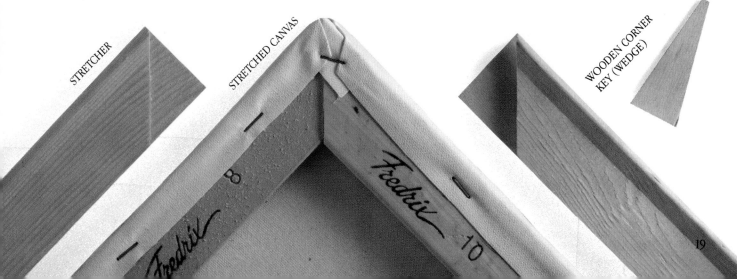

STRETCHER

STRETCHED CANVAS

WOODEN CORNER KEY (WEDGE)

and, with a sharp knife such as a Stanley knife, cut the fabric to size using a metal ruler or cutting edge as a guide. Allow a $1\frac{1}{2}$ in overlap on all four edges of the canvas. Fit the four parts of the stretcher together and lay the frame on the canvas so that it is parallel to the weave. Fold the fabric over one of the stretchers and staple or tack it in the center of one side. Then, using canvas pliers if you have them, stretch the canvas and fix it in the center of the opposite side. Repeat the process on the other two sides. Now, working on alternate sides, complete the stretching and tacking process until all four sides are firmly fixed and the canvas is taut and smooth. It is not necessary to exert any great force to stretch the canvas — in fact if you exert too much pressure you will warp the stretchers. Fold in the corners neatly. Tiny wedges of wood called corner keys fit into the corners of the stretchers and allow the canvas to be tightened or slackened as necessary.

PRIMING THE CANVAS

Raw canvas should not be used for painting. The fabric must be isolated from the paint, otherwise the oils will seep into the materials causing the pigment to become dry and flake off. Also, the chemicals in the pigments react with the canvas and will eventually destroy it. There are, of course, artists who break the rules; for instance, the English painter Francis Bacon (b 1910) primes one side of the canvas and then works on the unprimed side. Conservationists in museums and galleries are now faced with the task of preserving his works for posterity.

The conventional way of preparing canvas is by sealing it with a coat of glue size before putting on the ground. Animal-based glues are the best — either rabbit-skin glue, which is made from leather waste, or bone glue. Rabbit-skin size has a low adhesive power, but it is fairly flexible when dry, which means that there is less risk of its cracking.

To prepare the size, measure one cup of size crystals into seven cups of water and leave to soak for about 20 minutes or until it has doubled its bulk. Warm it over a low heat — do not allow it to boil or it will lose its sealing powers. You will find it useful to have special saucepans and containers for this operation. (Some people mix the size in a jar and put that in warm water, others use a double boiler.) Leave the size to cool. It will form a jelly which should be fairly firm and should not fall out of the container if inverted.

To use the size simply warm it gently, which will dissolve it again, and apply it to the right side of the stretched canvas while still warm. Use a large brush and work from one side to the other, making sure that you coat the edges. Keep the brush well loaded but do not apply too much glue, and do not scrub it in or you will destroy the surface of the canvas. You may like to apply just one coat or, as some painters do, apply two very thin coats, allowing several hours between applications for the size to dry.

Artists' size is also available ready-prepared in bottles. Unless you work on a very small scale, however, you will find that size bought in this form is far too expensive.

Once the canvas is sized the ground can be put on. This forms a layer between the size and the paint, provides a suitable surface for painting on and acts as a further protection for the support. Most grounds are white, which adds a brilliance to the paint and lessens the effect of the darkening of the paint with age. You can, of course, buy canvases ready-primed, but some artists find these surfaces rather unpleasant to work on and they are undoubtedly more expensive than the unprepared canvases.

There are various different kinds of grounds, and most artists' materials shops sell a selection, ready-mixed in cans. Oil grounds provide the artist with a white painting surface which has the flexibility particularly suited to a fabric support, but they take a long time to dry, and supports prepared in this way will not be ready for use for at least a month. If you want to make your own there are many recipes — the one given here is one of the simplest: 6 parts turpentine; 1 part linseed oil; titanium white powder.

Mix the turpentine and linseed oil together and gradually add the white pigment until the mixture is of a thick and creamy consistency. The ground should be applied to the surface in two thin coats.

There are many simpler alternatives to preparing a ground, however — for instance an oil-based decorator's undercoat, which can be purchased from hardware stores, and acrylic primers. These should be applied to canvas or board directly; if size is applied to the surface the ground will crack. The primer should be applied in

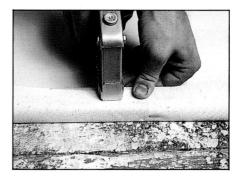

STRETCHING CANVAS
Lay the stretchers on the canvas and mark off the amount of canvas you require, allowing a 2in overlap on all four edges.

Cut fabric with scissors or with a Stanley knife, using a metal cutting edge or a steel rule as a guide. Make sure that you cut parallel to the weave.

Starting on one of the long sides, fold the fabric over the stretcher and staple it in the center. Repeat on the opposite side and then the other two sides.

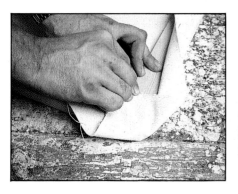

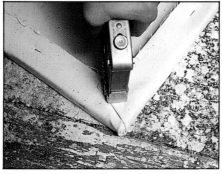

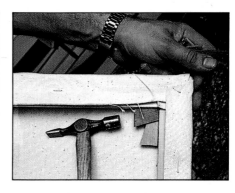

Now, working on alternate sides complete the stretching and tacking process, working from the center towards the corner. Fold the corner flap in.

Finish the corner neatly by folding it over along the stretcher joint, and fix it with a staple. If the corners are bulky the picture will be difficult to frame.

Insert two wooden wedges into the slots in each corner. These can be tapped in to tauten the canvas if it should become loose during painting or storage.

PREPARING SIZE
Rabbit-skin glue crystals can be bought from some artists' suppliers. Measure one cup of crystals into seven cups of water and leave to soak for about 20 minutes.

The crystals absorb the water, doubling their bulk. At this stage they look fluffy. Warm the size over a low heat because it is important that it does not boil.

Apply the still warm size to the right side of the stretched canvas. Use a large brush and work from one side to the other with even, sweeping strokes.

two thin coats, the first one thinned with water.

Experiment with different grounds — gradually you will find out which ones suit your style and the way you handle paint.

OTHER SUPPORTS

One of the oldest supports for easel painting is wood, though wooden panels are less favored today. Hard-woods, which are less likely to warp or crack, are most suitable, and well-seasoned mahogany is the best. The possibility of warping is lessened by cradling the board. To do this you fix two wooden battens to the back of the board across the grain of the wood. These should be cut to length — slightly shorter than the width of the board — and fixed with screws or glue. Another way of reducing the risk of warping is by priming the panel on both sides.

Hardboard (sometimes called Masonite) makes an excellent support — it is cheap and has two different surfaces, one smooth and the other textured with a woven finish. It is strong and does not need battening unless you are using very large sheets. Its only weak point is around the edges, and these can be strengthened by attaching battens. Hardboard should be primed on both sides to stop it bending.

Plywood supports should be at least five-ply or even eight-ply and should also be properly cradled. Particle board has the advantage of not warping, but it is very heavy and must be well primed.

Cardboard is an excellent support, and has been used by many artists of the past — Edouard Vuillard (1868-1940) and Edgar Degas (1834-1917), for example. The board should be sized on both sides to prevent warping, and possibly battened as well.

Paper may seem an unlikely support for oil, but it has often been used for works in oil, by Rembrandt, Constable and Cézanne, for example. Good-quality watercolor paper is best because it has both tooth and weight, but even drawing paper and colored papers are quite suitable. Paper can be used unsized, especially if you are not concerned about retaining the painting for posterity but want to use it merely for exercises and sketches. Unsized paper, however, tends to leach the oil from the paint, which eventually dries, cracks and falls off; by sizing it you will make the paint more permanent. To work on paper you simply clip it to a drawing board using bulldog clips or thumbtacks.

All these supports can be prepared with size and then

EMULSION PRIMER
An excellent and fairly cheap priming suitable for canvas or hardboard can be prepared by mixing equal proportions of household water-based paint with emulsion glaze. This can be bought from art shops.

SIZING HARDBOARD
The smooth side of hardboard does not have much tooth. Roughen the surface with sandpaper or a saw blade.

Apply warm size to the support using regular brushstrokes. Do not apply too much glue — two thin coats are better than a single thick one.

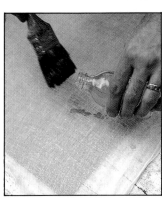

APPLYING MUSLIN TO BOARD
Cut the muslin allowing a 1½in overlap on all sides. Lay the muslin over the board, and apply warm size.

Using a large brush, apply the size to the muslin, smoothing out any creases. Turn the board over, fold in the fabric and paste it down.

primed with a suitable ground. Alternatively you can apply a coat of acrylic primer.

A very cheap support can be made by attaching scrim or lightweight muslin to a board such as hardboard. First cut the board to the dimensions required. Cut the fabric, allowing a 1½in overlap on all sides. Lay the fabric on the board and smooth it flat. Using a large brush, apply warm size, making sure there are no creases. Turn the board over and fold in the extra fabric. Apply more size to fix the fabric firmly. The size acts as an adhesive and a seal. Scrim is a rather coarse material and will require more size than the finer muslin. Both make very pleasant painting surfaces with an attractive texture, good tooth and interesting color.

You can also buy ready-made supports of various kinds, the cheapest being oil sketching paper. This is a commercially produced paper with a grained surface which is ready-primed. Although not suitable for finished work, it is useful for sketching. The kind that comes in pads is most convenient, since the pad provides a firm support for working; but the paper is also available in single sheets. Canvas boards have textured surfaces with a variety of grains, and they are sold with a priming suitable for either oil or acrylic. The advantage of all these products is that you are saved the bother of sizing and priming, but many people find the surfaces greasy and unpleasant to work on. This is entirely a matter of taste; several of the paintings in this book have been made on these supports.

PAINTS

All paints — watercolor, gouache, acrylics and oils — are made from pigment, which is a finely divided color substance that imparts its color effect to another material when mixed with it or when applied over its surface in a thin layer. Pigment that is mixed or ground in a binder to form paint does not actually dissolve, but remains suspended in the liquid. You can still buy powdered pigments quite easily, and there are some artists who remain convinced that hand-ground pigments are better than tube colors.

Pigments can be broken down into the following three basic groups: earths, inorganic pigments and organic pigments. Native earths occur all over the world, but pigments are usually produced from the earths of particular regions, where they may be available in an especially pure form. The earth pigments — ochers, umbers, terre verte and siennas — are all iron oxides and have been used for thousands of years. The Mars colors are synthetic iron oxide pigments and tend to be more opaque than the naturally occurring pigments.

Inorganic pigments are made from naturally occurring minerals. Deposits of these minerals are becoming increasingly rare and, with the exception of lapis lazuli (ultramarine) and cinnabar (vermilion), have virtually disappeared, so nowadays they are manufactured synthetically. These pigments include the cadmiums, cobalt blue, cerulean, viridian, vermilion and ultramarine.

Organic pigments were originally dyes extracted from plants and animals. They were made into the 'lake' colors by precipitating them onto a carrier such as alumina — a white powder which becomes colorless and transparent when ground with oil. Carmine and rose madder are lakes. The early synthetic dyes were attempts to match these natural products. The lakes tend to be fugitive and bleed through subsequent layers of paint, but some of the new organic pigments have a very high degree of permanence.

These days most artists buy their material ready-prepared, but the basic principles used in the past, when pigments were ground by hand on a marble slab, are still applied to their manufacture. The pigments are dispersed into linseed oil or safflower oil, which is paler and dries more slowly. The oils dry by oxidization and polymerize to a solid form, holding the pigments in suspension. When liquid, the oils are soluble in solvents such as mineral spirits or turpentine, but when dry they are insoluble. Drying continues for up to a year, and even then the dried film continues to harden further.

Oil paint sold in tubes is available in two qualities, Artists' and Students'. Artists' quality contains the best pigments and has the highest proportion of pigment to extender. All the pigments are chosen for their strength of color, which means that when mixed with white, they will go further than cheaper brands. Chemical additives are kept to a minimum and are added only to improve the color stability and shorten drying time. Some special colors are available only in the Artists' range of colors. Artists' colors are more suitable for working in the studio

because they take longer to dry than Students' color.

Students' colors are cheaper than Artists', and in some instances the expensive pigments have been replaced by cheaper substitutes. Vermilion, cobalt and the genuine cadmiums are rarely available in the Students' range. The paints are generally coarser in texture than the Artists' and contain a higher proportion of extender to pigment, but they are useful for beginners who are still getting the feel of oil paints.

Different colors have different drying times. Colors containing earth pigments dry fastest and, if applied in thin layers, may dry in a day or so. Alizarin crimson, on the other hand, may need ten days or so before it is dry to the touch, and complete drying can take anything up to a year. Drying time is also affected by humidity, temperature and the flow of air over the paint surface. Thick layers of paint dry slowly and tend to crack, so there is something to be said for building up paint in thin layers, allowing time for each to dry.

Different colors also have different degrees of permanence, and the following symbols are used by Rowney's on their tubes to indicate these:

**** most permanent
*** in full strength these colors would compare to **** but if mixed with white or in a thin glaze they would lose a certain amount of permanence
** less permanent than *** and not sufficiently inert toward other pigments when used in mixtures
* relatively fugitive

Other manufacturers indicate on the tubes whether the paint is permanent or non-permanent.

DILUENTS

Solvents are used to dilute tube color and clean brushes, palettes and hands. To be effective, a solvent must evaporate completely from the paint film. Turpentine is the most popular solvent. Made from the distilled resin of pine trees, it accelerates the drying of both the oils used to bind pigments and the painting mediums. It should not be left exposed to the air or light or it will become stale and will dry more slowly, becoming thick and pungent. There is a wide range of turpentines on the market, each with its special characteristics. The best quality is distilled turpentine, which is sold in art supply shops for painting purposes. Mineral spirits, or turpentine substitute, is a slightly weaker solvent than turpentine, does not deteriorate with age and dries more quickly. It is distilled from crude petroleum oils and is therefore considerably cheaper than distilled turpentine. Many artists do not like using it because they find the smell unpleasant, but it is quite adequate for most purposes, and can certainly be used for cleaning brushes and as a diluent when you want to work quickly.

Artist's colormen manufacture different solvents with particular qualities and drying times. Investigate them on your next visit to an art store. Only experimentation will reveal what suits your painting style.

BINDERS AND MEDIUMS

Oil paints, as we have seen, are made by grinding pigment into a binder, a natural drying oil such as linseed

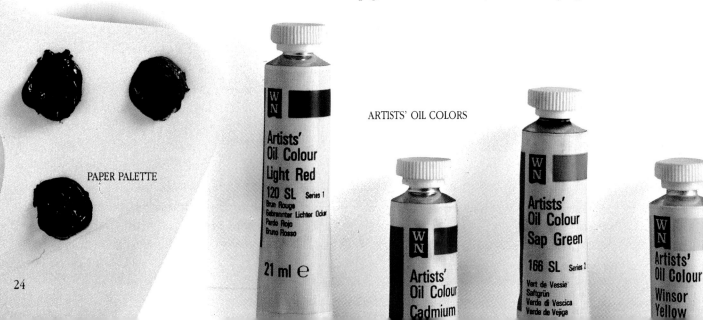

PAPER PALETTE

ARTISTS' OIL COLORS

or poppy. Some of these are also used as paint mediums (that is, substances which are mixed with the paint from the tube to change their character and consistency) and for glazing and varnishing. Drying oils are fatty oils, usually of vegetable origin, which dry to form a solid, transparent film when exposed to air. They dry by oxidization, which changes their molecular structure, and it is this characteristic that makes them suitable for binding pigments in oil paint.

Linseed oil is the most widely used of all the binders and mediums, and has been used by artists for this purpose since the Middle Ages. Raw linseed oil is produced by steam-heating the seeds of flax before pressing them to extract the oil. The best-quality linseed oil for painting purposes, cold-pressed linseed oil, is produced without heat, but less oil is extracted in this way and the oil is expensive and fairly difficult to obtain. The best substitute is refined linseed oil, which is produced by bleaching and purifying raw linseed oil. It is slow-drying, but increases the gloss and transparency of the paint. This oil varies in color from a pale, straw color to a deep, golden honey color. You should avoid the palest colors because these tend to darken with age. Sun-bleached linseed oil is paler and faster-drying than the refined oil and is useful for mixing with pale colors and white. Sun-thickened linseed oil has a much thicker consistency than its sun-bleached counterpart, and is used to improve the flow and handling of paint. Stand oil, yet another version of linseed oil, is produced by heat-treating linseed oil in a vacuum. The resulting oil is thick and pale, and dries to a thick elastic film which does not retain brush marks or darken as much as other linseed oils. Thinned with turpentine stand oil is excellent for glazing.

Poppy oil is made from the seed of the opium poppy, and is very pale in color. It is a suitable binder for pale tints or for use with white. When used as a medium it gives the paint a pleasing buttery quality which is especially good for 'alla prima' painting, the direct method, where the texture of the paint surface and the mark of the brush are important. For this reason it was popular with the Impressionists. It dries slowly, so should not be used for paintings on which layers of color are being built up, because it is inclined to crack more easily than linseed oil. Again there are several different qualities of poppy oil. Sun-bleached poppy oil is very pale and therefore ideal for adding to white and pale colors, whereas drying poppy oil, as its name implies, dries more quickly than other qualities.

The subject of binders and mediums is quite a complex one, and here only the most common products are mentioned. Unless you mix your own paints from pigments, or grind your own, you do not need to become too involved with binders, and by far the commonest medium is a mixture of turpentine and linseed or poppy oil. The proportions in which these are used are a matter of taste, method of working and habit, and you will very soon evolve your own recipes. Some artists add varnish to the paint, which helps drying and increases the sheen on the paint surface. Varnishes are

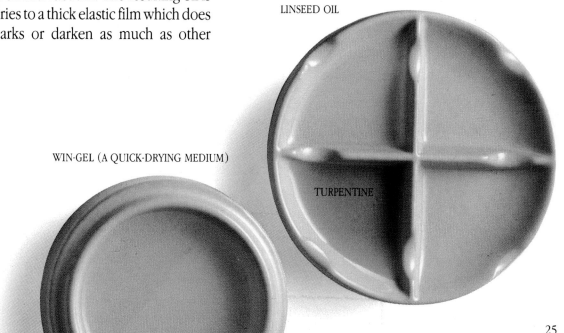

LINSEED OIL

WIN-GEL (A QUICK-DRYING MEDIUM)

TURPENTINE

particularly helpful for glazing.

There are various commercially available painting mediums. Oleopasto is a gel extender which can be mixed with paint to create impasto effects, especially with knife paintings. Win-gel, another gel-type material, is used for glazing and for building up slight impastos. It gives the paint a pleasant gloss. Liquin, which is used for glazing and thinning, also increases gloss, and dries fast.

All the paint manufacturers produce various oil-based mediums and gels which have different qualities and change the texture and handling qualities of the paint as well as affecting the drying time.

VARNISHES

All varnishes are a solution of resin in a solvent. Varnish has been used by painters for centuries, both as a protective coating and as a medium in glazing. Oil varnishes, or soft varnishes, are made by dissolving resins such as copal, amber and sandarac in drying oils such as linseed oil. The hard, or ethereal, varnishes are made by dissolving damar or mastic in turpentine. Varnish solutions have many uses in the studio apart from giving a final protecting film for the paint surface. Picture varnish protects the paint surface, as does retouching varnish, which contains more turpentine and is less glossy. Mixing varnish can be added to tube colors to create glazes, and isolating varnish is sometimes used over recently dried oil paint so that overpainting and correcting can be carried out without affecting the underpaint. Ready-made varnishes can be purchased in art stores, but you can also make your own by dissolving resin in either oil or turpentine.

BRUSHES

The oil painter has a large range of brushes to choose from. The main fibers used are bleached hog's hair, red sable and synthetic. Hog's-hair brushes, the most popular for oil painting, are made from bleached pig's bristles. The split ends of the fibers have particularly good paint-holding qualities. The bristles vary in length and thickness, depending on quality. Hog brushes are available in four different brush shapes:

Rounds are very useful: in the large sizes they can be used to apply thin paint to large areas. The smaller rounds are useful for drawing line and putting in details.

Flats are versatile and can be used to create short dabs of color, whereas the side or tip can be used to create thinner lines. A variation of the flat has an oval shape and is sometimes called a 'filbert' because of its resemblance to this nut.

Brights resemble flats, but the bristles are shorter, and many artists find them easier to control.

Filberts also resemble flats, but the bristles are tapered at the end.

Fan-shaped blenders, made from hog, badger or sable, are used for blending colors on the canvas.

Some brushes are more appropriate for certain purposes than others. The Impressionists, for example, who used stiff, buttery paint, tended to use flat brushes, whereas the Old Masters, who used elaborate glazing techniques, used round brushes. You need a lot of brushes for oil painting to avoid continually having to clean them, but because the paint takes so long to dry you can leave a color on a particular brush and return to it whenever you want to use that color. Some artists are

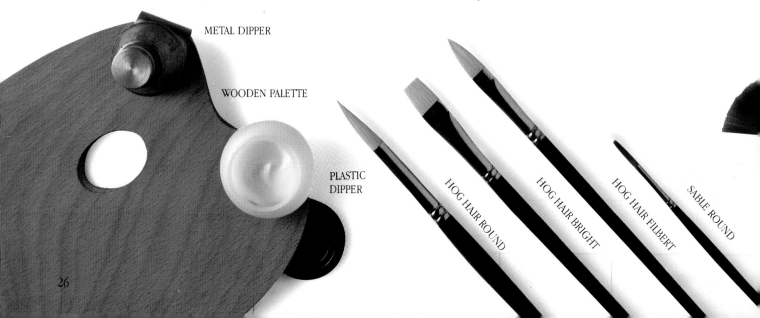

METAL DIPPER

WOODEN PALETTE

PLASTIC DIPPER

HOG HAIR ROUND

HOG HAIR BRIGHT

HOG HAIR FILBERT

SABLE ROUND

very conservative about brushes, using a very limited range of sizes and one or two shapes, whereas others work with the entire range of shapes and sizes. Again, your choice will depend on your method of working, the way you apply paint, and your pocket. It can be very helpful to explore the possibilities of different brushes from time to time; it can expand your painting technique and free your style. You should also invest in a small house-painting brush which will be useful for tinting a ground and for applying broad areas of paint.

Synthetic fiber brushes are a relatively recent addition to the artist's collection of materials. They are available in the same range of shapes as hog and sable but their bristles tend to be softer than real bristle and harder than sable. They are cheap compared to other brushes; they are also hard-wearing, and retain their shape very well. Artists vary in their response to them; some love them and others loathe them, claiming they do not have the paint-holding capacities of the natural fibers. Because they are quite cheap, it is worthwhile trying one to see whether it suits you.

Sable brushes are soft-haired and very expensive. Rounds are the most commonly used and are useful for putting in fine details, laying on thin glazes, or applying paint wet into wet without disturbing the paint underneath. Sables are also available as brights.

Some brushes are made from a mixture of fibers — for instance there are mixtures of sable and ox hair which obviously have many of the qualities of both but are cheaper than pure sable, and there are mixtures of synthetic and sable.

The size of a brush is indicated by a number inscribed on the handle. The number is useful for ordering brushes, but the sizes are specific to particular types, so a number 6 sable will not be the same size as a number 6 hog. Hog-hair brushes are available in size 0-24; sables start from an extremely small 00000 and go up to 24.

CARING FOR BRUSHES

This is vitally important. Good brushes are expensive, and a good brush which is carefully looked after can last for several years, whereas a brush which is used vigorously on a harsh painting surface and is not properly cleaned will last only a matter of days. Clean your brushes at the end of every painting day. If a brush is loaded with paint, remove the excess on a piece of newspaper or kitchen roll, then rinse it in mineral spirits and wipe it thoroughly on a rag. Wash it under warm running water, soaping the bristles with a bar of household soap. Avoid using detergent, because it is too harsh. Rub the soapy bristles in the palm of your hand so that the paint which has collected around the ferrule is loosened. Rinse the brush in warm water and rub it gently on the palm of your hand to make sure that all the paint has been removed. Shake it to remove the water and then smooth the bristles into shape. Leave the brush to dry, bristle end up, in a jar. Never allow your brushes to rest on their bristles.

KNIVES, PALETTES AND CONTAINERS

Palette knives have straight, flexible, steel blades. They are used for mixing paint on the palette, scraping paint from the support, cleaning the palette and occasionally applying paint to the support. Painting knives have

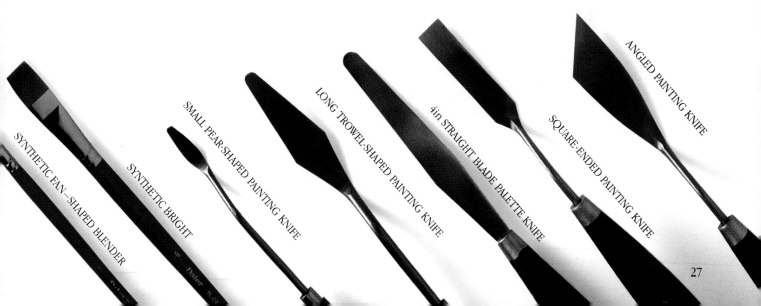

cranked handles and are easier to paint with because the bend in the handle holds your hand away from the paint surface. They are available in a range of sizes, and in pear, trowel or diamond shapes. Knife painting is useful for creating rich impastos, and is worthwhile trying if you feel that your painting style needs loosening up.

Palettes are used for laying out the colors you will use and for mixing paint. You should get into the habit of laying out your paints around the edge of the palette in a particular sequence — running from cool to warm, for example. This means that you will always know where to look for a particular color, as some colors are difficult to distinguish when squeezed from the tube.

The traditional artist's palette is a large kidney-shaped piece of flat wood with an indentation for the fingers and a hole for the thumb. Rectangular palettes are designed to fit inside painting boxes. Mahogany is the most popular material, but other woods and materials are also used. Palettes for oil painting are usually flat, but some with recesses are available, usually in plastic, ceramic or metal. These are used for mixing thinned paint for glazing or layering. Disposable paper palettes — peel-off pads of oilproof paper — are very useful, and save the trouble of cleaning palettes.

A palette can very easily be made from plywood or any cheap timber. Seal the wood by painting it with a layer of linseed oil, then wipe it with paper towels to remove the surplus oil. Allow that coat of oil to dry for about a day and repeat the process several times. You should also treat a new palette in this way because the oil will seal the wood and stop it from soaking up the oil in the paint. Ideally, you should oil the palette each time you clean it, and gradually a rich patina will build up.

It is important that your palette feels comfortable and gives you enough space for mixing, so buy or make it rather larger than you think you will need. This will allow you to lay out and mix plenty of paint. A small palette will inhibit you because it will quickly become overcrowded and will discourage you from experimenting with color and paint mixtures.

A palette need not necessarily be hand-held, and if it is not, you can use materials such as glass for mixing. Many artists find an old tea trolley or an industrial trolley very useful: it is easy to move, provides a large mixing surface, and usually has a shelf underneath for storing rags, tubes

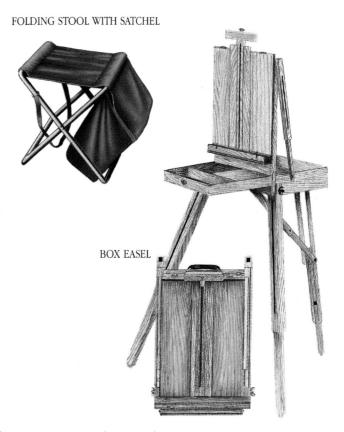

FOLDING STOOL WITH SATCHEL

BOX EASEL

of paint, spare medium and so on.

Clean your palette after a day's work, using your palette knife to scrape off the mixed paint, but keep any unmixed pigment if you are going to return to the work within a few days. Use paper towels soaked with mineral spirits to clean the palette, then rub it over with linseed oil. If you want to keep any paint, cover the palette with plastic wrap or foil to insure that the paint remains moist.

You will need containers for your turpentine, mineral spirits, oil and medium. A large jar will do very well for the spirits for cleaning your brush, but smaller containers called dippers are useful for holding the working mediums. Dippers are small metal pots which have clips that attach firmly to the palette. They come singly or in pairs, and some have lids.

EASELS

There is a large range of easels on the market — the one you choose will depend on where you paint and how large your supports are. For example, if you intend to paint outdoors you will need a portable easel. There are several types of sketching easel, the cheapest probably

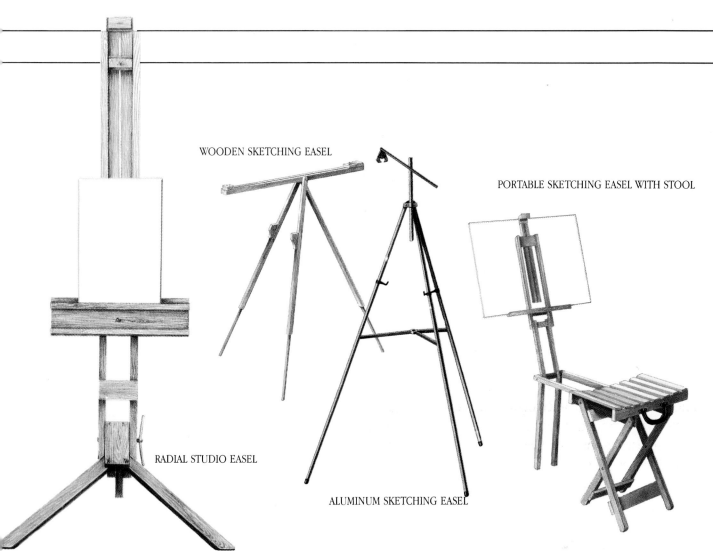

WOODEN SKETCHING EASEL

PORTABLE SKETCHING EASEL WITH STOOL

RADIAL STUDIO EASEL

ALUMINUM SKETCHING EASEL

being the wooden folding easel. Some types hold the work horizontally for watercolor, others hold it vertically for oil painting, and some can be adapted to either position. These easels are fairly sturdy, but they are light, so they are easily upset in a wind, especially if you use a large canvas, which acts as a sail. Some sketching easels have spikes on their legs which can be sunk into soft ground. Artists sometimes tie the legs to an available tree stump, anchor them with string and tent pegs, or stabilize them by suspending something heavy, such as a rock, from the center. Lightweight metal versions of the traditional sketching easels are now available; these are very sturdy and are slightly easier to erect than the wooden ones, but they are more expensive.

Another easel useful for sketching outside is the combined easel and painting box. These easels are convenient − though rather expensive − items, which tend to be more stable than ordinary sketching easels. The paints are carried in the box part, which becomes a table and provides a very useful working surface.

There are many easels for use in the studio, including the traditional artist's donkey, a combined stool and easel which the artist straddles to work sitting down. These take up a lot of room, but are useful if you like to work sitting down or do a lot of detailed work.

Radial easels are sturdy objects usually made from a tough hardwood such as teak or beech. They have short tripod legs and the angle of the upright column can be adjusted. The height of the canvas can be changed by moving wooden clamps that hold the support in position. Canvases up to 76in can be supported.

Studio easels are very stable, with a firm H-shaped base. The painting rests on a shelf which also forms a compartment for brushes, and a sliding block holds the canvas firmly in position. The shelf height is quite easily adjusted and the canvas can be raised from 15in to 39in above the floor. Canvases of up to 63in can be used. They are easily tilted and can usually be wound up and down by a ratchet device.

If you are very short of space, like to work sitting down, or work on a small scale, you might consider a table-top easel. These easels are very compact and relatively cheap. They can be tilted and the height of the support can be adjusted.

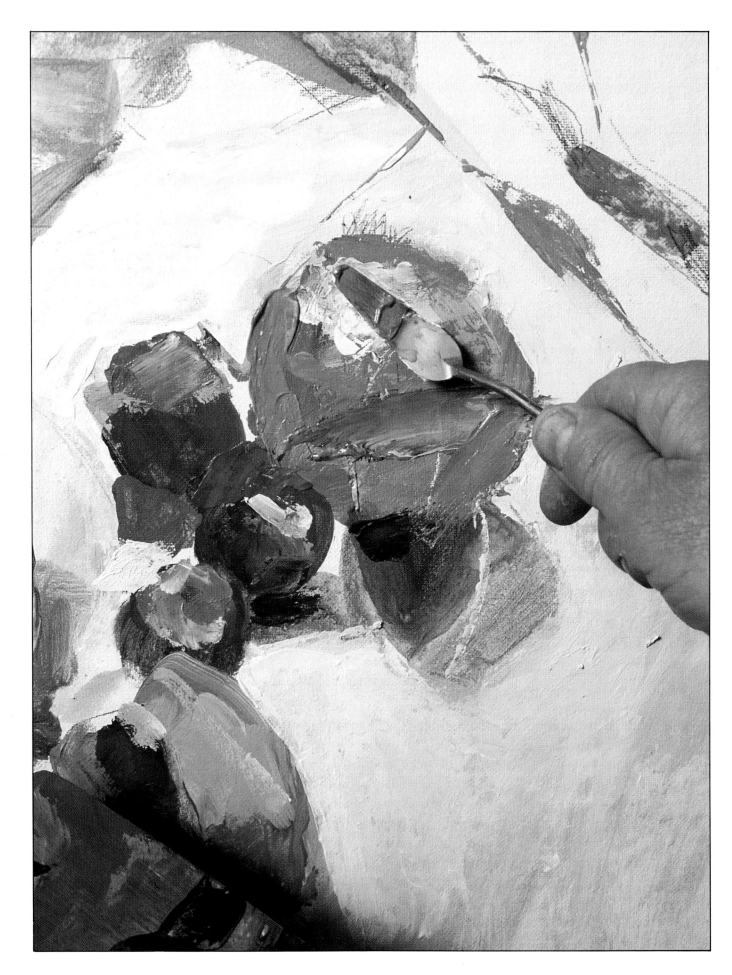

CHAPTER THREE

USING OIL PAINT

Oil is a very versatile medium and has led to the development of a great variety of painting techniques. It is important to understand that there is no 'correct' method of painting in oil, and you will undoubtedly evolve others for yourself as you become familiar with the medium. The way in which the paint is applied to the support makes an important contribution to the final appearance of any painting and can be as characteristic of the artist as his or her handwriting.

Left, the artist uses a painting knife in an 'alla prima' technique. He lays down the paint quickly, building up a thick layer in which the marks of the knife make an important contribution to the final painting.

One of the characteristics of oil paint is that it can be applied in transparent glazes, in thin opaque layers or in thick impasto, and the artist can alter the consistency of the pigment by adding different oils, varnishes and mediums. There are three basic approaches to creating an oil painting, two of which are based on a layering technique: in the first, the artist builds up a series of glazes over an underpainting; in the second, the paint is built up in opaque layers or in a combination of both transparent and opaque color. The third approach, known as 'alla prima', is a more direct method of painting, in which the artist puts down the color at one sitting, often with no drawing or underpainting.

Once you have set up the subject, *below left*, there are many ways of starting the painting. In the first example, *below right*, the artist has made an underdrawing using diluted paint. In the second, *bottom left*, he has used charcoal on a tinted ground. In the final example, the artist has developed a polychrome underpainting, blocking in the main forms in close approximations of the local color.

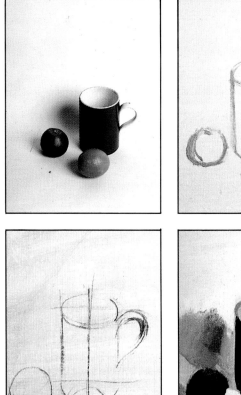

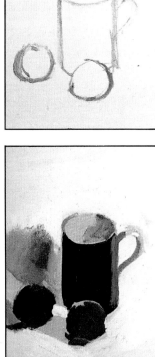

TONING THE GROUND

A white ground gives the subsequent paint layers a pleasing luminosity and brilliance, but a large area of white can be rather intimidating in this technique and some artists apply a layer of thin, transparent color all over the support. This layer is known as the *imprimatura*. Some painters, such as van Eyck, applied this over the underdrawing. The color you choose will depend on the subject of the painting: a warm color will enhance the blue of the sky or the greens of a country landscape, for example. You can apply the tint with a house-painting brush or a turpentine-soaked rag.

UNDERDRAWING

This may be made directly on the white ground or on a tinted ground. Almost any drawing material can be used, including pencil, charcoal or paint. If you choose pencil, use a soft one which can be erased and corrected. On canvas, charcoal is probably a better drawing medium because it is less likely to damage the support. Charcoal is a soft, dusty medium with a pleasant fluid line. Remove the excess dust by 'knocking it back', that is, flicking it off with a dustcloth. Alternatively, fix the charcoal with a commercial spray fixative before painting. If necessary you can reinforce the charcoal lines by retracing them with thinned paint. Some artists draw directly onto the support with thinned paint and a thin sable brush. Choose a neutral color such as ocher or brown, thinned with turpentine or mineral spirits.

UNDERPAINTING

The underpainting is also referred to as a 'dead color painting', and is usually laid in one color. The Old Masters usually used a dull brown, gray or green which was laid in with paint thinly diluted with turpentine or, in very early times, in tempera. The underpainting gives the

Left, we see glazes of ocher and viridian laid directly onto a canvas, the viridian overlying the ocher in the center. On the *right*, opaque white paint is scumbled on a muslin and hardboard support. One of the qualities of oil paint is the way colors can be blended by working wet into wet, *far right*.

artist the opportunity to design the painting and to establish the tonal values. The artist often starts with a mid-tone, and into this the shadows and the highlights are worked. In this way the main elements of the composition and the three-dimensional forms can be developed. The underpainting can also be laid in several colors which relate to the color distribution of the final painting. These colors can be allowed to show through, adding warmth or coolness to the overlying colors. These days many artists use acrylic paint to lay in a rapid underpainting. Acrylic paint dries very quickly, and the artist can start to lay in the next layer in oil almost immediately.

GLAZING

A glaze is a transparent layer of paint applied over a ground, an underpainting, another glaze, or impasto. Light passing through the glaze is reflected back by the opaque underpainting, or by the ground, and is modified by the glaze. From the Renaissance until the nineteenth century, paintings were made up of complicated layers of underpaintings, glazes, scumbles and small areas of impasto. To create interesting effects with glazes the artist must build up several layers, allowing the paint to dry between applications. Various mediums and varnishes can be mixed with the paint to improve their translucency and to speed drying. It is not necessary to glaze all areas of a painting — certain parts only of the subject may require this approach, whereas others may be more appropriately handled 'alla prima'. The color effects that result from overlaying a series of glazes are quite different from those achieved in any other way.

SCUMBLING

In this technique opaque paint is brushed very freely over a preceding layer, which may be flat color, a glaze or impasto. The important characteristic of scumbling is that the underlying areas are allowed to show through in an irregular way. A scumble may be achieved in many ways, by laying light over dark or dark over light. The paint may be dry or fairly fluid, and may be applied with a brush, or smudged on with a rag or even fingers. Scumbling is a very useful way of creating interesting color combinations and textures. The unpredictability of the effects can be very exciting.

'ALLA PRIMA'

'Alla prima', or direct painting, is a technique in which paint is laid on quickly and opaquely and the painting is completed in one session. The Impressionists were great exponents of this method of painting, which is particularly suited to painting outdoors, and Constable's marvelous oil sketches were also made in this way. In this technique the underpainting may be dispensed with altogether, or used merely to provide the artist with a compositional guide. Each patch of color is laid down more or less as it will appear in the final painting. The artist may blend some colors on the canvas, but the attraction of the technique is the freshness and directness of the paint application. The mark of the brush or the knife is an important element in the finished effect. The artist must consider line, tone, texture, pattern and color simultaneously. To achieve the necesssary unity it is advisable to work on all the different areas of the painting at the same time rather than concentrating on one particular area.

WET INTO WET

This is a variation of the 'alla prima' technique. The artist may not complete the painting at one session, but the fact that oil paint dries so slowly allows the paint to be worked into over quite a long time, and the final painting may look as though it was completed at one sitting. Wet paint allows the artist to make changes and to blend color together, but once the paint layers start to build up it takes great skill to 'drift' color over wet color without disturbing the underlying layers. Paint that is overworked can become churned up and muddy, and lose its original freshness. Details can be worked into wet paint with a fine sable brush and colors can be blended with a fan blender.

IMPASTO

The term describes the application of paint in thick, solid masses, in contrast to thin glazes and scumbles. Painters such as Rembrandt and Rubens used impasto for areas of highlight, but later artists used it much more extensively. The thick buttery paint retains the mark of the brush or knife, adding an important textural element to the paint surface. For this technique paint can be used straight from the tube, or can be modified by the addition of a suitable medium such as Oleopasto. Impastoed paint is often used by painters who use the direct method, or 'alla prima' technique.

KNIFE PAINTING AND SGRAFFITO

Most painters use a brush or several brushes to apply paint to the support, but more or less any implement can be used. The painting knife, with its cranked handle and flexible metal blade, is a versatile tool and can be used to achieve a variety of marks. Painting knives, available in a variety of shapes and sizes, are generally used to achieve rich impastos, but they can also be used to smear colors together and to inscribe into thick paint.

They can also be used for a technique called sgraffito, in which the artist creates patterns or outlines by scratching through a layer of paint to reveal underlying paint layers or the ground. Any sharp or pointed tool can be used for this — a pencil, or the handle of a paint brush will do just as well — and it provides the artist with yet another way of adding textural interest to the paint surface.

STAINING

Sized canvas can be stained with thin paint in a way that resembles the effect of watercolor on paper. It differs from the toning of a ground in that the translucent color is applied to a sized support rather than to a ground or an underpainting, and the weave of the canvas shows through. Many artists like to feel the tooth of the canvas rather than have it disguised by the application of a ground. In some cases they stain an unsized canvas, but this is not really recommended, because the oil and chemicals in the paint will eventually cause the canvas to deteriorate. If you want to use staining techniques you should think about using acrylic paint.

BROKEN COLOR

Colors can be mixed optically — in the viewer's eye — as well as on your palette. This discovery was the real breakthrough of the Impressionists, who found that they could most satisfactorily represent light and color by using broken color. They worked 'alla prima', applying small dabs of color which, when viewed from a distance, combined in the eye to form another color. Antoine Watteau (1684-1721) and Delacroix were the first to use this technique, but it was developed most systematically and scientifically by the neo-Impressionists and, in particular, Georges Seurat (1859-91), culminating in the technique known as pointillism. This involved applying tiny dots of pure pigment, of a uniform size, so that a complete fusion occurred when the painting was viewed from a sufficient distance. The size of the dots of color was related to the size of the support. As with glazing, you do not have to apply this technique in every part of a painting, but the occasional use of areas of broken color can create interesting and subtle effects.

TONKING

This is a very useful technique named after the artist Henry Tonks, who was Professor of Painting at the Slade School of Art, in London. It is a method of removing surplus oil paint from a canvas by laying a sheet of absorbent paper, such as newspaper, over the canvas and gently rubbing it. The paper is then peeled off, taking with it a layer of pigment. You may find this useful if you are working 'alla prima' and have allowed your paint surface to become overloaded.

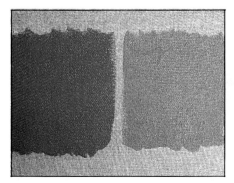

The range of brushes available to the oil painter and the variety of marks they can make is enormous. *Far left*, we have selected a few from an artist's collection, and beside each we show a typical mark. *Left* are marks that can be made with two painting knives. The marks on the left were made by the medium pear-shaped knife. From the top, the artist used: the flat of the blade; the flat of the knife with a rocking motion; a dabbing gesture with the tip of the blade; a lateral dabbing motion. The next row of marks was made by the small diamond-shaped knife and were made with: the tip of the blade; a stabbing gesture with the tip of the blade; a dabbing gesture; and the flat of the blade. The sgrafitto marks in the red paint were made with the tip of the blade, the orange paint was laid with a rocking motion and the red and blue paints were blended with the larger painting knife.

Above, the artist has laid flat color onto hardboard prepared by applying muslin and fixing it with size. Even with such a textured surface it is possible to achieve an unmodulated paint surface.

A thin film of color was laid onto a fine-grained canvas. A rag was then dabbed into the wet paint to create texture, *above*. The effects that can be created with oil paint are almost limitless.

Small dabs of colors are laid onto the surface, *above* — seen from a distance they merge to create a new color. This effect, known as optical color mixing, was applied by the Pointillists.

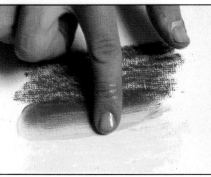

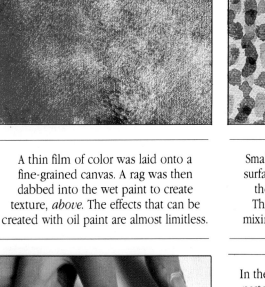

In the detail, *far left*, yellow and red oil pastels have been worked over wet oil paint. *Left*, the artist has laid down two patches of oil pastel — yellow and Venetian red — and is now blending the two using a small drop of turpentine. Oil pastel can be combined very successfully with oil paint.

COOL COLORS TEND TO RECEDE WHEREAS WARM COLORS ADVANCE

IDENTICAL RED SQUARES ARE CHANGED BY SURROUNDING COLORS

A YELLOW SQUARE LOOKS BIGGER ON WHITE THAN ON BLACK

A RED SQUARE LOOKS SMALLER ON WHITE THAN ON BLACK

CHAPTER FOUR

COLOR FOR THE ARTIST

Man's first experiments with color are recorded in the paleolithic cave paintings of France and Spain. The paints used were naturally occurring earth colors, which gave various shades of red, yellow and black. Greens and blues were not found. Artists today have access to an enormous range of colors in all the media, many of which have only become available in the last thirty years, and art historians can sometimes date paintings very precisely by studying the colors used by the artist. Some artists are natural colorists – they have an instinctive feel for color – whereas some regard it as incidental to other aspects of their work – form and structure, or line, for example. Painters such as Henri Matisse (1869-1954) and Paolo Uccello (1397-1475) had an instinctive feel for vivid color; others, such as James Whistler (1834-1903) and Gwen John (1876-1939) used a more limited and very subtle palette. The latter two are good examples of artists who were able to create as rich a visual experience with a few colors as with a more extensive palette.

The way in which an individual perceives color is affected by many factors. Demonstrated *left*, are some of the ways in which colors can be modified by surrounding colors.

Color is an extremely complex subject, and its study falls within several disciplines: physics, chemistry, physiology and psychology. Physicists study the electromagnetic vibrations and particles involved in the phenomenon of light; chemists look at the properties of dyes and pigments; physiologists are interested in the way the eye and the brain allow us to experience color, and psychologists look at our awareness of color and the way in which this affects us. The artist must be aware of all these considerations, but each discipline defines color in a different way, which can cause a great deal of confusion. Here we restrict ourselves to some of those aspects of color theory that will be of immediate use to you as an artist.

It is more than 300 years since Sir Isaac Newton found the color in light and discovered the light spectrum in the course of an historic experiment. He directed a beam of sunlight into a glass prism, and because glass is denser than air the light rays were bent, or 'refracted', as they passed through the prism. The light that emerged from the prism was separated into the band of colors we now know as the solar spectrum. The colors of the refracted spectrum range in a continuous band from red through orange, yellow, green, blue and indigo to violet. If these colors are collected again by means of a converging lens they will combine to form white light once more.

The artist, however, is concerned with the color of reflected light rather than that of direct light, an important distinction to bear in mind, because it explains the difference between the color of light and the color of pigments.

The color wheel, color circle, color sphere and color tree are all devices by which artists have sought to come to terms with color and to explain their theories. Various circles have been suggested containing from six to 24 colors. The color wheel illustrated here has six colors: red, orange, yellow, green, blue and violet. Complementary colors are those which are directly opposite each other and therefore most widely separated on the color wheel. Yellow and violet, and red and green, are examples of complementary colors. Each of these pairs of colors combines to make gray. They and their effects are very important in the way we perceive color, and are therefore vital to painting.

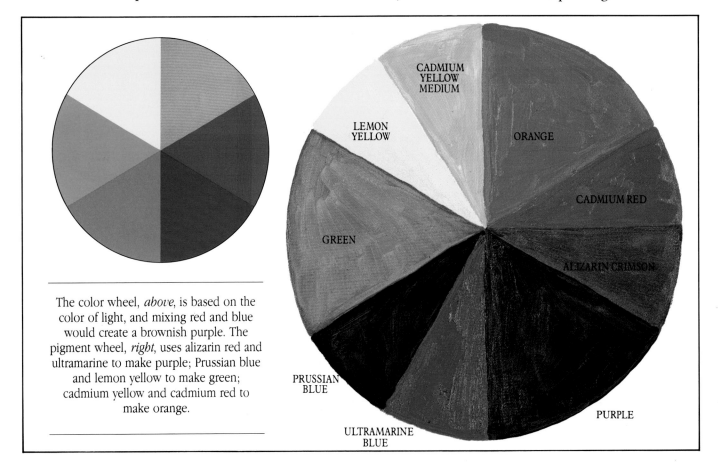

The color wheel, *above*, is based on the color of light, and mixing red and blue would create a brownish purple. The pigment wheel, *right*, uses alizarin red and ultramarine to make purple; Prussian blue and lemon yellow to make green; cadmium yellow and cadmium red to make orange.

CADMIUM YELLOW MEDIUM

LEMON YELLOW

ORANGE

CADMIUM RED

ALIZARIN CRIMSON

GREEN

PURPLE

PRUSSIAN BLUE

ULTRAMARINE BLUE

ADDITIVE AND SUBTRACTIVE COLOR MIXING

Any color in the visible spectrum as well as white can be created by mixing different amounts of light from the red, green and blue sectors of the spectrum. These are called the additive primaries. The spectral complementaries are any two colors from different parts of the spectrum which can be combined to form white light. When colored lights are mixed the resulting color corresponds to the combined wavelength of the lights that are mixed. From this we get the term 'additive color', which is specific to the color of light.

The artist deals with pigments, however, not light. When colored substances, such as pigments or dyes, are mixed another process occurs. All colors, being properties of light, have a wavelength, and the color of the pigment corresponds to the wavelength of the light which is reflected to the eye. This corresponds to the wavelength of the colored light that is not absorbed by the pigment or dye. Certain wavelengths are 'subtracted' and the remaining wavelengths are reflected to the eye — and this is the color of the pigment. When two pigments are mixed, both absorb certain wavelengths, and the reflected light corresponds to those wavelengths which neither has absorbed. This, then, is 'subtractive' color mixing. The amount of light that two combined pigments reflect is obviously less than the amount each reflects separately. For this reason artists tend to avoid mixing a large number of pigments, because as more pigments are mixed the color becomes increasingly muddy.

The subtractive primaries are cyan, magenta and yellow. From pigments or dyes of these colors any other color can be created, and when all three colors are mixed together the result is black. Inks of these colors are used together with black in the color-printing process to produce the entire range of colors that you see in color magazines, posters and other printed matter.

Artists' primaries are red, yellow and blue pigments. These are pure colors, but although it is sometimes claimed that the artist can produce all colors and hues from these three, this is not absolutely true. For example, it is not possible to create an intense green or purple using these colors. The really useful pigment primaries for the painter are red, yellow and blue, and the most useful colors are green and purple.

SOME USEFUL TERMS

'Hue' is a term used to describe the type of color on a scale through red, yellow, green and blue. There are said to be 150 discernible hues. They are not evenly distributed throughout the visible spectrum because we find it easier to discern colors in the red area of the spectrum. 'Saturation', or 'chroma', are the terms used to describe the intensity of a color's appearance. The saturation of a color can be changed by various factors such as the strength of surrounding colors. 'Brightness', or 'tone', refers to a color's place on a dark-light scale.

WARM AND COOL COLORS

The color circle can be divided into two groups: the 'warm' colors and the 'cool' colors. The yellow-greens, yellows, oranges and reds are generally regarded as warm colors and the greens, blues and violets are considered to be cool. A reaction to color in terms of warm and cool is obviously subjective and people vary in the extent to which they perceive color temperature — some people are almost unaware of the distinction. But by looking at colors in this way you will find that the warm, fiery ones do convey a very different feeling from their color opposites. When we describe colors as warm or cool, we are not, of course, referring to physical qualities, but to aesthetic qualities of the colors. Some colors fall rather obviously into one or other of the categories, others are more difficult to place.

The inherently hot colors are the cadmiums, cadmium yellows and reds, and their derivatives. These colors are at their most intense and dynamic when used in their pure form straight from the tube. Despite these classifications, there are warm blues and cool reds — for instance, ultramarine and cerulean are warm blues, whereas alizarin and light red are cool reds.

The degree of warmth and coolness of a color depends very much on how you juxtapose them and what you mix with them. Lemon yellow is cool when placed next to warm cadmium yellow, but the same lemon yellow would be perceived as warm if placed beside Prussian blue.

AERIAL PERSPECTIVE

Warm and cool colors are useful to painters in many ways. When they are situated in the same plane and at the

same distance from the eye the warm colors advance and the cool colors recede. This aspect of color can be used to create a sense of space in a painting. The artist cools the colors in the distance and warms those in the foreground. This can be seen in the work of many landscape painters of the past, who traditionally used blue to describe distant objects. This method of aerial perspective combining warm and cool colors and contrasts of color, tone and line to create a sense of space is known as aerial perspective. All colors in our world are perceived through the atmosphere. Dust and droplets of moisture cause scattering of light as it passes through the atmosphere, affecting the way we see the colors, which appear to change according to the distance from our eyes. Objects in the distance appear less distinct and take on a bluish tinge, while in the far distance only the broad shapes of objects can be observed, and are perceived as pure blue. The contrasts in tone are greater in the foreground and smaller in the distance, a quality exploited by aerial perspective.

DISCORDANT COLORS

Some color relationships are naturally discordant – the colors compete or clash with each other, setting up visual vibrations. Discordant colors can create very exciting effects, and such color vibrations are exploited by some contemporary artists. A visual 'screaming' effect can be created by juxtaposing two complementary colors. This relationship would normally be harmonious, but by marginally adjusting the tonal order, one can make the relationship discordant. If, for example, blue and orange were laid side by side, a blue-orange discord would be created by making the blue fractionally lighter than the orange. Vibrations and discords are created more dramatically when the pairs of colors involved are complementaries, or nearly complementary, and when they are intense and of the same value. These effects are set up along the edges of the color areas and can be maximized by the creation of many color boundaries.

Any two colors can be made to clash either by making the tonal values equal or by creating an inversion of the natural tonal order of the hues. You will find that some pairs of colors will be more difficult than others. Of the complementary pairs violet and yellow will probably cause most difficulty. Remember that violet must be made as light or even lighter than yellow. It will therefore appear almost white and will seem to have lost its hue, but the addition of white does not actually alter the hue of a color.

You may wonder why anyone would want to create color discords, but these startling effects can be very useful and are often exploited in both commercial advertising and painting.

USING COLOR TO CREATE MOOD

The pigments an artist uses can be selected to reflect the local color of a scene, whereas tone is used to create the forms, but our feelings play an important part in the way we perceive color, and these emotional responses can be used to create mood in a painting. We all feel cheerful on a bright sunny day when the sun streams in through a window spilling over a vase of bright flowers. Contrast this with the way you feel when you look out of the window on a drizzly winter's day and see wet, gray, rain-sodden buildings and people hunched under rain-shiny umbrellas. A photograph of these two scenes would reveal two important and contrasting features – light and bright color in one; low, even light, and dull color in the other. As a painter you should take these elements and make more of them. Colors can suggest happiness, excitement, or serenity.

USING A LIMITED PALETTE

Too many colors in a painting may well diminish rather than increase the total color effect. Some of the most successful paintings have an identifiable color key – Turner, for example, often painted a picture with a blue-gray bias, but used an area of golden ochers to provide a contrast. Try painting in a single color with a few areas of contrasting hues. You could either set up a monochrome still life, selecting objects of one color such as blue, or you could collect waste objects such as bottles and cans and paint them all white or gray. Another way of tackling the exercise is to set up a still life and make a series of sketches of it. Work from these sketches away from the subject itself, so that you will not be distracted from your purpose by the true color of the objects. Exercises such as this are revealing and are the best way of learning about paint and color.

The artist set up the simple still life, *right*, in order to develop his awareness of spectral and pigment color. He deliberately chose strong colors for the subject. In the first exercise, *far right*, he used cadmium yellow, cadmium red, ultramarine and black. With this palette he was able to match all the local colors almost exactly. In the second exercise, *below right*, he denied himself the pigments required to match the local colors and instead chose red ocher for the pepper. He then developed the orange and the blue by relating them to the red of the pepper, so that the final image is as close an equivalent of the subject as is possible with these pigments. For the final exercise, *below far right*, the artist used mixed colors based on a palette thought to have been favored by the artist Walter Sickert (1860-1942) – the diagram *below* shows how these colors are created. Cadmium red, cadmium yellow and ultramarine blue were mixed to create the secondary colors, which were then mixed to create a tertiary level of color. The artist can then use 1, 2 or 3 plus 4, 5 and 6. In this case the artist used 1, 4, 5 and 6.

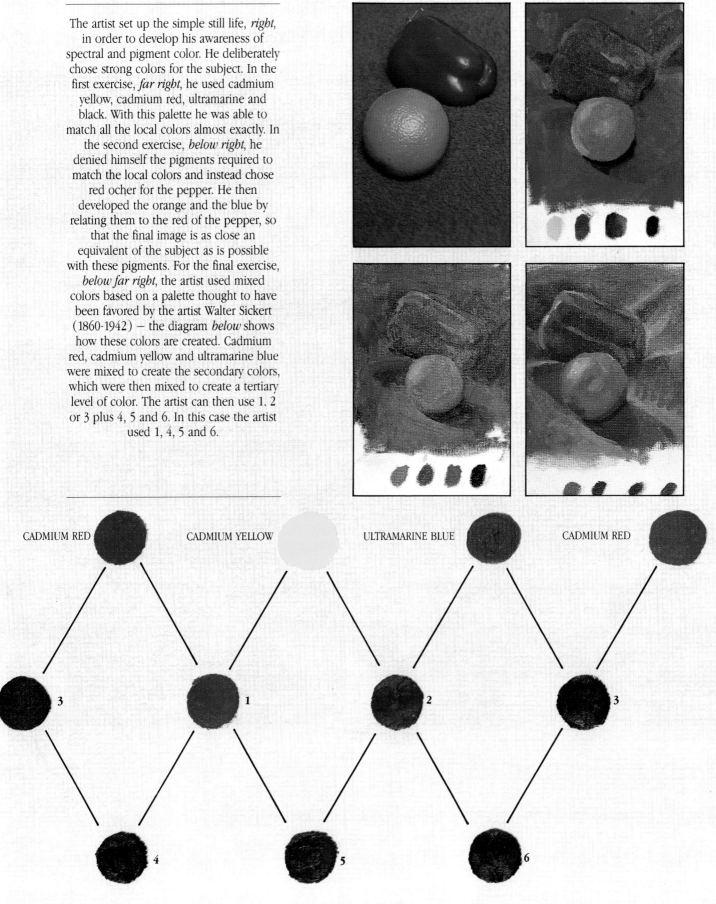

CADMIUM RED CADMIUM YELLOW ULTRAMARINE BLUE CADMIUM RED

3 1 2 3

4 5 6

COMPOSING A PICTURE

The eye of an artist is always alert, looking for material, seeing pictorial possibilities in even the most everyday objects and events. Painting is not just about manual dexterity, or an extensive knowledge of paints and pigments, or the chemical composition of grounds and binders. It is about looking, learning to see and making something of what we see. Only when you start to paint do you realize how little you have seen before. The painter sees the world with new eyes every day, and the great artist is able to convey that fresh excitement to the viewer. A picture does not compose itself; the artist sees the potential, and weaves the image from the surrounding world, from experience and from the imagination. The artist selects, processes, sorts and rejects, and from all this a new and original vision is born.

An interesting way of studying composition is to assemble a selection of small, bright-colored objects and arrange them on sheets of colored paper, *left*. You can move the objects around the picture space to investigate the color relationships and look for satisfying arrangements of color and shape.

Above, the artist has found a subject in the view through the studio doorway and used oil paint, thinly diluted with turpentine, to make a rapid sketch of the view. He handled the paint freely, laying in the broad outlines of the subject.

Many painters seem to think that some subjects are more legitimate than others, but this is really not so. Any subject can be the basis of a painting, but the choice must depend on your interests and on the opportunities available to you. The best idea is to start with subjects close at hand.

Still life provides the painter with wonderful opportunities for exploring ideas about color, composition and painting. The subjects are near at hand and the choice is almost limitless. It is also the only subject that is entirely under your control. It is not restricted by schedules, and you can continue to work on a subject over a period of time — unless, of course, you have included fruit or vegetables which may rot. When choosing the objects, go for themes, select particular colors or contrasting shapes and textures, and don't forget that you can play with the lighting.

Interiors are an excellent subject, setting you the problem of creating an illusion of space and coping with the perspective. Further interest is added if the room is illuminated from outside, so that the enclosed intimate feeling of an interior space is enhanced by glimpses of a contrasting exterior. This is seen in the works of Giovanni Bellini and Domenico Ghirlandaio (1449-94) for example, where we glimpse through a window delightful views of typical Italian landscapes in which walled towns cap small hills. Similarly, in the work of many great Flemish painters we catch sight of the bustling life of a Flemish town of the early fifteenth century through a window. Later painters like Jan Vermeer (1632-75) indicated the outdoors by including a window, a door, or more usually part of a window, through which sunlight was filtered into the room within. Further interest can be added to this subject by introducing a figure in the room.

For many beginners the choice of subject presents an appalling problem — they just cannot think of anything to paint. Of course the answer is that anything and everything is fair game for the artist. Just look around you as you read this and you will see any number of 'pictures': the texture of a table; the view glimpsed through the window; the figure of a friend leaning against the door jamb engrossed in conversation; a bowl of fruit; or wilting flowers, their petals scattered on the table. Can't think of anything to paint indeed!

FIGURES AND PORTRAITS

Figure painting and portraiture provide the artist with a never-ending source of material. Not unnaturally, artists have always been interested in the human figure, and great ingenuity has been expended in exploring the infinite variety of the human form and the problems it sets the artist. The artist often paints self-portraits, a good way of starting because, like still life, it is under the artist's control. When you stop your model stops work and if

Even in the city there are opportunities to work out-of-doors. *Left*, the artist paints from life in a city garden.

you are prepared to stay up until midnight, well, so will your model. The members of your family may also be persuaded to pose for you, and this will solve a lot of problems, but try not to ask too much of your models and do not expect them to sit immobile for long periods of time. Learn to make sketches and supplement these with photographs.

LANDSCAPE

Landscapes provide the artist with yet another infinitely variable subject. Again you may be lucky enough to have suitable subjects on your doorstep — you may, for example, live in a pretty part of the countryside. Do not fall into the trap of thinking that only rolling hills and rural scenes constitute a landscape. Some of the most stimulating subjects can be found in your backyard, in a city park or even in the view from your window. The geometric lines and startling perspectives of a roofscape, a view over an industrial landscape or an apartment building, all provide fascinating material.

USING REFERENCE MATERIAL

Reference material is very important for most artists. Never leave home without a sketchbook and always have one lying open at home, with a drawing implement close at hand. The journey to work, the office, lunch in the park, all these occasions provide you with information for your sketchbook, and these sketches can be incorporated and collated to create interesting pictures. Other reference material to jog the visual imagination and act as a catalyst to your creativity includes newspaper pictures, pages torn from magazines and, of course, your own photographs. The subject of photographs is a difficult one; many people disapprove of using photographs as the basis of paintings. What they are really objecting to is the fact that the camera has been allowed to do the selecting and, because selection is one of the artist's most important contributions, there is a risk that paintings from photographs will be dull, lifeless copies of the photograph. Nevertheless, it should be borne in mind that the camera does to some extent distort reality. Some of these fortuitous distortions have been taken up and exploited by artists such as Degas and, especially, Walter Sickert (1860-1942). Again, as long as you are aware of what is happening, you can decide what you will use and can treat the material in the photograph in your own way.

Cut a frame from colored paper or cardboard and look through this to isolate the part of the subject that you want to paint. *Right*, the artist uses two L-shaped pieces of thin cardboard to mask off part of his sketch.

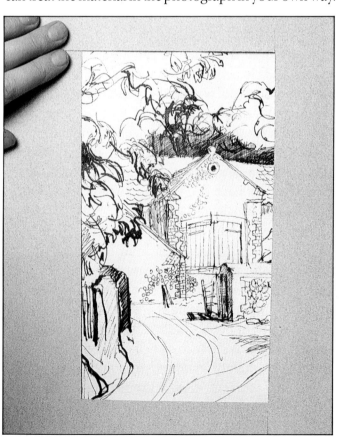

THE GEOMETRY OF A PICTURE

Since ancient times artists have considered the geometrical proportions of their compositions. The artists of Ancient Egypt divided the walls on which they were going to paint into a network of verticals and horizontals, and along these they disposed the elements of their compositions in such a way as to create a harmonious effect. Artists have evolved various formulas to help them achieve stability and coherence. One of these is the Golden Section, one of the most important of the systems with which artists sought to codify these particularly pleasing proportions. It is defined as a line which is divided in such a way that the smaller part is to the larger part as the larger part is to the whole. It is used to divide lines and create shapes which are aesthetically harmonious. In practice it works out at about 8:13, and it is surprising how often this proportion occurs in both art and nature. The Golden Section has been known since the time of the Greek mathematician Euclid, and was particularly popular in the Renaissance. The proportions of this formula can be identified in many paintings of the fifteenth century and ever since.

SHAPE AND SIZE

The shape of a picture is an important but often overlooked element of the final composition. When you are constructing a picture don't forget to include the shape and size of your support in your calculations. Different shapes suggest different emotions and moods; a square will convey a sense of stability and compact solidity, whereas a long narrow rectangle will suggest calm. Pictures have been painted within many shapes but they are usually rectangular.

The size of the support is important. Think of a painting that you knew well from reproductions and were quite shocked to come across in a gallery because it was either so much larger or so much smaller than you imagined. When choosing the scale for a painting or drawing, be guided by the demands of the subject and the medium. For instance, pencil is best at quite a small scale; if you attempt anything larger you will set yourself enormous problems. Artists sometimes work on a particular shape and size of canvas for no better reason than that it is the only one available, and the painting then evolves restricted by those parameters, sometimes with unhappy results.

If you buy prepared boards or canvases you are obviously limited by the range of sizes on the market, but if you prepare your own you can choose what suits you. Some painters use ready-processed canvases which come in a limited range of shapes and sizes. This may be habit or laziness, or may be for economic reasons. It is, however, a good idea to try something different periodically — if you habitually work very small try working on a large painting, or vice versa.

SPACE AND SCALE IN PAINTING

Since the time of the Renaissance, Western artists have been concerned with the problems of representing a third dimension on a two-dimensional surface. They have tried through devices such as linear and aerial perspective to create the illusion of a three-dimensional space beyond the picture plane. A knowledge of these subjects is helpful for the artist, though not essential, because it is quite possible to achieve a sense of space in a painting by empirical methods, simply by observing what is there.

Linear perspective is based on so many assumptions that the illusion is very much a matter of faith. It works because it is how we have been taught to see. But there are many other devices which help us to see space in a painting; for example, an object placed high up on the picture plane will be assumed to be farther away than an object which is lower down. Scale is another important device; for instance, if two like or recognizable objects are in the picture, and one is very large and the other is small we will assume a distance between them. We will make this assumption because we have been brought up in the traditions of mathematical perspective of the Renaissance. It is interesting to note that in paintings from the twelfth to the fourteenth centuries the donor, the person who commissioned the painting, is always portrayed smaller than the saint.

Another device which aids the illusion of space is overlapping figures, a method attempted by the Greeks of the Classical period in the procession frieze on the Parthenon. But someone of another culture would perceive such an image quite differently, not as one person standing behind another, but as an incompleted

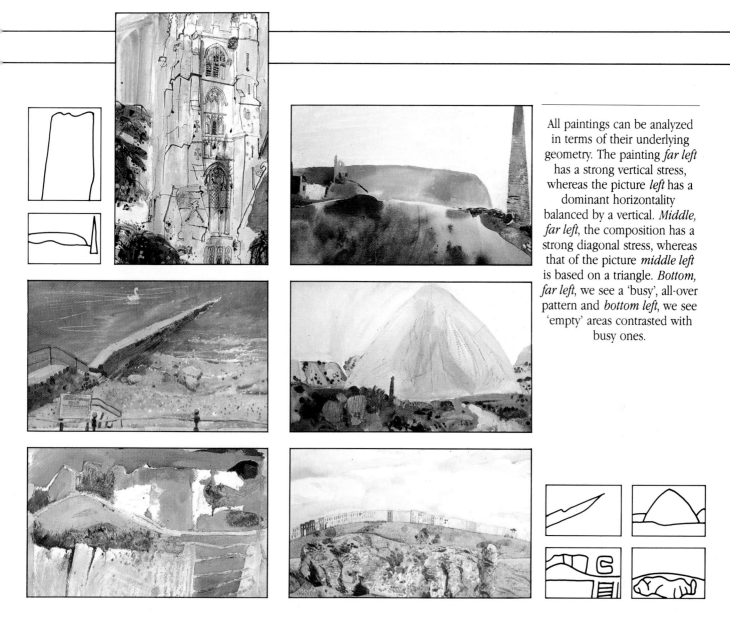

All paintings can be analyzed in terms of their underlying geometry. The painting *far left* has a strong vertical stress, whereas the picture *left* has a dominant horizontality balanced by a vertical. *Middle, far left*, the composition has a strong diagonal stress, whereas that of the picture *middle left* is based on a triangle. *Bottom, far left*, we see a 'busy', all-over pattern and *bottom left*, we see 'empty' areas contrasted with busy ones.

person. This was an important consideration for the Egyptian tomb painters, because they did not want to send the individuals portrayed into the afterlife with half their heads missing!

USING A MASK

One of the problems an artist faces is isolating the elements of the subject for inclusion in the painting. This is especially true when the artist is painting landscape outdoors. The subject can be isolated by using a mask — just a frame cut from card or paper. The frame is held up to the eyes and moved backward and forward so that the artist can isolate different parts of the scene. If you don't have a mask at hand you can cup your hands together and peer through them. A camera can be useful in this way, because it can narrow your view of the scene. Some artists use a polaroid camera to check still life arrangements as well as to make a record of the arrangement so that it can be reassembled at a later date.

The sketchbook is very useful for working out arrangements and compositions; a few lines can sometimes highlight the important features and draw attention to potential problems.

RHYTHM AND STRESS

All paintings have edges, and it is the relationship between the objects within the picture and between these and the edges that creates the tension within a painting. In some pictures the interest is focused in the center of the picture, and the outer parts are empty. In others the areas of activity are confined to the corners, to one side, near the top or bottom. Some paintings have areas of activity scattered evenly over the entire picture surface. Where the areas of activity are modulated with areas of calm the eye moves from one area to the other, led around the picture in a way which the artist can control. Where the areas of activity are more evenly dispersed the eye wanders ceaselessly with no natural

point of focus on which to rest.

The artist should not underestimate the value of flat, calm areas in a painting, and should resist the temptation to fill in all the empty space. Even the word 'empty' is a misnomer, because no part of a painting is actually empty. Even a flat area of color, or an area where the canvas or ground is allowed to show through, uncovered by paint, is defined by the shapes that enclose it, and is thus part of the geometry of the picture.

The artist can draw attention to the rhythms and stresses within a work by the kind of line he or she uses, by stressing the direction of the structural lines, by the quality of line, by the colors used, and by the way the images are contained within the picture frame. The edges of the picture can also be used to great effect.

There are many ways of indicating movement within a painting. A clever artist manipulates the viewer, whose eye is persuaded to follow the direction the artist intends by being tricked into following a path around, and even off, the painting. Composition can only really exist when the area of the picture is clearly defined, because this forces the artist to make decisions about how to work within limited parameters. Our forefathers working on their cave walls were unhampered by such decisions; their picture area was limited by the size of the rock face only and had no clearly defined edges.

SHADOW AND LIGHT IN PAINTING

All the images we see are composed of reflected light — without light we would see nothing. Light can be a very important element of painting. We need light to reveal form, and therefore the direction of light is important. If light falls on a figure from one side of the painting it catches only certain parts of the figures. All solid forms are actually composed of planes, and we understand form because of the way light falls on it. Even a curved surface can be thought of as an infinite number of tiny planes. A change of plane occurs when one plane meets another, and the tone is likely to change at this point because of the different angle of incidence of the light. The change of plane is important in painting because it helps us to explain and represent three-dimensional objects.

The way in which the change of plane occurs depends on the nature of the material. Hard crystalline substances have sharp angular changes, but a soft fabric will have a soft, wavy change of plane. Light, therefore, reveals the form, and the light may itself become the subject of the painting. The patterns cast by falling light dissolve forms, which become a foil for the play of light so that the forms allow us to see the light.

Shadows are useful too; they help to describe spaces and give further clues to the shapes occupied by the forms within the painting. Shadows are obviously dependent on the way the subject is lit. For example, a landscape painted on an afternoon in late winter will have long shadows cast by the weak winter sun that hangs low in the sky. A landscape painted on a summer's day, on the other hand, will be bright and almost shadowless. This will make for a higher-keyed, brighter painting and greater range of colors, whereas the winter scene will have more contrast. Indoors, the light may be natural sunlight falling through a window. The shadows cast by window frames can be incorporated into the painting, and the bright pools of light used to create focal points and draw attention to important features.

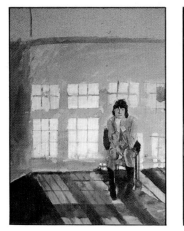

There are many themes that an artist may pursue and it is often useful to make several studies of the same subject. Some artists devote their whole life to just one or two subjects. *Left,* we show three studies dealing with the figure, light and an interior space.

The subjects of a still life or figure painting can be positioned so that you exploit these light effects. You will have to work quickly, because light changes during the day as the sun climbs through the sky.

PATTERN IN PAINTING

Pattern is not something that should be imposed upon a painting — it is something that evolves quite naturally from what is there. Nevertheless, it is true that some painters have an innate awareness of pattern and can perceive and exploit it even when it is not obvious to the rest of us. Wherever a color or form is repeated, a pattern is made. Pattern is to be seen everywhere in nature: in the pebbles on a beach, the leaves of trees, the rows of vines climbing a hillside. By accentuating what is there the artist is engaged in a process of selection and rejection, and once again it is what is left out as much as what is included that is important.

TEXTURE

Texture is apparent in many aspects of painting: the texture of the materials, the weave of the canvas, and the marks of the brush as the artist models the paint surface, scratching into it, working it and moving it. Texture can also be an aspect of the subject — the foliage of a tree has texture, as does hair or fabric. By contrasting the texture of, for instance, smooth skin with hair or with velvet cloth the artist makes us aware of the surface of the things depicted.

NEGATIVE SPACES

The concept of negative space is a very useful and important one. Negative spaces are the spaces between the objects, rather than the objects themselves. By looking for these spaces and drawing them the artist can achieve a more accurate drawing. He or she will be

The three studies, *above*, show different approaches to the same subject — trees within a natural landscape. No matter how often a subject has been tackled each artist can always find something new to say.

forced to draw what is there rather than what is known to be there, and any device which forces the artist to look carefully at the subject is useful. If you have not yet done so, try making a drawing using only the spaces, not the object. It will be hard at first, but force yourself to look and to concentrate and you will be surprised and pleased with the accuracy of your drawing. By looking at a subject in this way you are automatically abstracting, the image becomes a pattern of shapes on the support. This highlights an aspect of composition which is of great interest to the artist, the fact that pattern and design are to be found everywhere. The artist should be aware of this underlying sense of organization and arrangement in every project undertaken, because it is this which gives a sense of coherence to a work of art.

The silhouette is another aspect of negative space. Objects silhouetted against one another create strange and wonderful shapes which make a strong and important impact. Some artists are consciously aware of these elements of a composition, whereas others incorporate them intuitively. Very strongly silhouetted shapes can produce interesting dynamics within a painting, drawing attention to certain features and leading the eye around the picture surface. A great feeling of energy can be generated by these devices. The considerations for creating a good composition are manifold, but the artist should be aware of them in the search for harmony, beauty and meaning in a painting.

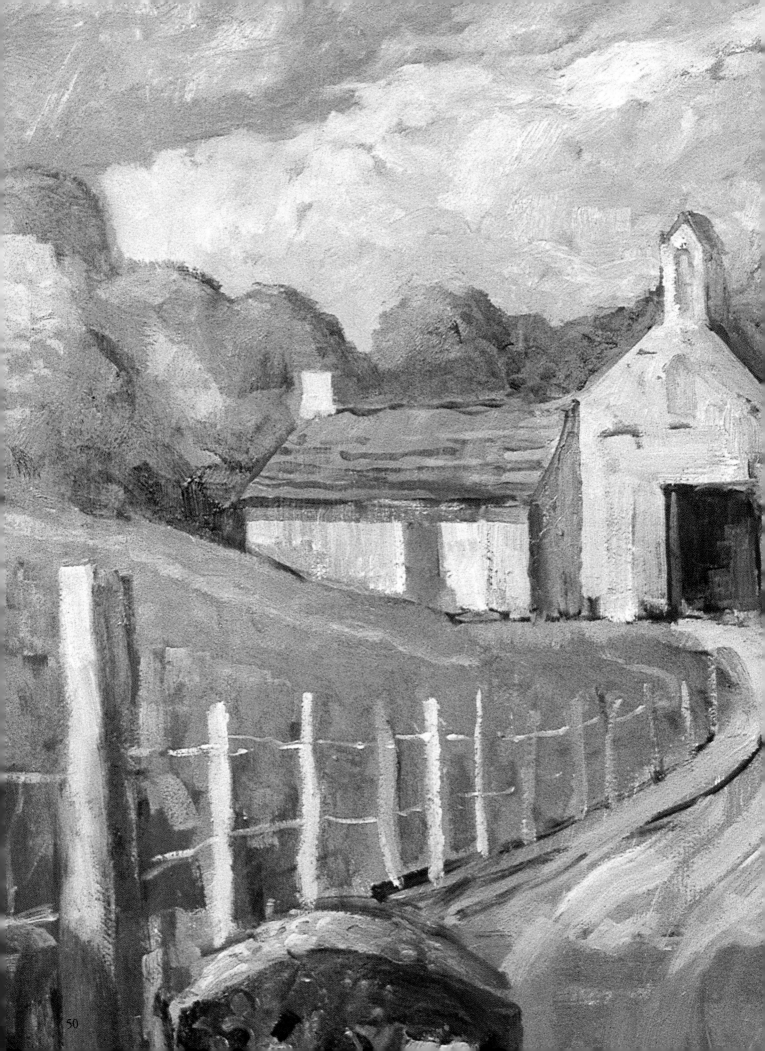

50

CHAPTER SIX

LANDSCAPE

Landscape provides the oil painter with wonderful opportunities for exploring the possibilities of the medium. There is no substitute for the experience of painting directly from the subject, so try to paint out of doors whenever you can.

Work quickly 'alla prima' — this is a direct method of painting which is more difficult than it seems, because the artist must have a very clear idea of what is essential and what can be left out. All the elements of the painting — color, form and tone — are dealt with at the same time, so the artist needs to be sure of his or her intention and assured in the chosen technique. The advantage of 'alla prima' is that the painting is finished at one sitting and has a special freshness and immediacy.

Another way of working out of doors is to lay in a polychrome underpainting, possibly in acrylic (which dries very rapidly) and to complete the painting later in the studio. Oil paint can also be used for rapid sketches on paper or on oil sketching paper, in a thinly diluted state or straight from the tube.

Oil is an infinitely variable medium and can be used as thin washes or thick impastos. The artist can work paint into wet paint, or can wait until the paint is dry and apply subsequent layers. Thick opaque impastos of pure pigment can be contrasted with areas of flat color, and areas of color can be modified by overlaying thin glazes.

A Farmhouse in Derbyshire

The artist worked from a sketch made on the spot. He did not follow this slavishly but re-organized the composition to create a more pleasing and balanced image. The subject as shown in the original sketch tended to trail away to the right, but this composition is firmly established in the center — or slightly off-center. The painting sweeps from the foreground into a middle distance and a fairly high horizon. The artist has included the gatepost, which establishes the picture plane as close to the viewer. This is a good example of the way in which a rapid change in scale can be used to create a sense of space. The curve of the lane leads the eye to the farmhouse, which is the focal point of the painting. The composition hangs on two diagonals which cross just above the midpoint of the painting, creating two shapes which mirror each other — the green cleavage of the hills and the triangle of the lane. This geometric device is simple, but nevertheless very effective. The light color of the path leads up to, and connects with, the light tones of the house.

The artist has used hardboard prepared with an acrylic primer, and has toned down the white of the ground with thinned yellow ocher loosely scrubbed onto the support. He prefers to work on a colored ground because it is less distracting than white, and allows him to judge his colors more accurately. The color he chose has given a warm glow to the final painting.

The artist painted this picture very quickly, establishing the main parameters of the composition in a charcoal underdrawing. Charcoal is a pleasant medium with a freshness that encourages the artist to work freely and vigorously. This very sketchy drawing helps the artist to assess the composition and allows him to find his way around the painting. The subject is complex, and the components — trees, fields, sky and so on — do not provide the obvious location points that a still life, for example, would. It is interesting to ponder the way in which we reduce a complex subject such as this to a series of outlines when, in fact, we see it as a pattern of light and dark.

1 The artist frequently sketches at this spot, *right*, and used several drawings as reference for his painting.

USING A COLORED GROUND

In the first picture *right* we see the artist preparing the tinted ground for this painting. He uses acrylic paint thinned to a fairly fluid consistency with water and applies the paint with a brush, working quickly. He uses acrylic because it dries quickly and is able to start working on the painting immediately. Oil paint can be worked over acrylic, but acrylic cannot be worked over oil. In the second picture *below right* we see the artist using oil paint to tint a ground. He uses umber thinned with turpentine. This is laid on the canvas and rubbed in with a cloth. This ground will take at least a day to dry completely. In the final picture the artist has laid a multicolored ground. Again the support is canvas and the artist is applying the paint with a cloth. A multicolored ground can be useful if you have a clear idea of the layout of your picture and want a warm tone for, say, the land area, and a cool tone to underlie the sky area.

2 The final composition is developed from several drawings, and the artist makes slight adjustments in order to create a balanced and pleasing image, *below left*. He works onto a tinted ground, laying in the broad outlines, first in charcoal and then in thinned paint.

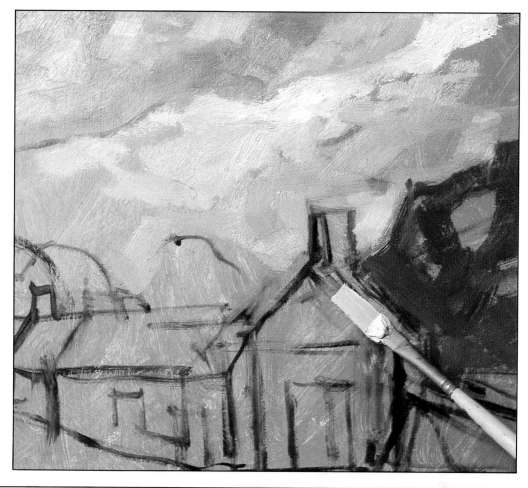

3 Using broad sweeping strokes with a loaded brush *right*, the artist starts to block in the main areas of color. He works quickly, trying to recapture in the studio some of the excitement he felt when making the original sketches.

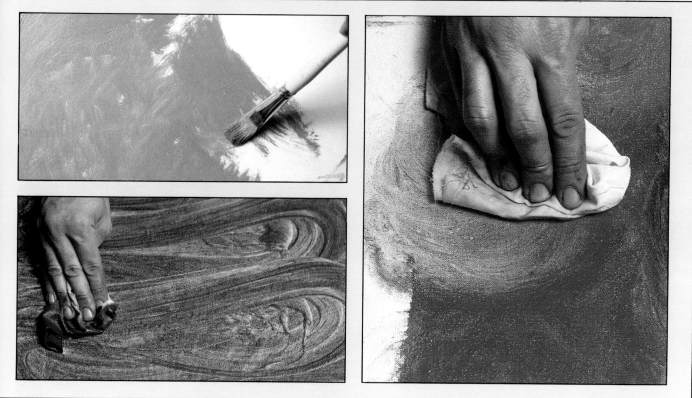

4 *Right*, we see the image beginning to emerge from the loosely scumbled paint. The artist works on every area of the painting at the same time, moving from sky to foreground and from path to foliage.

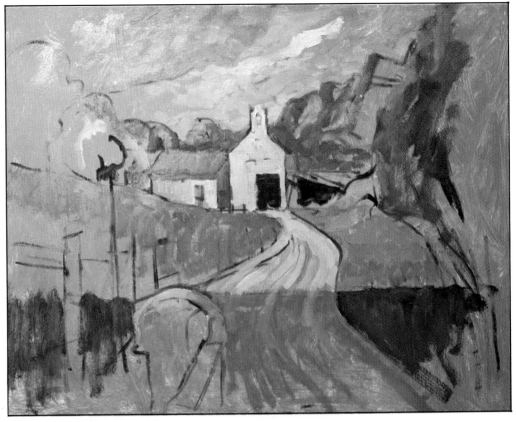

5 In the detail *below*, we can see that the paint has been incompletely mixed on the palette. With each brushstroke the artist applies several colors, creating a richly modulated effect rather than flat color.

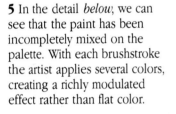

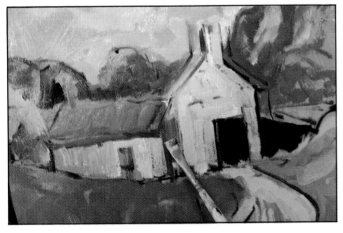

6 The artist uses short, jabbing strokes *above right*, to suggest the leafiness of the massed trees and bushes. At this stage he is working wet into wet. He avoids scrubbing the colors together in order to maintain their freshness. Overworked paint becomes dull and dirty.

7 *Right*, the artist uses a small brush to put in the steps running up the side of the house. Here, and in the final picture, the golden color of the support shows through the loosely scumbled paint, uniting the whole composition with a golden glow.

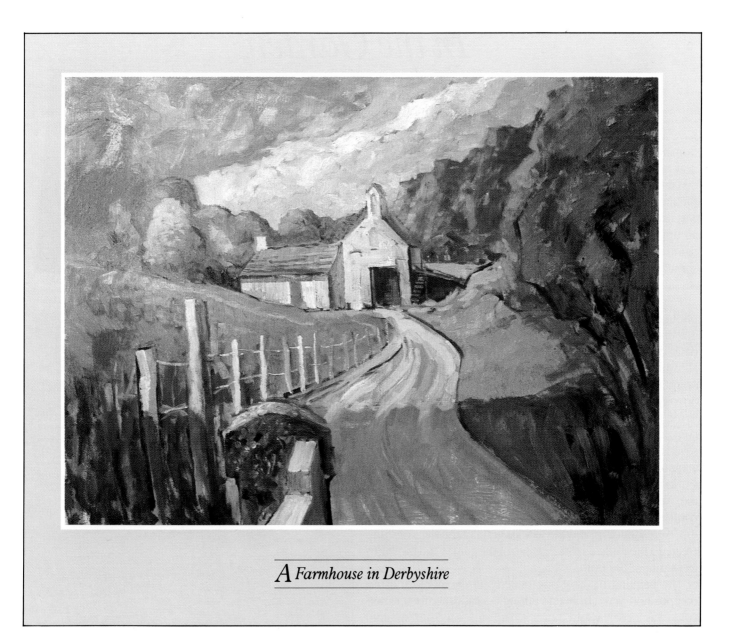

A Farmhouse in Derbyshire

What the artist used

A sheet of hardboard 28in × 36in prepared with an acrylic primer. He used an acrylic yellow ocher to tone this ground. His brushes were numbers 5, 7 and 10 flats and brights. He used the following colors: permanent green, yellow ocher, raw sienna, burnt sienna, ultramarine, sap green, chromium oxide, ivory black and white.

In the Garden

Even city dwellers have the opportunity to paint outside if they have access to a garden or if there is a park nearby. Painting from nature is an experience which every artist should try every now and then. Painting directly from the subject in this way certainly poses a great many problems. The light changes all the time, and in this instance the skies opened and the artist was caught in a rainstorm — he completed the painting under an umbrella, showing an admirable dedication to his task. A painting executed *en plein air* (in the open air) has a spontaneity and conviction which is difficult to capture in the studio.

Painting from the subject in this way reveals just how much photographs flatten perspective and modify colors, and fix only one moment in time. The artist working under these conditions, on the other hand, is constantly having to make adjustments as the light changes and different aspects of the scene are thrown into prominence. The landscape is vast, with no obvious beginning and end. In this case the artist was working in an urban area, so his field of vision was fairly contained, surrounded as he was by dwellings. There were several views he could have chosen, but he selected the subject at his feet — the plants and the pots on a small area of the paved garden. He was attracted by the pattern of the paving stones, the overlapping geometric tension of the vertical stake, and the contrasting softer lines of the plant and the pot. The colors, too, were attractive, and the various grays of the slabs of stone created a pleasing foil for the green of the quince and the warm terracotta of the pot.

The painting has a strong underlying geometry, and the composition was firmly and strongly established before the color was loosely washed over it. The artist was short of time, because the weather was not reliable, and he wanted to get the painting finished before the light or the weather changed. The picture highlights the importance of an accurate but simple drawing made with a conviction which comes only from the confidence of experience gained from years of drawing and questioning observation.

1 The artist worked in a town garden on a wet day, *right* — even in town you can work outdoors.

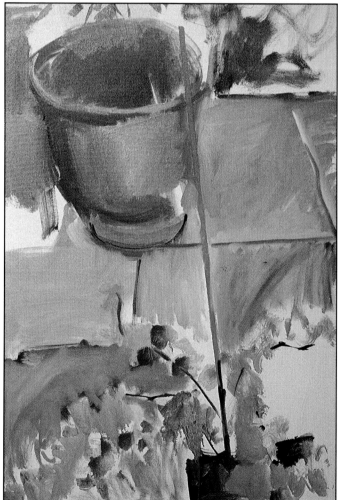

2 The artist has to work quickly because of the threatening weather conditions and the rapidly changing light, *above*. He blocks in the main areas of color using thin, washy paint. He soon realizes that the composition needs to be adjusted, and changes the line of the stake.

3 Using a creamy mixture of white and Naples yellow *below*, the artist now splashes in the lighter areas of the paving stones. He introduces blues and reds to create a range of subtle grays.

4 In the detail *above center*, the artist uses a loaded brush and brisk brushstrokes to create a rich impastoed highlight around the rim of the pot.

5 *Above*, we see the variety of ways in which paint is applied, stained canvas contrasting with roughly scumbled paint and thick impasto.

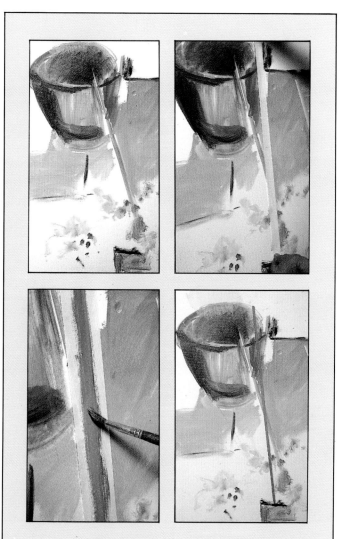

MAKING ADJUSTMENTS

In the first detail we see the artist's problem: the line of the stake runs exactly parallel with the line of the stone to the right. This is visually disturbing and leads the eye relentlessly out of the picture. This was not what the artist intended, so he decided to change it. In the second picture the artist is using the masking tape to define the new line. He lays down another piece of masking tape beside it and draws the new line by laying in color loosely over the two pieces of tape. When he lifts the tape the new line is firmly and neatly established.

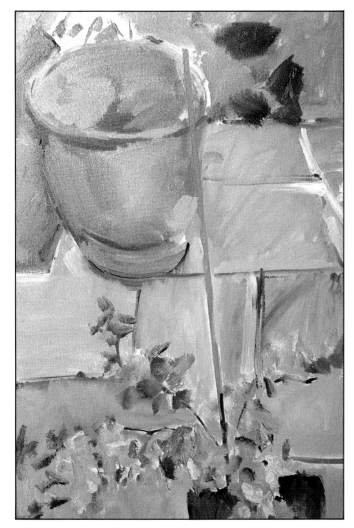

6 The broad areas of color and the main tonal values are established very quickly *above*. Time is short and the artist builds up layers of color but has to work 'alla prima'.

7 In his haste the artist uses his fingers to smudge in highlights, *above right*.

8 In the detail *right*, we see the richness of the paint surface and the way in which the characteristics of a particular brush are exploited to create the impression of foliage.

What the artist used

A bought, ready-stretched canvas measuring 30in × 20in. The canvas was primed for oil, and had a smooth, 'plastic' finish. He used a number 5 and a number 12 flat hog's hair brush and a number 12 soft synthetic brush. The colors were Payne's gray, sap green, chrome green, burnt umber, raw umber, cobalt, viridian, chromium oxide, white, Naples yellow and cadmium red.

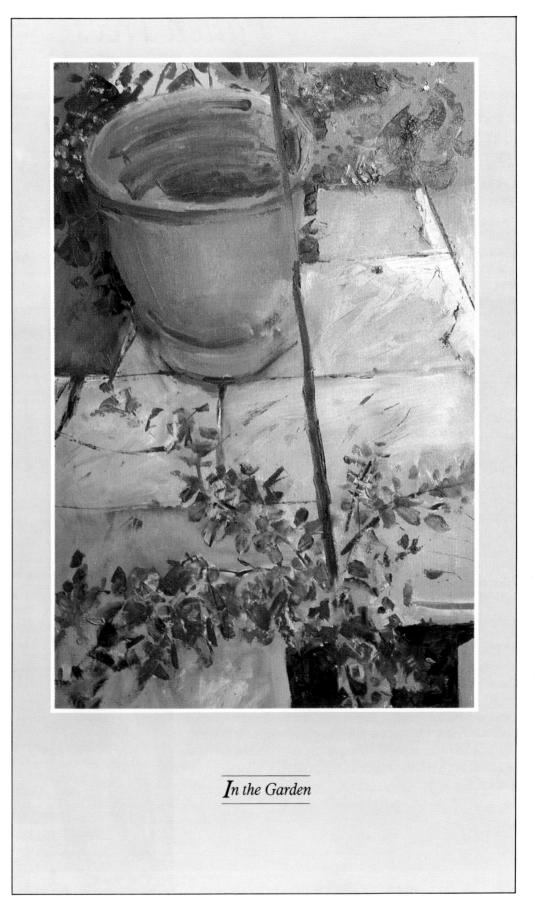

In the Garden

Fallen Trees

The interest of this subject lies in the shapes and textures of the trees: the silvery grays of the fallen trunks, the strong verticals of the standing trees and their reflections in the pool, and the contrasting diagonals of the fallen trees. The dark gloomy depths of the shaded areas around the pool contrast with the openness and brightness of the smaller landscape which is glimpsed through the trees to the left. The eye is led to this area by the path that curves through the lefthand side of the painting. This shape is echoed by the curve of the hills on the horizon, the path and the tree canopy together forming a semicircle which is balanced by the curve of the pool and the tree canopy on the other side. This curvilinear theme is reflected in the cross-section of the tree trunk. The centrality of the painting is re-established by the way in which the tree trunk leads the eye to the upright clump of trees just off the center of the painting. These curves and verticals are in turn counterbalanced by the strong horizontal that runs along the far side of the pool and through the base of the small cottage. The composition is stable, the spatial elements are confidently handled and there is a convincing feeling of space.

The artist has thought carefully about the textures in the painting and the feel of the different surfaces. With very simple brushstrokes he has conveyed the smooth surface of the shadowy pool, the green lushness of the grass and vegetation in the foreground, the leafiness of the tree canopy, the smooth textures of the tree trunks and the craggy appearance of the old tree stump.

Light is also important: the lefthand side of the painting is a brightly lit landscape, while the righthand side provides a cool contrast. The warmth of the sun is suggested by the dappled light as the sun is filtered through the trees. Here the golden color favored by the artist as a ground lends an important underlying warmth to the painting.

The artist has used the graphic qualities of the brush. The tones undoubtedly describe the forms, but in certain passages the way the paint is laid on helps to reinforce those forms. Look, for example, at the small agitated strokes used to describe the foliage, the way the thick crunchy paint is laid onto the silvery trunk of the fallen tree, the vertical lines which describe the reflections in the water and the horizontals which establish the smooth surface of the pool.

1 This felt-tip sketch *right*, evolved from a series of sketches made on a number of visits to the area.

LETTING THE GROUND SHOW THROUGH

In the details *below* you can see the way in which the artist has allowed the golden color of the ground to shine through the paint, influencing the subsequent paint layers and acting as a unifying and harmonizing influence. From these details you can see that it is not necessary to cover the entire surface with paint; the areas that you leave uncovered can be just as important as those that are covered in paint.

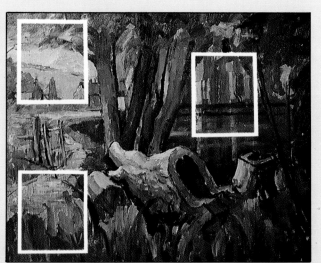

2 The ocher ground is worked with willow charcoal *left center*. The lines are reinforced with dilute black paint, which is also used to indicate the deep shadows in the foreground.

3 A detail *left*, shows the way in which the graphic qualities of the brush have been exploited to describe the forms.

4 The picture builds up quickly *right*, as the artist moves from area to area, rather than concentrating on one particular part of the painting. Accidental bits of color are introduced — the silvery gray of the bark in the foliage, and greens, appear throughout the canvas. This fortuitous color gives the paint surface the lively excitement of natural light.

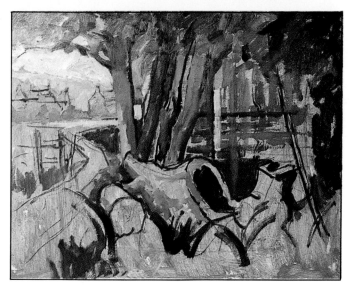

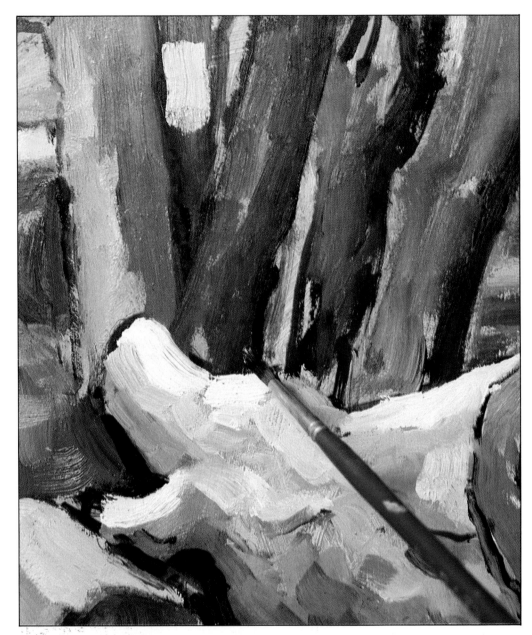

5 In the detail *left*, we see the vigor of the artist's brushwork which breaks up the surface into facets of light and color. The artist is using a small soft-fibered brush to reestablish the drawing.

6 Many people find water a difficult subject to tackle. Here *bottom left*, the water is suggested by a network of horizontal lines which establish the surface, and vertical lines which create a sense of depth.

7 Tufts of grass in the foreground are indicated by slashes of paint laid on with a small bristle brush, *below*. By using thick paint and clearly defined brushmarks the artist firmly establishes this area at the front of the picture plane and creates a sense of depth.

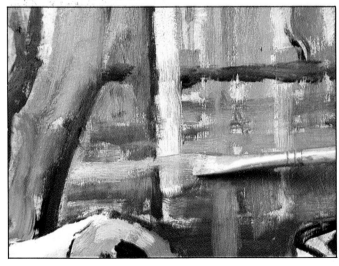

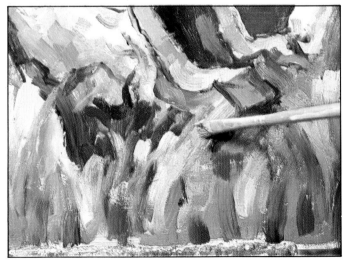

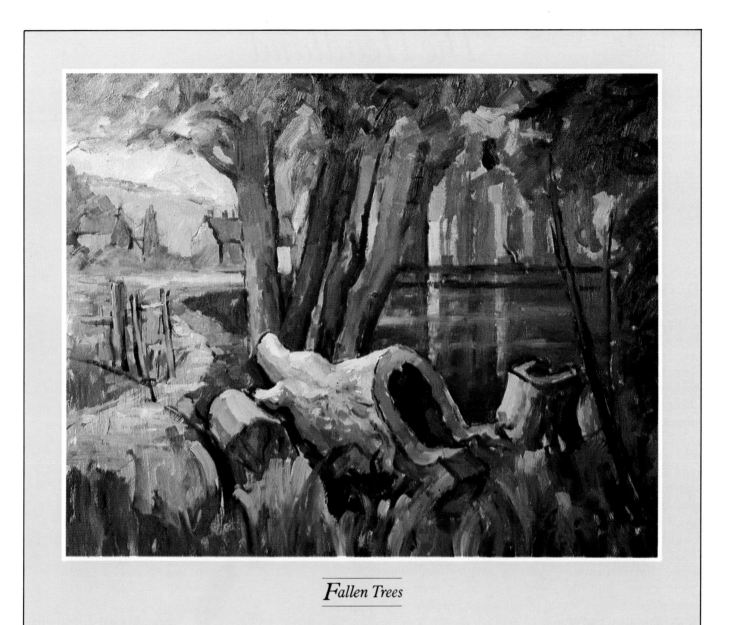

Fallen Trees

What the artist used

The smooth side of a piece of hardboard measuring 24in × 30in was prepared by first roughening the surface with sandpaper and then laying on a coat of Roberson's hardboard primer. The artist used eleven colors in all: white, Winsor yellow, yellow ocher, raw sienna, light red, burnt sienna, cadmium green pale, chromium green, Prussian green, sap green and ivory black. His brushes were a number 5 bright and a small sable for the detailed line work, and he mixed his colors on a large mahogany palette.

The Headland

In this painting the artist cleverly matched the subject to the support. His chosen surface is a 30in × 20in canvas board — a very narrow, upright shape which accurately reflects the verticality of the subject. The shape of the board and the nature of the subject combine to emphasize the impression of steepness, which is what first attracted him to the subject.

The artist has used oil paint in an unusual way. He used thin paint — much diluted with turpentine — and has allowed it to dry between each application. To assist the drying he used Liquin, a medium that thins the paint and dries quickly. The thinness of the paint is demonstrated by the texture of the canvas board which shows through in places. The mark of the brush is unimportant, but the artist introduced texture using what might be considered unconventional methods. He used pencil to draw onto the paint and a scalpel to scratch back into it; he then splattered and dripped paint onto the surface and scrubbed away areas of paint with a piece of tissue.

The artist restricted himself to a very limited palette. The subject requires a cool palette, a mixture of blues, grays and greens, and he mixed the colors he required from the six set out on his palette. Many people assume that gray is a boring color, because the word is used pejoratively to describe something dull and uninteresting, but in the hands of a confident colorist it can be a subtle, infinitely fascinating color which can be used to great effect. It can also be a very useful foil for more positive colors.

This is a simple but effective painting of a fairly ambitious subject. The artist was attracted by the composition, the simple color scheme and the opportunity to investigate and experiment with the textural possibilities of oil paint used in flat opaque areas and scumbles.

A quick glance through the paintings in this book will show just how varied the approach to paint can be. Some painters work in a tight way, others apply the paint loosely. Some are fascinated with line or with form, for others color is all-important. You will undoubtedly have your own prejudices. Be aware of the scope of the medium, experiment with other techniques and approaches — this will prevent your own work from becoming stale. After that you can return to your own pet loves with a confidence born of experience of other techniques. Above all enjoy paint and its manipulation.

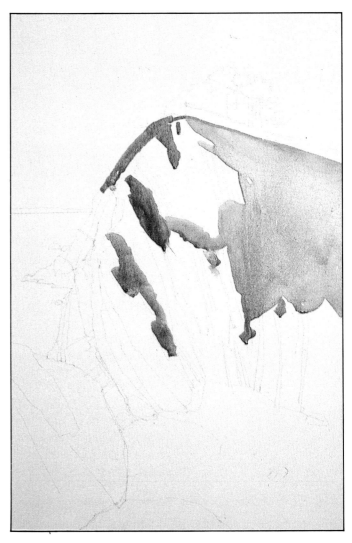

1 The architectural forms and contrasting textures of this coastal scenery, *right*, begged to be painted.

2 *Right*, the artist has drawn on the fine-textured canvas board with a sharp 3B pencil. He did not make any preparatory sketches but worked directly on the support.

3 The paint is thin and does not cover the light pencil, *right*. It is diluted with turpentine and allowed to dry before the next layer is applied. Liquin is added to speed up drying.

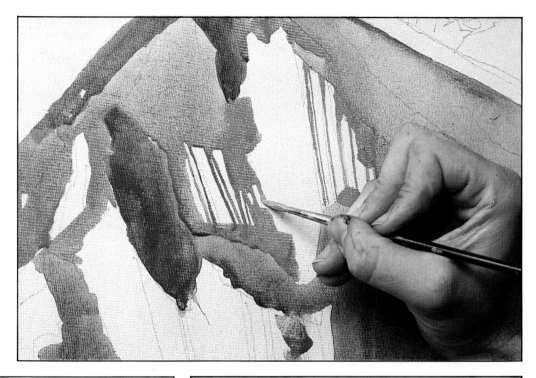

4 *Below*, a mixture of ivory black and a little sap green is used to describe the stark silhouettes of the trees which cap the headland. The artist works with a very fine sable brush to create the necessary degree of detail.

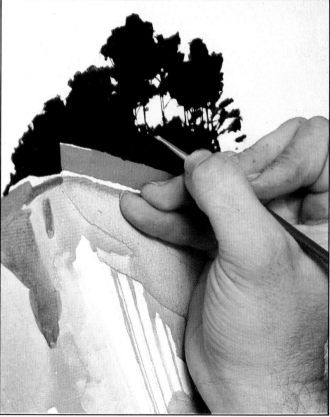

USING PENCIL TO CREATE TEXTURE

In the detail *above* we see the artist using a sharp, soft (3B) pencil to create the texture of the fissures in the rocky slopes of the steep rock face. Many inexperienced painters feel constrained by their media; they do not like to mix them and feel that a 'real' painting must use one medium only. In fact the only test is whether the technique is successful — if it creates the effect you desire, then use it.

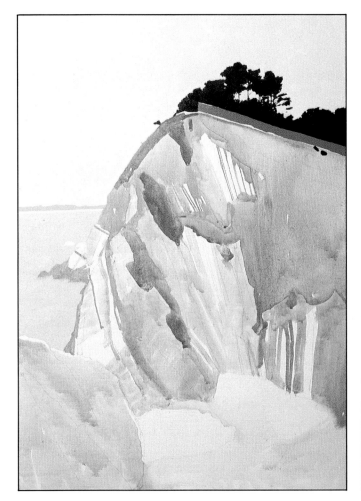

5 At this stage *above* the artist allows the painting to dry before applying the next layers of color. He has worked over the entire support but has not blended the colors so that the edges between areas of color are still sharp and clearly defined. This methodical building up of thin layers of color resembles the techniques of the first oil painters.

6 Working over the dry paint the artist explores methods of suggesting the disturbed geology of the rocky headland, *top*. He dabs wet paint on with a crumpled tissue.

7 In the detail *above*, the artist uses diluted paint and a stiff brush to splatter paint onto the canvas, creating a stippled effect.

8 *Left*, the artist uses a scalpel to scratch into the paint surface exposing the white canvas beneath. This technique is called *sgraffito*.

9 Using an opaque mixture of Payne's gray and white the artist brushes in the highlights, *right*, which he then smudges with his finger to complete the picture, *opposite*.

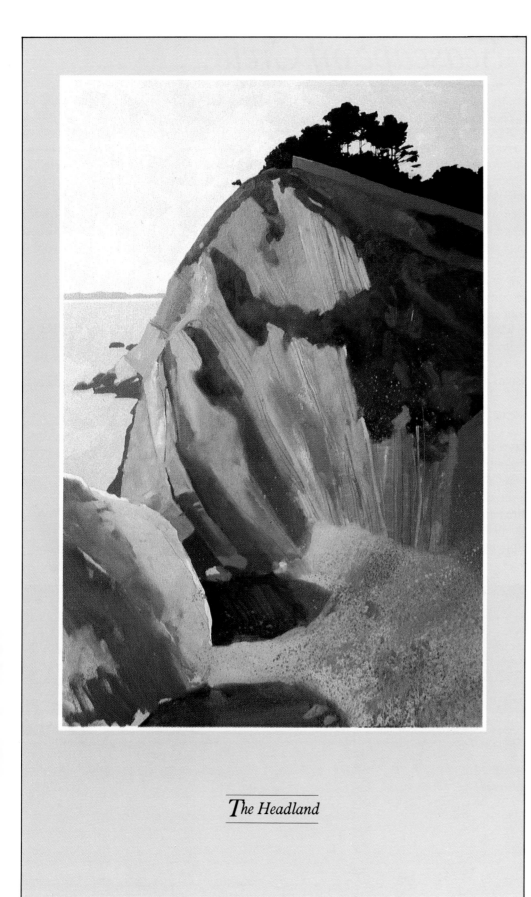

The Headland

What the artist used

For this picture the artist used a purchased canvas board measuring 30in × 20in with a fine-grained surface. He used Students' quality paints in only six colors — sap green, titanium white, cobalt blue, Payne's gray, ivory black and yellow ocher. He also used the alkyd-based medium Liquin and lots of turpentine. He used a 3B pencil, tissue and a scalpel to create texture. The brushes were a number 6 sable, a number 6 soft-fiber synthetic and numbers 4 and 7 flat bristles.

Seascape off Crete

This painting evolved from a series of photographs taken on vacation in Crete. The location is a harbor in northern Crete. It was early October, when the summery weather begins to be disrupted by blustery winds blowing in from Africa. The photograph was taken in late evening at the end of a day which had seen wind and rain as well as sunshine. Under a glowering sky the sea reflects an exaggerated light which sparkles theatrically. The strip of bright water occupies the central part of the composition.

The regular horizontal divisions and the repeated wedge shapes are the key to the whole composition. None of the important lines are actually horizontal. The image can be seen as three simple wedge shapes over which the other elements of the painting are superimposed. Both the top and bottom wedges of land lead the eye to the focal point of the picture – the area of bright water which glistens and gleams in the right of the picture.

The support was hardboard covered with scrim, which was fixed to the board using glue size. This produced a pleasing surface and color, because the texture of the scrim resembles a raw linen canvas, and the artist exploited this, dispensing with a white ground. The cool, neutral color is an important element of the painting, binding the composition together.

The texture of the support is rather coarse, and takes a lot of paint to cover effectively. This influences the way in which the artist handles the paint. He has exploited the textural qualities of the paint – the way in which it can be applied to the surface in an infinite variety of ways to create a range of different marks that is one of the most seductive aspects of oil paint. He has mixed his media, using any materials at hand – pencils, oil pastels, rags and paint applied directly from the tube – to create the desired effects. All have been used in the search for new and apposite effects which lend energy to the work and convey the excitement that the artist felt as the image evolved on the canvas.

1 A photograph *right* can be used as a starting point or an *aide-memoire*, but do not follow it too slavishly.

2 Using a rich creamy mixture of cerulean blue and white the artist scrubs in the paint using a loaded brush and vigorous brushstrokes, *right*. He is generous with the paint because the coarse, scrimmed surface absorbs a lot of paint. However, the rich warm color of the support and the way in which the paint is caught on the raised parts of the woven surface add another dimension to the final picture.

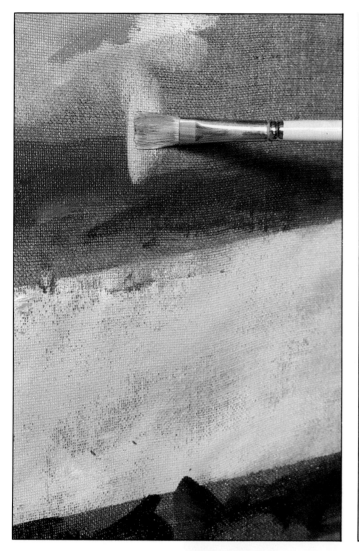

USING PAINT DIRECTLY FROM THE TUBE

Here the artist is using the paint in the most direct way possible – applying it to the surface straight from the tube. Paint applied in this way has a three-dimensional quality which creates a kind of bas-relief which articulates the paint in an unusual way. The raised edges of the paint reflect and scatter light differently from the way in which it is reflected from a flat, smooth surface, The white paint applied in this manner accurately depicts the way in which light is reflected from the rippled surface of water. The thick smear of Mars yellow contrasts with the woven texture of the scrim.

3 We see *above*, the ways in which the paint takes to the support. In places, the surface is completely obliterated; in others it shows through in patches. Here the artist applies a gauzy film of color for the sky.

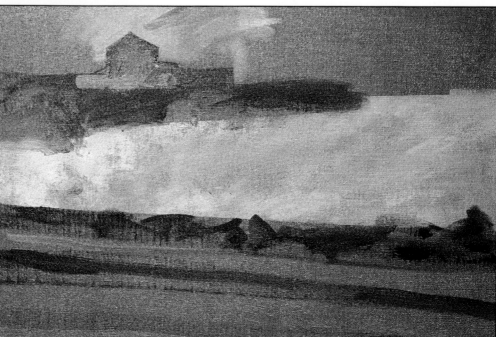

4 The geometry of the painting *right* is very simple – three simple wedge shapes upon which the details of the composition are superimposed.

5 Oil is an infinitely variable medium: it can be used as thin washes or thick impastos; the artist can work wet paint into wet paint to create one effect, or can wait until the paint is dry and apply subsequent layers only when the paint is dry. *Above*, the artist applies dabs of white paint straight from the tube, using his finger to smear the paint.

6 *Above*, the artist mixes raw umber with black and uses a rag to apply broad swathes of paint in the foreground of the painting. The paint adheres to the support inconsistently so that in places the ocher of the support shows through, modifying the dark paint layer.

7 Thick opaque areas of impasto can be contrasted with areas of flat color, and colors can be modified by overlaying them with thin glazes which subtly modify the colors beneath. *Left*, the artist has knocked back the earlier work and uses a pencil to redefine the forms.

8 *Left*, the artist uses yellow oil pastel to create texture and color in the water. He dabs the pastel into the paint, creating a stippled effect, the yellow enhancing the complementary blue. The final painting *below*, illustrates the way in which an artist can develop an exciting composition from a poor and rather uninteresting photograph.

What the artist used

A selection of paints was used on a piece of hardboard prepared by covering it with a piece of scrim, onto which warm size was brushed. The paints were cerulean blue, white, Mars yellow, burnt sienna, raw sienna, raw umber, Naples yellow and ultramarine, and were applied with a flat brush, number 12.

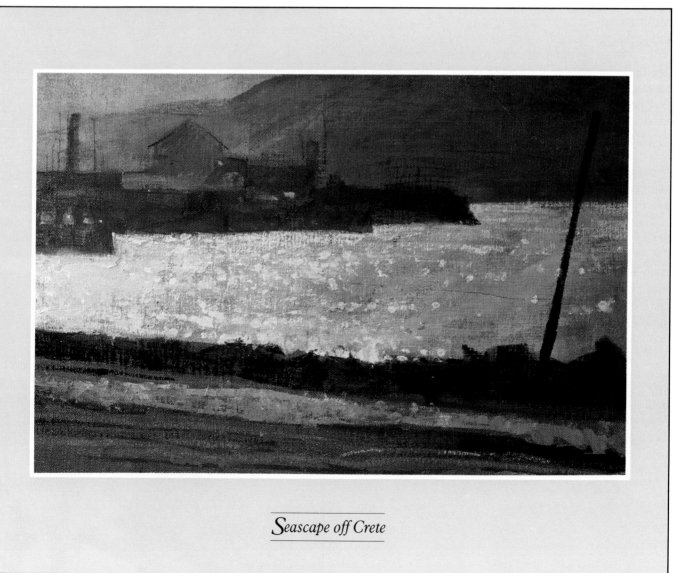

Seascape off Crete

Winter Landscape

The artist has captured the wintry bleakness of this exposed and windswept spot, working in the studio from sketches made on a visit to the area. The low sky — charged and leaden — had seemed a possible subject for a painting. He made his sketch with a felt tip pen which he always has at hand and hastily scribbled in the areas of strongest contrast, such as the tree trunks seen against the sky. He also made color notes to jog his memory in case he returned to the subject at a later date. A sketch can perform many functions; it is both the artist's diary and a source of reference. The artist might, for example, want to incorporate a stormy landscape, or some winter trees in silhouette, into the background of a painting. Sketching also concentrates the mind in the same way as note-taking does. You may think you have taken in the main elements of a particular subject by just looking at it, but the kind of looking and seeing you do with a sketchbook and pencil in your hand is of a completely different order. As soon as you start to draw you find that you are mentally saying 'aah, so that is what happens', or 'how on earth could that be there?' You are forced to concentrate, to peer, to look again to see if in fact your eyes are deceiving you.

But when the artist returns to the studio the sketch is not followed slavishly; material in the sketch is processed and measured against other experiences, is added to, exaggerated, adjusted and highlighted. The artist makes of it something which is uniquely his or her own.

The composition of the painting is simple: it is clearly divided into three areas — the foreground, the hills beyond and the sky, with the trees in the middle distance linking the three main areas. Imposed on this there are a series of diagonals which criss-cross the painting: the line of the wall, leading the eye into the painting; the edge of the grassy field; the lines of the hills. The picture surface is a complex web of interlocking geometric shapes which lead the eye over and into the painting. Many painters handle this aspect of the organization of a picture quite subconsciously, whereas others are very aware of the underlying geometry of a picture. The best way to train yourself to see these relationships is to study the work of other painters and analyze them in these terms. Once you recognize them you will start to use them in your own paintings.

1 In this rapid sketch *right*, made on the spot, the artist has recorded a great deal of information.

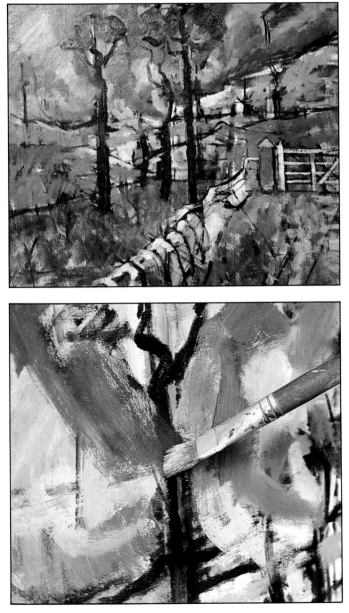

RE-USING AN OLD CANVAS

Here the artist has painted over an old painting, a method which can be just an economy measure, but in this instance was also a carefully considered device to make the painting more lively. The old support acts as a multicolored ground, and also provides the artist with an excellent surface to paint on. Turn the old painting upside down so that the original image does not interfere. Where it remains uncovered the accidental bits of color add interest to the final work.

2 The broad outlines of the composition are beginning to emerge from the complex web of lines and the random color of the original painting, *left*. The artist has used fairly heavy black lines to help him find his way around the painting.

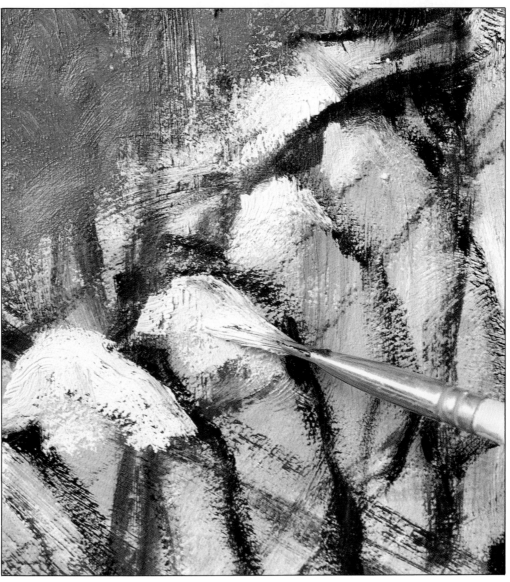

3 In this detail *left* we see the rich and complex pattern of color that evolves as paint is loosely scumbled over an existing painting.

4 The impastoed surface of the original painting *right* creates a textured ground so that the rich creamy paint brushed onto the tops of the dry stone wall adheres to the high spots and lets the underlying color sparkle through.

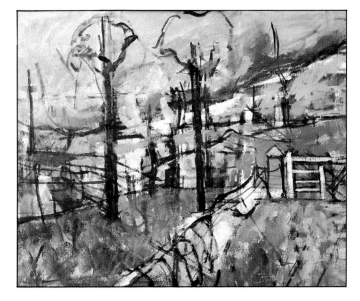

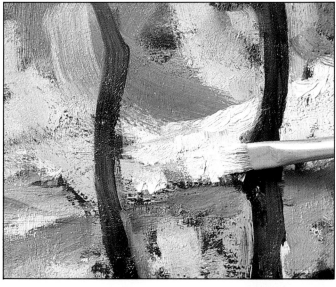

5 By developing every part of the painting at the same time the artist keeps the final picture firmly in mind and does not lose his way among the super-imposed images, *above*.

6 The slash of the bright light just over the horizon is an important element in the composition. *Above right*, the artist lays it in using a mixture of ocher and white.

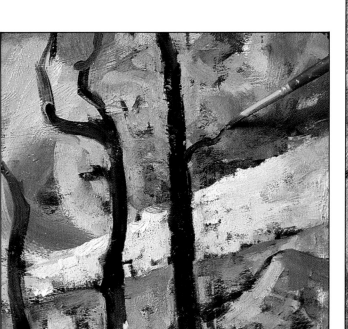

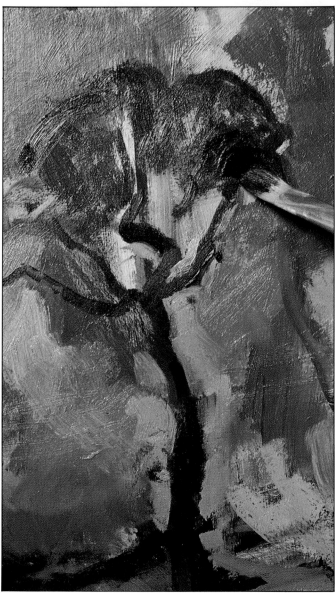

7 Using a number 6 sable brush and black paint *above*, the artist reinforces the silhouettes of the trees and defines the smaller branches.

8 With a mixture of sap green and black the artist scrubs in the clustered foliage of the coniferous trees *right*, conscious of the way the needlelike leaves grow.

What the artist used

A piece of hardboard 24in × 30in on which there was already a painting. His colors were cadmium yellow, yellow ocher, raw sienna, burnt sienna, ultramarine, sap green, cobalt blue and chromium oxide. He used flat brushes numbers 8 and 10, with a fine synthetic brush for the details.

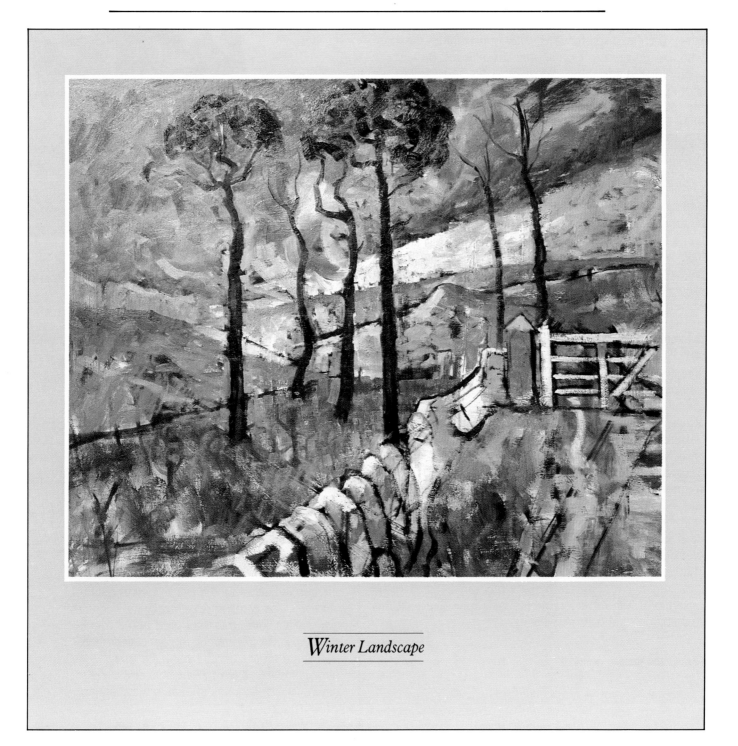

Winter Landscape

View Across the Rooftops

Most of us are city dwellers, and as towns and cities relentlessly spread their boundaries, and urban conglomerations become larger we are further removed from the traditional subjects of the landscape painter. Hills, valleys and seashores are accessible to a lucky few only, while the rest of us have to make do with weekend trips and vacations to study nature at first hand. The city does, however, offer opportunities for those who are prepared to look and be adventurous. Besides the countryside-in-miniature offered by parks and gardens we should not dismiss the urban landscape itself. The search for the picturesque in the eighteenth century and by the Romanticists of the nineteenth century led artists to believe that the only legitimate subjects for the landscape painter were wild and craggy mountain slopes or idealized Tuscan scenes, as portrayed by Claude Lorrain (1600-82) or Nicolas Poussin (1594-1665). In our century there have been myriads of different art movements and less consensus about what should be the subject of art, which leaves the artist free to choose for himself. There is a great deal to be said for painting what you have access to, especially if the time you have available for painting is limited. The view from your window will be there every evening when you return from work and at weekends, so at every spare moment you can pick up your brush and paint.

The urban landscape provides the artist with many delightful views and just as many challenges. The particular view illustrated here is a fine example of the way in which the commonplace can set the artist a great challenge. These rooftop arrangements are complex and you must look carefully and apply your knowledge of perspective in order to achieve a realistic representation.

Here the artist has divided the painting into two definite areas, with about half the canvas given to empty sky and the other half to a jumble of patterns. The patterned area is composed of the geometric forms of rooftops, chimney pots and the striped patterns of roofs, the cool grays and whites enlivened by an infrequent touch of bright red. He has not been afraid to leave a large area of the painting empty, which provides an exciting contrast with the clutter of roofs beneath. The viewpoint, the distribution of forms within the picture area, and the way in which the forms can be seen to be topographical and abstract patterns at the same time make this an ambitious and exciting painting.

1 The subject *right* is complicated, and the artist starts by making a fairly detailed drawing.

2 The artist begins by blocking in the darkest parts *right*, using a mixture of black and raw umber diluted with turpentine.

USING EMPTY SPACE

In this painting the artist has resisted the temptation to fill in all the spaces, but has let them stand, allowing the eye a place to return to and rest. The empty spaces highlight by contrast the excitement of the other parts of the painting. In the second painting by the same artist, p.93, the entire surface of the painting is busy, generating a feeling of excitement and latent energy which is quite different in this painting.

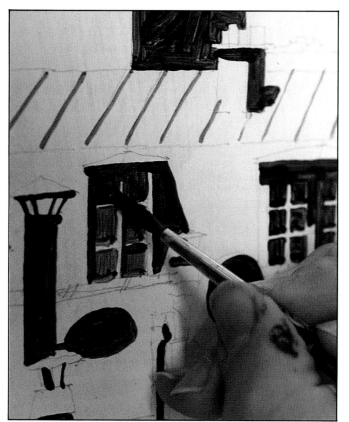

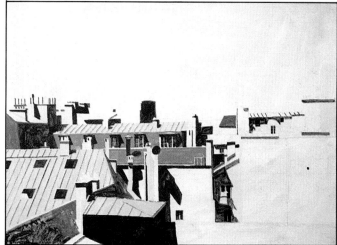

3 He blocks in the slightly lighter tones next *above*, using Payne's gray and a number 3 sable brush. These dark tones will be used as a key for middle to light tones.

4 Middle tones are created by mixing white, yellow ocher, cadmium red or burnt sienna, and adding them to the original dark tones, *below*.

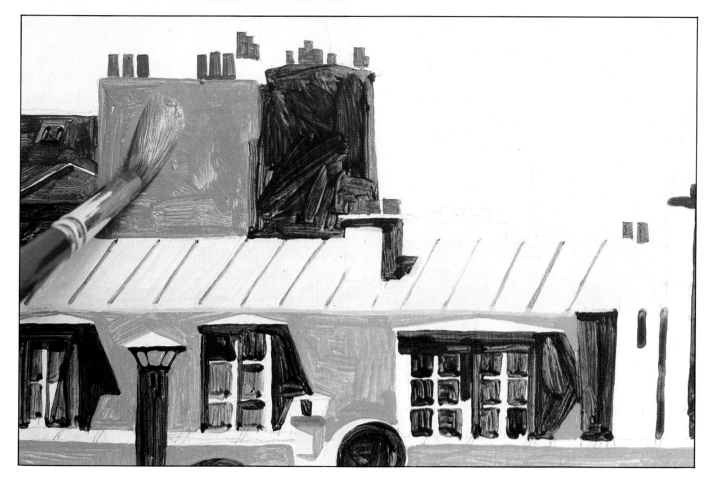

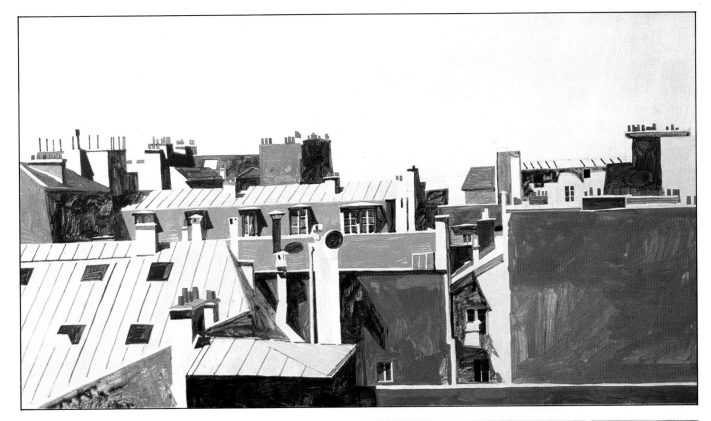

5 The painting *above* is obviously an accurate representation of the subject but is also an abstract pattern of geometric shapes.

6 The detail *below*, reveals the thinness of the diluted paint and the way it responds to the smooth support.

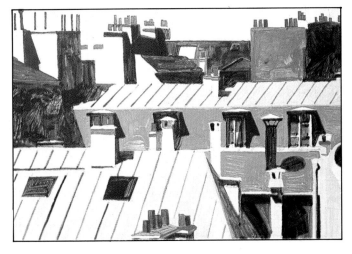

7 The artist adds details using rich reds and beiges mixed from Payne's gray, yellow ocher and white, *right*. In the final painting *opposite*, the sky has been added with a mixture of titanium white and cerulean blue, toned down with a thin glaze of raw umber.

What the artist used

A piece of hardboard 22in × 26in was primed with emulsion paint mixed 50-50 with emulsion glaze. This provided a smooth surface on which he worked with a limited palette of only eight colors: cerulean blue, Payne's gray, ivory black, cadmium yellow, yellow ocher, cadmium red, burnt sienna, raw umber and titanium white. The artist's brushes were a number 6 sable and a number 10 synthetic fiber.

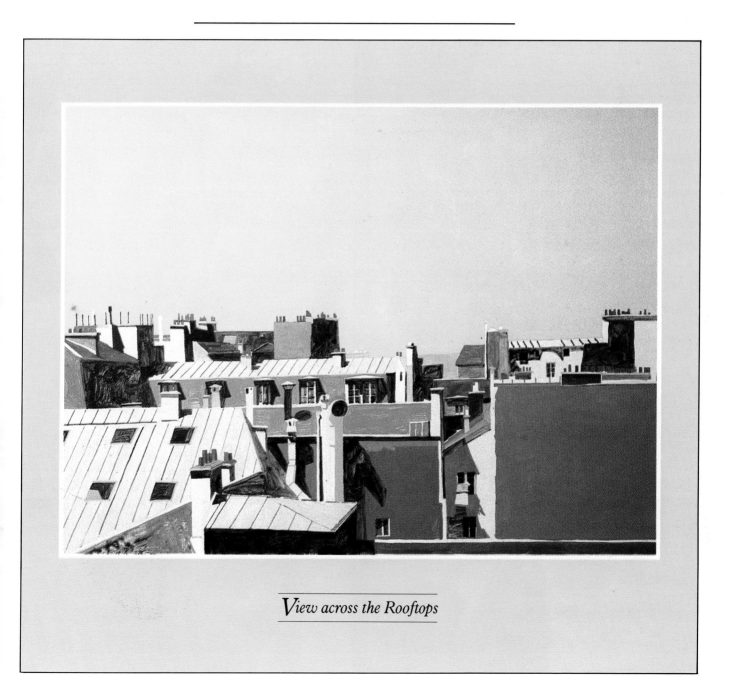

View across the Rooftops

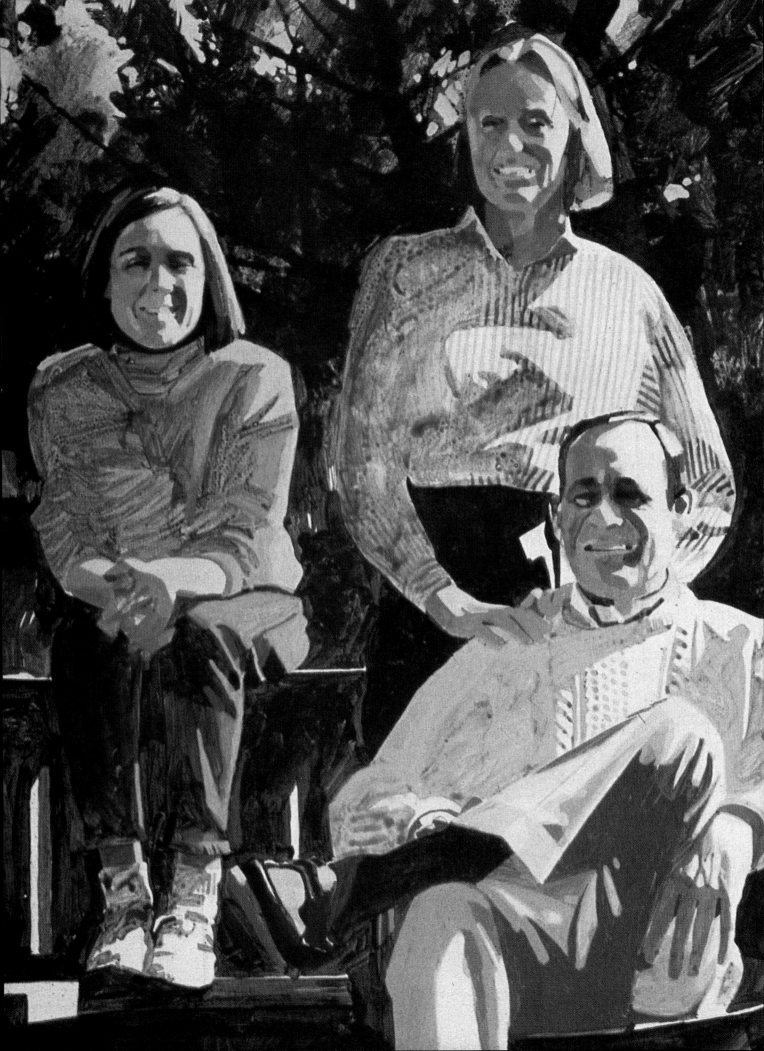

PORTRAITS

The portrait provides an infinitely fascinating source of inspiration, but the richness of the material is almost equally matched by its problems. The artist must represent not only the subtle tints of living flesh and the almost endless variety of human features, but also the slight differences that distinguish youth from old age and all the ages in between. Your first problem is to find a model. Professional models require payment and if you paint slowly this can become expensive. Your family may be persuaded to pose, but few people realize how tiring 'sitting' can be and, after initial enthusiasm, start making polite excuses.

Undoubtedly you will be your cheapest and most cooperative model, and this explains why artists throughout the ages have constantly returned to the self-portrait. The most difficult problem of all, perhaps, is presented by the expectation of achieving a likeness. The ability to get a good likeness is a matter of luck; some people are just very good at it while others, even some very talented artists, never get a good likeness but paint delightful pictures which reveal a lot about the character of the sitter. The best approach is to ignore the 'likeness' aspect of the subject and handle it in the same way as you would any other – a still life, for example. Try to see your sitter as a pattern of planes revealed by the light – paint what you see and you may surprise yourself and produce a good likeness anyway.

Evie Seated

This charming portrait of a child was painted from life. Children present artists with particular problems, not least of which is their inability to hold a pose for any length of time. The artist interested in child portraiture must use great patience and wiles if he or she is to capture a likeness of a young model. In this case the child was very keen to pose, so the artist held her attention by chatting to her, allowing her frequent pauses. He got the main details of the painting down at this session and completed it later, using a combination of memory and sketches he had made during the sitting. This was supplemented by a polaroid photograph.

Children's faces contrast strongly with the developed, sculptured appearance of the adult's mature features. In children it is the expression rather than the features which is important. There are certain general rules, however, that will help you to achieve an accurate likeness. Notice the child's leggy, gangly look and narrow shoulders. She has adopted a typically upright posture and her arms and legs are thin and less shaped than those of an adult.

Another device the artist used was to start the painting in acrylic, which dries quickly, thus allowing him to get a lot of information down in a short time. He made a rapid underdrawing in charcoal; it was quickly executed, but the main details of the subject are there. Charcoal has many advantages, one of them being that it is soft and can easily be erased. If the subject is complex and you think you may have to play around with the composition you should choose charcoal for your underdrawing.

One of the most pleasing elements of this painting is the delightful singing colors — quite fortuitously the child was wearing a dress in the three primary colors — red, yellow and blue.

CHARCOAL UNDERDRAWING

In the two photographs *below* we see the artist using a thin stick of willow charcoal to make an underdrawing. Charcoal produces a sinuous line. It is easily erased, and as you can see, is capable of creating thicks and thins, lights and darks — all very useful when making a drawing. In the second picture the artist is using a cloth to 'knock back' the charcoal drawing. Because charcoal is a soft, crumbly medium there is a risk that the excess powder may contaminate the subsequent paint layers. Knocking back with a cloth is one way of avoiding this; another is to fix the charcoal with a patent spray fixative.

1 The little girl *right*, chose her own pose. Children get bored and fidgety very quickly, so the artist allowed her frequent breaks and completed the painting later from sketches and a photograph.

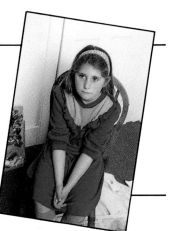

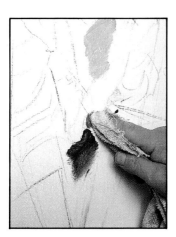

2 The artist starts with a charcoal underdrawing. Anxious to make the most of the sitting, he works at great speed. He uses a rag to scrub in smudges of the dominant colors of red, yellow and blue, using acrylic paint straight from the tube, *above*.

3 Using a flesh tint mixed from cadmium red, white and a little yellow ocher the artist scrubs in the forearms *right*, over which he brushes stripes of yellow. The colors mix in the viewer's eye to suggest the warm glow of living flesh.

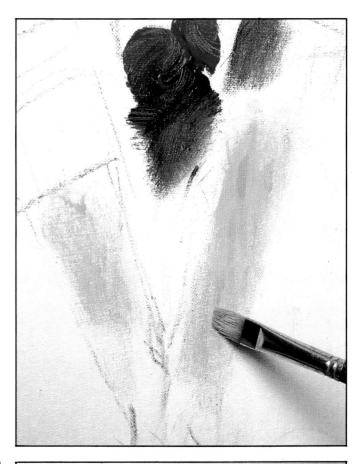

4 Having roughly described the clasped hands in acrylic *below left*, the artist draws on the dry paint with a pencil.

5 The artist constantly checks his drawing and looks, for example, at the shapes betweeen the arms, and between the arms and the legs, *below right*.

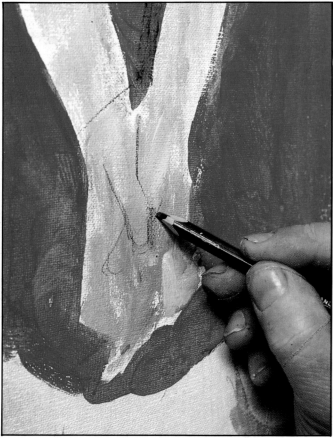

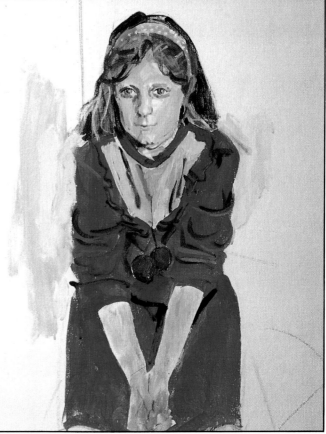

6 The artist is no longer working from the model, and as time is less of a constraint he changes to oil paint. The background *left*, is brushed in with a mixture of raw umber and ocher. He blends Payne's gray and touches of cadmium red into the wet paint to create the varied tones of a wood floor.

7 More detail is added to the eyes by the artist *below left*, avoiding the temptation to overwork them.

8 In the detail *below*, the artist uses a painting knife to touch in the pattern on the socks. The thick impasto adds texture and interest.

9 The artist squeezes a thick line of white paint from the tube directly onto the support *above*, which simply and accurately describes the door panel. As you can see there are many ways of applying paint to a support. In this painting the artist has used rag, brush, palette knife and the paint tube itself. Experiment with these techniques and you will create exciting textures and effects.

10 *Above*, the artist uses a fine brush to add highlights to the hair. Pencil used over dry paint creates further texture. The final picture *opposite*, is an excellent likeness which captures the charm and youth of the model. The artist has carefully balanced the composition; the background spaces are positive elements which create interesting shapes providing a foil for the bright colors of the subject.

What the artist used

The support was a fine canvas board 28in x 20in. The colors used were cadmium yellow, ultramarine, white, burnt sienna, raw umber, cadmium red, yellow ocher and Payne's gray, and were applied with a number 7 bright brush and a small sable brush. The artist also used a pencil, a painting knife and a rag.

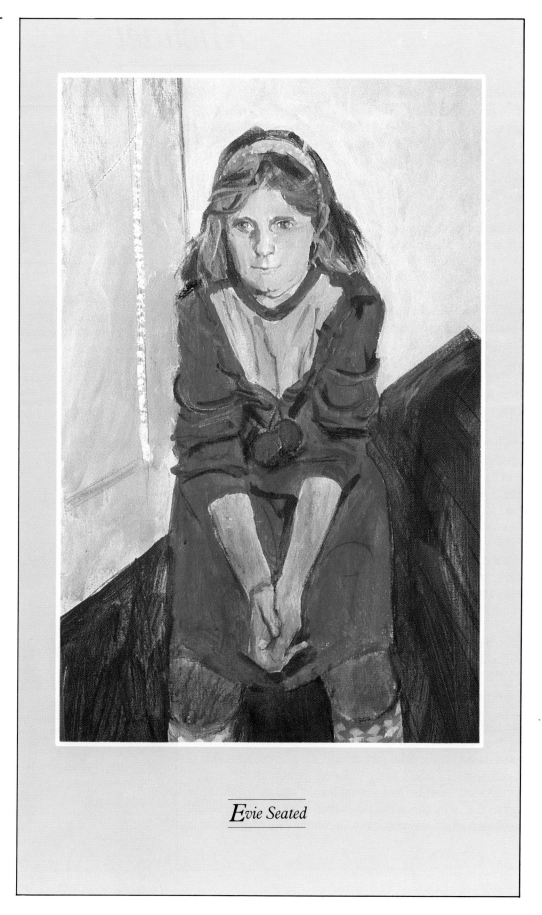

Evie Seated

Michael

This painting is really an oil sketch — the artist was anxious to get the broad outlines of the subject onto canvas, and in order to do so worked quickly with loosely handled paint, diluted with turpentine. She started with a brief charcoal sketch, but did not 'knock back' the charcoal lines because she likes the way the charcoal dust modifies the colors. Within half an hour she had established the broad outlines of the study. The white of the support was soon completely covered — this was important, because the artist likes to work with colors that are very close in tone, and they cannot easily be judged against white. She established form by using warm and cool colors and line. Because warm colors tend to advance, the artist used a warm cadmium yellow on those parts of the torso and shoulders that catch the light, and reserved the cooler colors for the background areas, especially the junctions between background and figure as, for example, on the right shoulder.

The board was smooth with a closely woven texture, but even this is apparent through the thin paint layer. The paint was easily manipulated over this finely textured surface and also allowed the quality of her line to stand. Her love of line is evident in the agitated brushstrokes that capture the springiness of the model's curly hair.

The artist worked in three stages. She first established the rough color areas, which toned down the support, and gave her a key against which to measure her colors. Next she re‑established the drawing, looking for the sinews and the angles of the limbs and those areas where the bones come closest to the surface. In the final stages she attended to the flesh and the musculature — the surfaces of the subject. In effect she approached her model from the inside out, feeling the layers of the anatomy.

The painting is a fine example of oil paint used as a sketching medium. The artist has diluted the paint with turpentine. Thinned in this way, it is easy to manipulate when working fast, dries quickly and economizes on pigments. The artist worked with the same colors and materials she would use if she were to carry the portrait further or use it as the basis for a finished portrait.

You will notice that there are very slight differences in the pose between the final picture and the photograph. This is because the model's body slumped slightly as the session progressed. Also he had several breaks and it is difficult to achieve exactly the same pose after a break. These are all problems which the artist has to accommodate when painting.

1 The model is encouraged to make himself comfortable because the artist is eager to study his face in repose, *right*. She selects a three-quarter view and includes the torso.

2 Broad outlines of the figure are indicated with light charcoal lines, *below*. The artist works lots of loosely applied paint over this base.

3 The artist blocks out the white of the support with thin color in order to reduce the tonal values as quickly as possible, *right.* She then starts to develop the details of the face, but is dissatisfied and scrubs out the wet paint with a turpentine-soaked rag.

4 The artist redraws the eyes, nose and mouth using fluid paint and a thin brush, *below.* Her concern with the quality of line is evident here and in the slash of madder lake used to

define the inside of the right arm. The white of the support gleams through the thin paint creating a luminous effect. Scribbled charcoal lines on the left arm have been smudged.

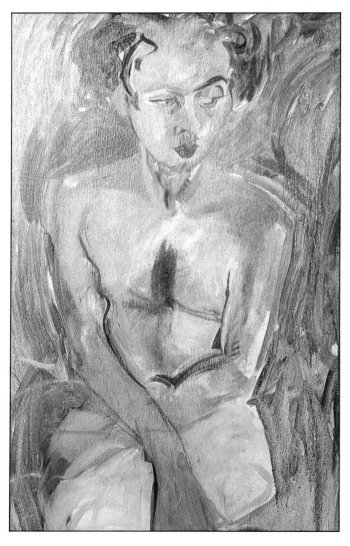

DRAWING WITH A BRUSH

For many people the term 'drawing' means pencil drawing or pen-and-ink drawing. But the brush has been used as an instrument for drawing as well as painting, since the Middle Ages. It is an eloquent instrument, and can be used to create sinuous lines that swell and thin, allowing the artist to describe different kinds of junctions. Artists often start with an underdrawing which is completely obliterated by subsequent paint layers. If you work with loose, broken color it is easy to become lost on the picture surface, and reestablishing the lines of the underdrawing can help you to adjust the image; lines can be modified or incorporated in the composition later on.

5 A mixture of madder lake and flesh tint is used to strengthen the full and sculpted lips, *left*. The artist likes to contrast areas of thick and thin paint and uses this device to draw attention to the lips.

6 The detail *above*, shows the way thin paint reveals the canvas texture, and the almost calligraphic quality of the artist's line.

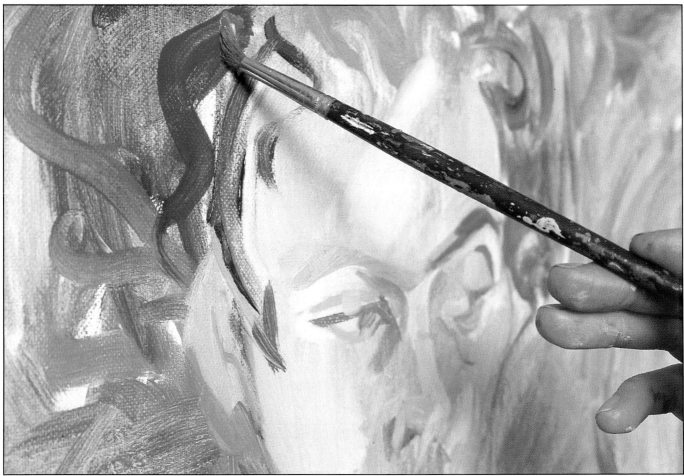

What the artist used

A fine-grained canvas board 36in × 24in was used. This is a cheap support which can be purchased with a priming suitable for either oil paint or acrylic. Her colors were: cadmium yellow, Naples yellow, yellow ocher, flesh tint, Payne's gray, cadmium red, cerulean, madder lake light and raw umber. The brushes were numbers 2 and 5 bristle rounds and flats and a number 3 long-handled sable.

7 *Left*, the artist adds rich magenta highlights to the hair. The brushmarks have a decorative calligraphic quality as well as being descriptive. In the final picure *right* we see the way in which thin washes of oil paint can be used to develop a rapid sketch which is both an accurate record of the individual and a personal and expressive response to the sitter as an individual.

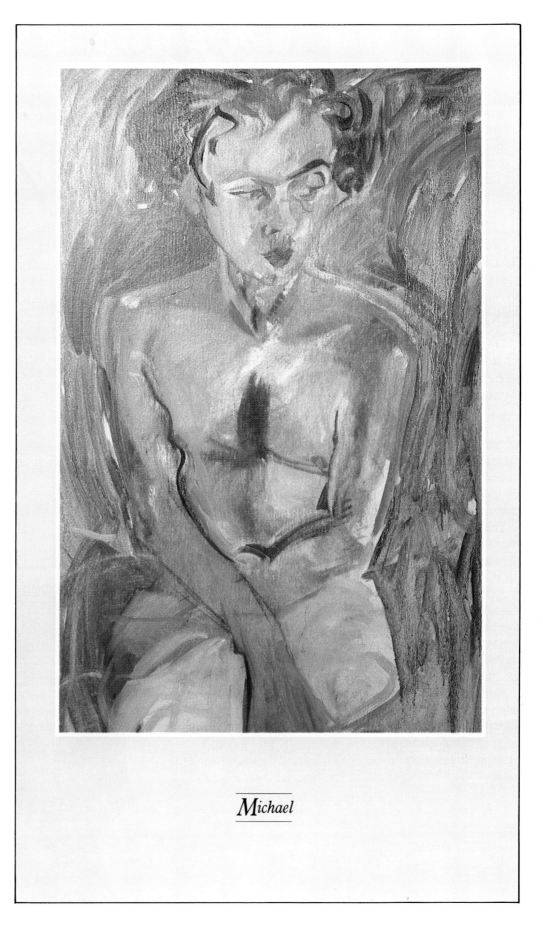

Michael

A Family Group

This oil painting was made as a study for a much larger portrait commission. The artist works on a large scale and, before committing himself to the final painting, works through several stages. First he visits the sitters in their home and, having spoken to them and found out how they wish to be represented, presents them with his ideas. Between them they evolve a possible solution. He usually makes several sketches at this stage and takes several photographs. In this case he very soon found what he thought would be a suitable location, on a balcony. He posed the family and made a few compositional notes. He then went away and worked up the pencil drawing shown on this page. This was sent to the client and various adjustments were made at this stage. He then proceeded to this oil painting, which he gridded up from the drawing.

The portrait will be very large and will take several months to execute. The artist could not possibly have access to the sitters for the time required to paint them from life, so he has evolved a method which allows him to create the good likenesses that the clients require, and gives himself plenty of time to play around with the composition, often returning to see the sitters several times. In the drawing the young man on the right of the group is farther away from the rest of the group than in the photograph. He leans away and rests his arm on the back of the bench. In the photograph and in the oil study he is closer to the rest of the family, and rests his hand on the seat.

The artist's technique contrasts with those in the previous studies. His paintwork is a series of carefully controlled glazes. He uses Win-gel to aid the spreading of the paint and to speed up its drying. Each paint layer is allowed to dry before the next is applied. The technique is reminiscent in many ways of a carefully controlled watercolor, built up from layers of overlapping and interlocking washes. The white of the support is left to shine through the paint in various parts of the painting, representing sunlight falling on hair, faces, clothing and the ground.

The composition is intricate – group studies provide the artist with interesting angles, shapes and forms. The spaces between and around the figures add yet another compositional element to the subject. In this group, for example, the angle of the father's left leg, and the young man's left leg and left arm set up a diagonal stress that contradicts and balances the pervading verticality of the composition.

1 The artist worked from life and a photograph, as well as sketches, *right.*

2 The artist made a detailed drawing in 2B pencil on drawing paper. This was then transferred, square by square, to the hardboard support *left center*, again using a 2B pencil.

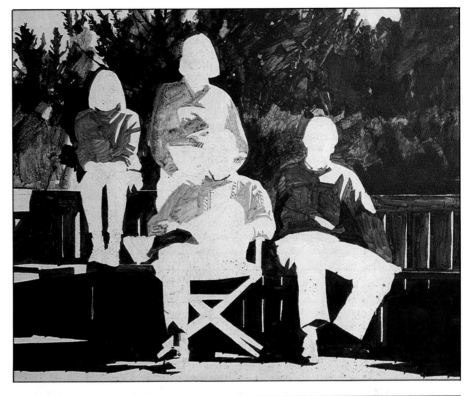

3 The foliage is blocked in with diluted sap green and ivory black, with Win-gel added to speed up drying. When this layer is dry it is worked over with a more opaque mixture of the same colors, *left bottom*.

4 The artist continues working in this way, allowing each layer to dry before painting the next one, *right*.

GRIDDING UP

This is a very useful method for reproducing drawings or paintings. They can either be reproduced at the same size, on a larger scale or on a smaller scale. In the pictures *right* we show the artist gridding up from a photograph. He uses a transparent drafting film on which he rules a grid of centimeter squares. The support he chooses must be in proportion to the original. He then rules up a grid on the support, in this case a sheet of cartridge paper. The number of squares on the support must be the same as those on the original. The artist then transfers the image square by square from the original to the new support.

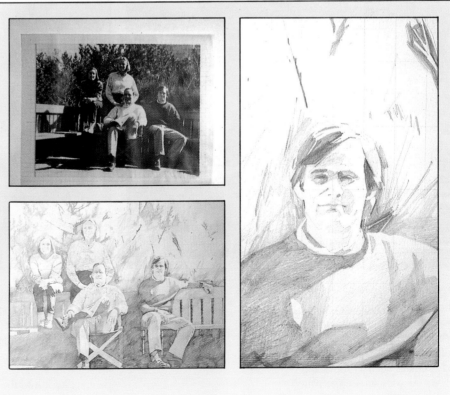

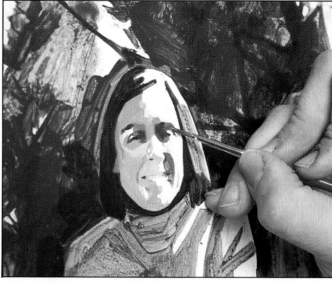

5 These streaky, dribbled effects *above*, are achieved only on a smooth support. Here the artist uses ultramarine and Payne's gray to paint the shadows on the trouser leg.

6 The face is modeled with white and burnt sienna, whereas raw umber is used in the deep shadows under the chin and around the eye sockets, *above right*. A small sable brush is used for the details.

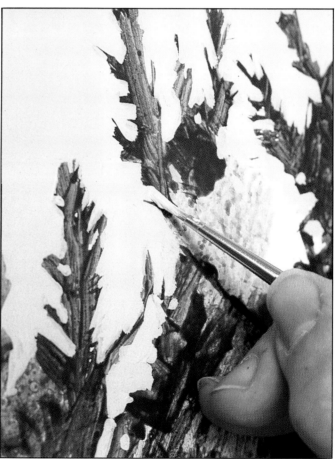

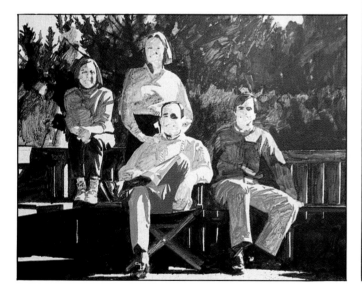

7 The final image emerges as the artist works methodically over the picture surface *above*, constantly looking at his references. At this stage he adds details such as shoes and chairs. As you can see the paint layer is very thin.

8 Cerulean mixed with white paint is used for the sky, *above*. Here the artist manipulates the paint around the silhouetted shapes of the foliage with a fine brush. By painting back into the leafy twigs he achieves the spiky effect he desires. He is treating the negative background space as a positive form which is used to improve the accuracy of the drawing.

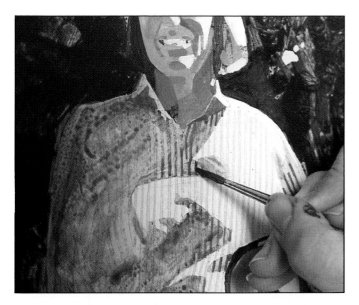

9 Payne's gray is used to darken the stripes of the blouse in the areas of deep shadow, *left*. The artist does this only in some parts, leaving the eye of the viewer to supply the rest of the information. In many ways the artist only provides the viewer with clues; a picture in which all the minute details were supplied would in fact look less real.

What the artist used

A piece of hardboard measuring 24in × 29in and prepared with emulsion glaze mixed half-and-half with emulsion paint. He used a limited palette of white, sap green, ivory black, Payne's gray, burnt sienna and raw umber, and a 2B pencil. His brushes were a number 5 hog's hair and a small sable.

A Family Group

Self-portrait

An artist is often his or her own best model – no other model will ever be so patient, so readily available or so cheap. Most of the great artists have painted self-portraits at some stage during their career; Rembrandt's for example, are a wonderful record of his development both as a man and as an artist.

Setting up a self-portrait is important. Make sure you have a mirror in which you can see yourself easily without twisting or stretching. You should be able to look from canvas to mirror merely by shifting your gaze, not by moving your body. You will need an adequate light source – this can be natural or artificial. The light should be sufficient to see by, but should also add interest to the painting. Make sure that you can reach all your materials easily. Don't forget to mark the position of the easel, the mirror and your feet so that when you step back or leave the painting for any period of time you will be able to resume the position and the pose again.

The artist started by making a fairly detailed underdrawing using charcoal. The degree of detail in the underdrawing depends on the artist's method of working; some produce a very sketchy underdrawing and work up to the details in paint; others, as in this case, use the drawing to work out details of the composition, such as the distribution of the tonal areas.

The artist's approach was simple and direct. He painted what he saw, concentrating on tones and shapes, but he has nevertheless managed to achieve an excellent likeness of the subject. One of the problems with which the portrait painter has to cope is creating skin tones that are convincing. You will only learn what color to paint skin by studying it under different lighting conditions. Skin tones vary enormously even within the same racial group. Some painters have a formula for achieving skin tones, and you will undoubtedly evolve your own, but even so you should avoid applying these kinds of formulas too rigorously, and should look at each subject anew. The commercially available paints marketed as 'flesh tint' are not well named, even for white skin; they vary from bright salmon pink to a pinkish ocher, and although they can be a useful addition to your palette they should be avoided when painting skin. Look carefully at the paint as you work – stand well back from the painting to see just how the colors work together. Work cool colors into the shadowed areas and warm colors onto the highlighted areas – for instance, the cheek and forehead and nose. Apply the paint lightly and freely, working wet into wet. An overworked paint surface can be the death of a portrait more surely than any other subject – skin must look fresh and living. Remember to think of the face as an abstract object, not as a face that you know well and of which you are trying to achieve a photographic likeness.

1 The artist set up his easel so that he could see himself in a mirror. Natural light comes through the window, but he decided to close the shutters and use artificial light, *right*.

EXPLORING CHARCOAL

Charcoal is a very useful medium for establishing the underdrawing. It is particularly responsive, creating a sympathetic, fluid line, but can also be used to lay down very intense black areas. It can be removed with a cloth or lightened with a kneaded eraser, so it is possible to change your mind or rework areas. With charcoal it is possible to achieve a wide variety of tones and textures using line, tone, blending or erasing.

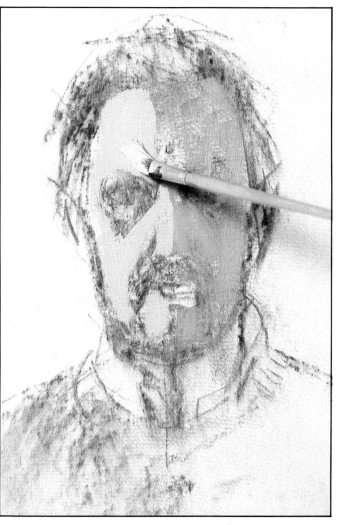

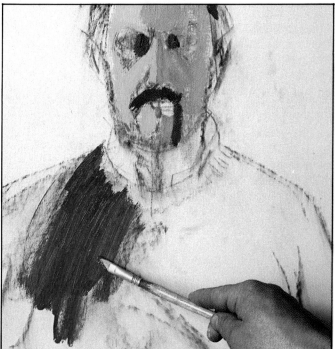

2 The artist starts with an underdrawing, using a medium-thick piece of willow charcoal *above*, with which he has created a variety of marks by using the charcoal in different ways. By using the flat of the blunt stump and the side of the stick he has created broad areas of middle tones. By breaking the stick in two he creates a sharp edge with which he can draw thin black lines.

3 Excess charcoal dust is removed by flicking the support with a soft dustcloth. Broad areas of color on the head are blocked in with burnt sienna and white, *top right*. A little ultramarine is added for the darker tones and cadmium red for the lighter tones.

4 Broad slashes of raw umber establish the darker tones, as in the deep shadows in the eye sockets and the hair on the head and face, *right*. The artist starts to brush in the pullover with ultramarine.

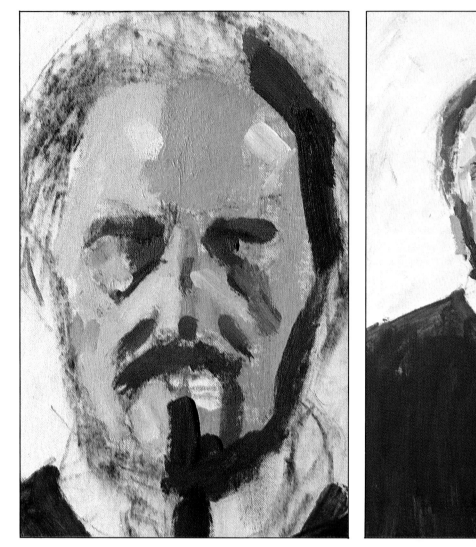

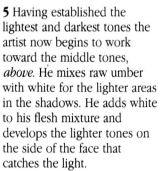

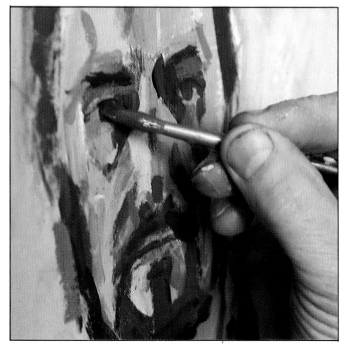

5 Having established the lightest and darkest tones the artist now begins to work toward the middle tones, *above*. He mixes raw umber with white for the lighter areas in the shadows. He adds white to his flesh mixture and develops the lighter tones on the side of the face that catches the light.

6 The background is scrubbed in vigorously using a mixture of raw sienna and white, *above*. Colors are modified by the shades that surround them, so that the blue and ocher tones of the background exert an important influence on the facial tones.

7 The artist half-closes his eyes to simplify the subject. This technique helps him to identify the subtle changes in tone as the planes of the face catch the light, *left*.

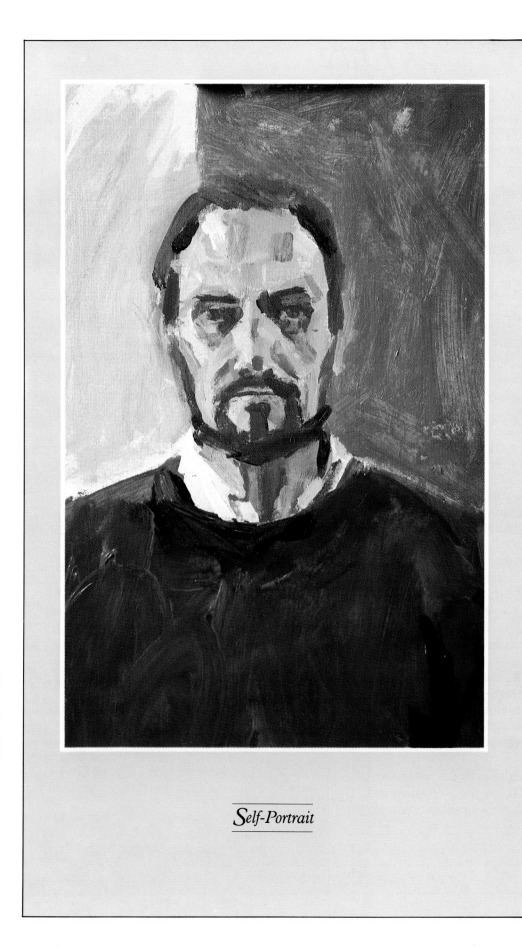

Self-Portrait

What the artist used

The colors used were white, cadmium red, cerulean, ultramarine, burnt sienna, raw sienna and raw umber. The artist used charcoal for the underdrawing, and the brushes were a number 10 round and a number 12 flat. The support was a prepared canvas board 24in × 20in.

Tony

The sitter here was more solid and sculptural than *Michael* in the earlier painting, but in both paintings the artist's approach to the paint reflected the appearance and personality of the subjects.

The composition is interesting. The artist has chosen to let the image 'bust' the picture frame on all four sides, which creates a sense of space beyond the painting. It also conveys a feeling of contained energy, of the subject's forcing his way out of the picture area. By concentrating on part of the subject, by depriving us of the contours of the image, she makes us look at a familiar subject in a new way. We could supply the missing contours, but this new cropped form makes us look at the ordinary or obvious anew. It also very firmly divides the picture area into a pattern of geometrical though organically derived shapes. The background spaces captured between the subject and the picture frame become important. The painting creates a feeling of stillness — but it is an alert stillness expressing latent energy rather than lethargy.

The support was a piece of hardboard covered with lightweight muslin, and sized. The natural golden brown of the hardboard, showing through the muslin, provided the artist with a useful middle tone.

She started by drawing the silhouette of the image and then proceeded to block in the background, thus emphasizing the abstract qualities of the image right from the very beginning. Then, using a flesh tint mixed from yellow ocher, magenta and Naples yellow, she filled in the flesh areas of the torso. With a fairly fluid paint, the interstices of the fabric support soon filled up and were well covered. Because it is difficult to introduce new color working wet into wet, she let the paint dry before adding any more color.

The tonal values are much the same as those in the earlier painting of *Michael* where the artist established form with color — cool blues for the shadow areas, warm ochers for the mid-tones and warm pinks for the highlight areas. All her color mixtures have a good deal of white introduced into them. She works into the highlights, building up the areas of light tones against the darker tones, using thick paint to help define the form.

In this portrait the artist was seduced by the patterns and internal rhythms of the subject. The process is revealing, and draws attention to aspects other than the literal representation of the subject.

1 The artist was attracted by the massive sculptural qualities of the sitter, *right*. Her approach is influenced by this factor and by the stillness which he emanates.

USING MUSLIN-COVERED BOARD

The quality of the surface you use affects the way you handle paint, and you may choose a particular surface to achieve a particular effect. On the other hand you may be forced to work in a certain way by a new support. The board *below* was prepared by placing lightweight muslin over a piece of hardboard and then fixing and at the same time sealing it by brushing on warm size. This provides the artist with a cheap and simply prepared painting surface. The size takes approximately a day to dry before it can be used.

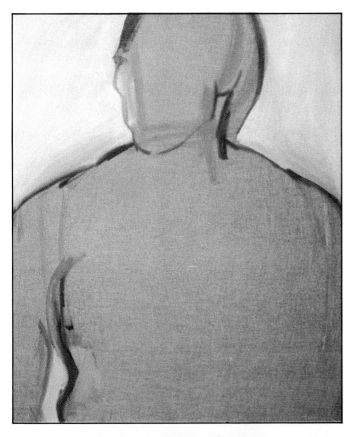

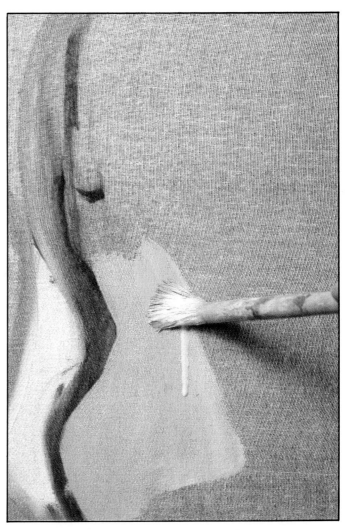

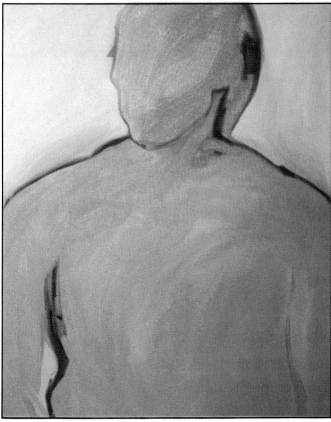

2 The way the artist frames the image is an important aspect of this composition, *top left*. Using washy black paint she draws the broad outlines of the subject, allowing the figure to break out of the picture area on all four sides.

4 Forms are defined by subtle tonal changes, *left*. The artist avoids extreme light and dark but exploits color to describe form. Here the abstract quality of the subject is evident. Compare this painting with the early stages of *Michael*, p.86.

3 The artist starts to block in the torso using yellow ocher, magenta and Naples yellow, *above*. The finely woven and heavily sized surface soon fills up with paint thinned with turpentine. At this stage the sitter is allowed to rest while the paint dries.

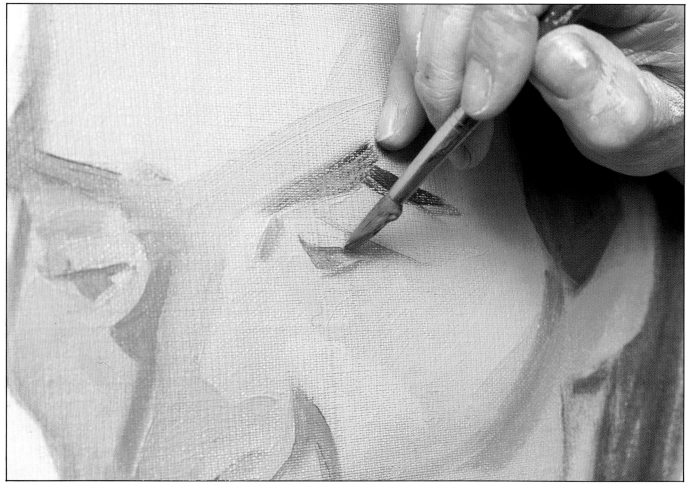

5 Facial features are established by using a combination of line and thin overlapping glazes of color, *above*.

6 The detail *left*, shows the thinness of the paint through which the fine muslin can be seen, adding texture to the paint surface.

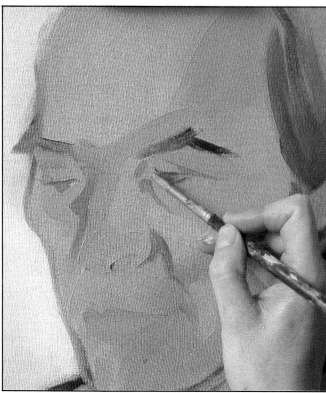

7 Using a creamy mixture of yellow ocher and white the artist works into the background *below*, suggesting the model's shadow cast on the wall behind.

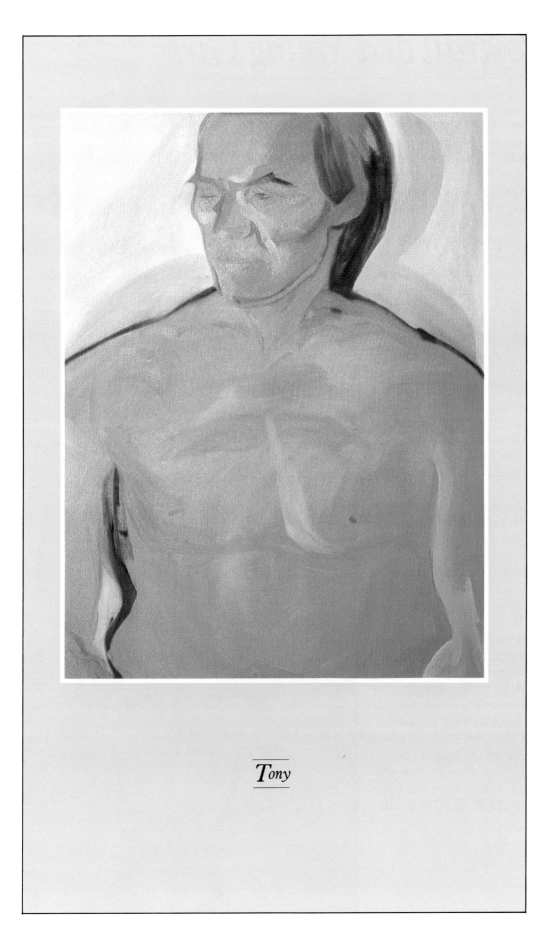

Tony

What the artist used

The palette consisted of cerulean, yellow ocher, raw umber, magenta and Naples yellow, and the artist mixed her grays from these colors. She also used linseed oil, mineral spirits and a number 4 round bristle brush, a number 10 flat and a small number 5 sable. The support was a piece of hardboard 30in × 24in prepared with lightweight muslin and size.

Portrait of a Young Girl

In this painting the artist was particularly interested in the effect of light on the model, the way it illuminates and describes the form and at the same time dissolves it into strange abstract shapes and facets. He is obviously concerned with the image and with achieving a good likeness of the sitter. Painting and drawing from life is one of the best-established traditions of fine art, and remains so for very good reasons. Part of the value of working from a live model is that the pose changes very slightly all the time, and the play of light on the face can be studied at length. Some artists with a good knowledge of form and volume prefer to use photographs as reference, but a flat image is lifeless and gives only part of the information to be gained from the live subject.

The artist made the initial drawing in charcoal, because it is easy to erase. Spend some time on the drawing and make the necessary adjustments at this stage, for as you progress with the work it will become increasingly difficult to make changes — both physically and psychologically. It takes a strong-minded person to recognize and change drawing or compositional faults after hours of concentrated work. So do look carefully at your drawing to check that it is accurate, and that the composition is balanced and fills the space in a pleasing way.

Having established the broad outlines of the painting, you can now start to block in local color. It is important to get some paint onto all the areas of the canvas — even the background. This will give you something to key your colors against. Colors are changed by the surrounding ones, so a color seen against a white support bears little or no relationship to the color as it will appear in the final work. Notice the way in which the artist has used several shades of one color to establish the lights and darks on the hair and on the dress, even at this early stage. He matches the pigment to the color of the subject as closely as possible before he lays it on the canvas, rather than putting down a close equivalent and lightening it or darkening it on the canvas. You will need a lot of practice before your eye is so keenly trained that you can match color by eye precisely.

The artist quickly established the main color areas and continued to apply color, working on the background, the flesh tints, the hair and the fabric of the dress. Remember to look for the tonal changes as you work — the white of the blouse is not the same all over, it becomes darker in the folds and along the upper arm.

1 The artist experiments with different lighting *right*, and selects an artificial light source which casts the right side of the model's face into deep shadow.

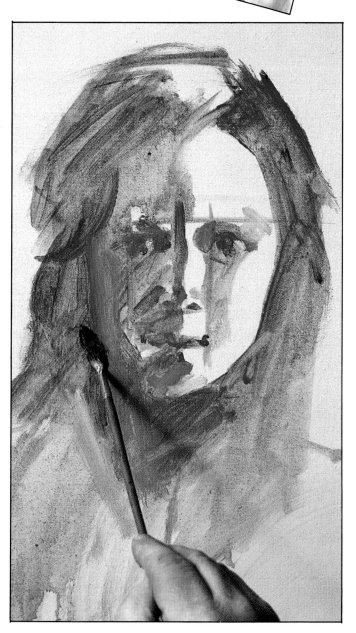

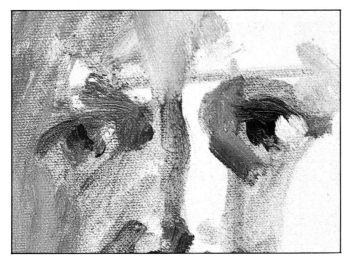

2 Using a solution of ultramarine and turpentine the artist develops a monochrome underpainting, *left*. He is able to describe all the forms accurately because it is possible to establish lights and darks and all the half tones between with only one color. The image resembles a black and white photograph but the cool blue will provide an excellent foil for the warm flesh tones laid over it.

3 The artist starts to lay in blocks of color, working tentatively at first with thin paint as he tries to analyze the colors and tones, *above*. At this stage you should spend more time studying the model than painting.

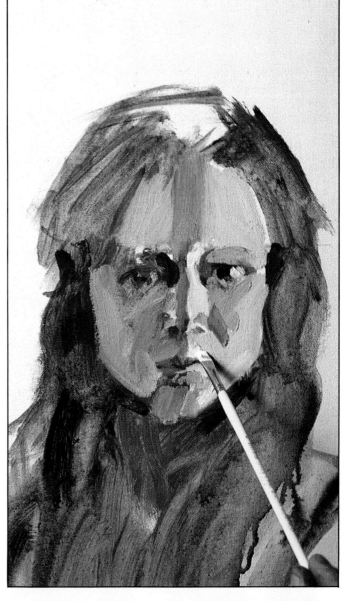

4 The artist now uses thicker paint, building up an impasto while trying to keep the colors fresh, *right*. He mixes each patch of color on his palette, constantly returning to the subject to check the tones.

SCUMBLING

This attractive word describes the technique of applying a thin layer of broken paint over an existing color so that the two colors are mixed in a seemingly accidental way, the first color modifying the other. The second layer of paint is opaque rather than transparent, as it would be with a glaze. The effect is complex and exciting.

5 The subject is seen as tone and color, so that the artist does not paint an 'eye' but merely the facets of reflected light which we perceive as an eye, *above.*

6 Similarly *right*, the artist portrays the way in which the lower lip catches the light, while the upper lip is dark on the left and light on the right.

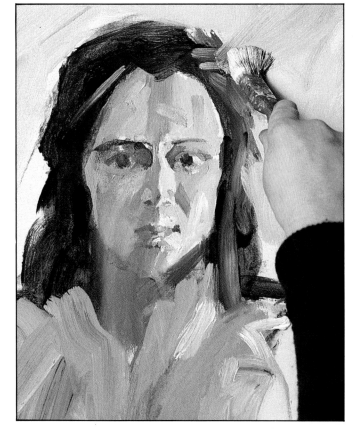

7 Using a small decorator's brush the artist scrubs in the background and the blouse, *left*. He uses white, into which he introduces small touches of other colors. The vigorous strokes accurately express the folds and ruffles of the fabric.

8 In the final detail *above*, we see the variety of ways in which the paint has been applied, from thin scumbles, through which the underpainting is visible, to areas of impasto which obscure the texture of the support.

What the artist used

His palette included flake white, cadmium yellow, cadmium red, chrome orange, alizarin, yellow ocher, raw sienna, burnt sienna, ultramarine blue, viridian and black. The support was a prepared canvas board 36in × 28in with a coarse texture. He used charcoal for the initial drawing and then worked with a variety of brushes.

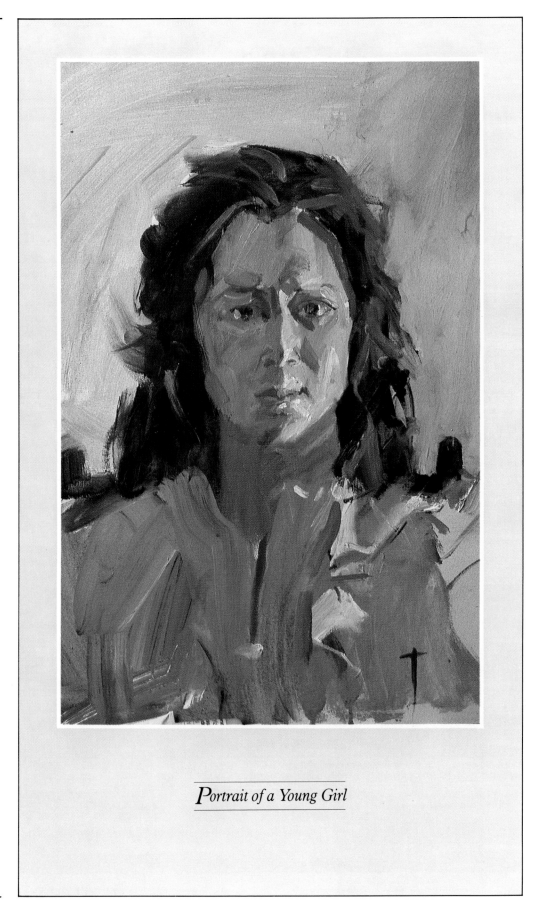

Portrait of a Young Girl

CHAPTER EIGHT

STILL LIFE

Still lifes have appeared as elements of compositions from earliest times – in the tombs of Ancient Egypt, on Greek vases and on the walls of Pompeii. But it was not until the seventeenth century, in the works of the Dutch painters, that still life emerged as an exclusive subject matter of painting. By this time the Reformation had swept through Northern Europe, transforming religious life. The result was that the patronage of artists was affected, as was the subject matter of art, and painters turned to more secular subjects, such as still lifes. Ironically, these still lifes often had hidden symbolic or religious meanings.

The subject of a still life drawing or painting can be any object or group of objects which have been removed from their natural context. One of the great advantages of still life is that the elements of the composition are under the artist's control and can be selected and arranged before the artist puts brush to canvas or pencil to paper. Added to this, potential subject matter is all around you: sticks and stones, flowers, fruit and kitchen utensils – even the contents of your vegetable basket. All these objects are suitable and can be assembled to make pleasing compositions. If you collect objects which you find interesting or attractive you will always have material to hand. When setting up a still life, select a theme – this could be texture, color or form. You could, for example, make a monochrome arrangement to help you study the way tone defines form. Alternatively, you could arrange highly textured objects beside others with smooth, untextured surfaces. You need never be at a loss for a subject.

Still life with Melon

For this delightful and exuberant painting the artist selected some fruit and vegetables from the kitchen — a melon, tomatoes, an onion and a green pepper. The complementary bright green and red of the tomatoes and peppers set each other off. The subtle matte color of the melon is traversed by regular dark green lines which divide it into segments echoed in the smooth, golden surface of the onion.

The artist started started by blocking in the broad areas of the different objects with thinned paint. He built up the color, applying it in broad thick sweeps, and then worked into it, using a pencil to describe the rounder forms, and a painting knife for the more angular shapes. The underpainting contributes to the overlying layers.

The shadow areas are an important element of the painting, and here the artist uses warm and cool grays rather than dead black and white. You can enliven your painting by creating exciting shadows, and there are several ways of enlivening your half-tones. You can add the complementary of the basic half-tone mixture, or you can add some of the adjacent color.

The artist used color to describe the forms — white was used for the horizontals, cool white for the verticals. The reflected lights are important for the description of forms, the point of the turn being the darkest part. The topmost part of the tomato reflects the maximum amount of light, and was rendered in a warm red, whereas the turn of the tomato is a cool red; and in the underpart, which is turned away from the light, the artist introduced a complementary shade of green. Much of the form is described by the backlighting, which makes the top curves of the vegetables stand out against the white of the background. In this painting the shapes of the subjects create one set of patterns over which the shadows impose the further pattern, and the spaces between — the negative spaces — create yet another set of shapes and patterns.

The way in which the artist has handled the paint contrasts with the restrained handling in the previous painting. The artist has articulated areas of thin paint with areas of thick impasto laid on the topmost surfaces. The paint has been applied with a great variety of implements: a paint brush, a paint knife and even the artist's thumbs.

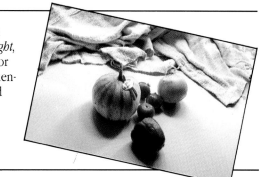

1 The items in this still life *right*, were chosen for their complementary colors and interesting surfaces.

APPLYING PAINT WITH FINGERS

One way of applying the paint to the canvas is to slur the paint together, using your fingers to work the colors one into another. Many artists, from Titian onward, have handled paint in this way. To achieve a particular effect an artist must use whatever implements are at hand.

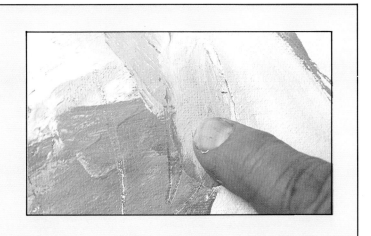

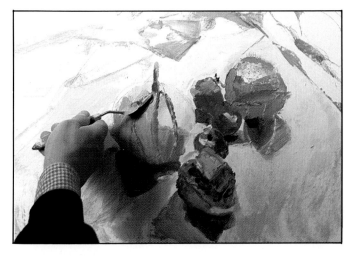

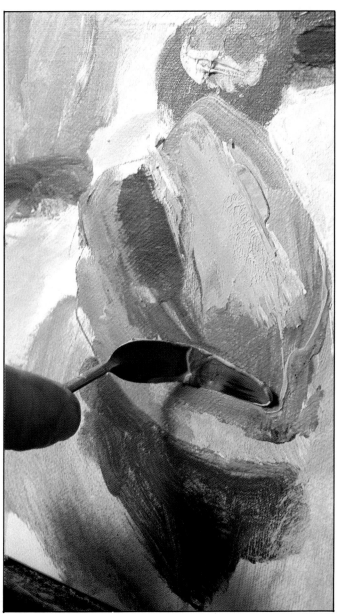

2 Using paint thinned with turpentine the artist blocks in the shapes of the fruit and vegetables, using the appropriate local color, *left center*.

3 The detail, *left*, shows how the artist has built up the paint on the onion, using cool tones on the surface that is turned away from the window, and impastos for the top surface. He has striped the surface with a pencil, creating a dark gray line on the dry paint and sgraffito marks in the wet paint.

4 The artist builds up the thick impasto using a painting knife, *above*. The fresh colors are laid down quickly, smeared together in places but not blended. The knife is also used to 'draw' the thick green lines that segment the melon.

5 *Right*, the artist uses the flat of the blade to sweep paint over the support. A painting knife is a flexible tool which must be used with an understanding of its possibilities. In insensitive hands the effect can be mechanical.

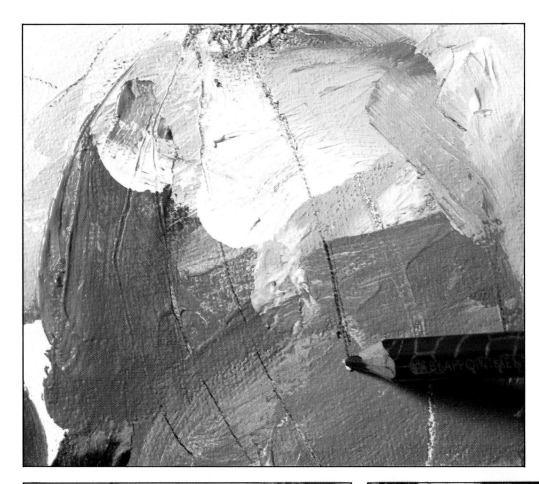

6 *Left*, a pencil is again worked into the surface of the onion, the curving lines simulating the pattern of its skin.

7 *Below*, the artist applies paint straight from the tube, using a knife to describe the angular shapes and folds of the fabric in the background.

8 The artist puts in details such as the ribbon and seal on the melon. He then develops the form of the tomatoes, blending the shadow areas and drifting highlights onto the top surface, *above*.

9 *Right*, the artist continues to build up the painting, applying the paint with light touches of the blade so as to disturb previous layers as little as possible. This is necessary to avoid a 'tired' paint surface.

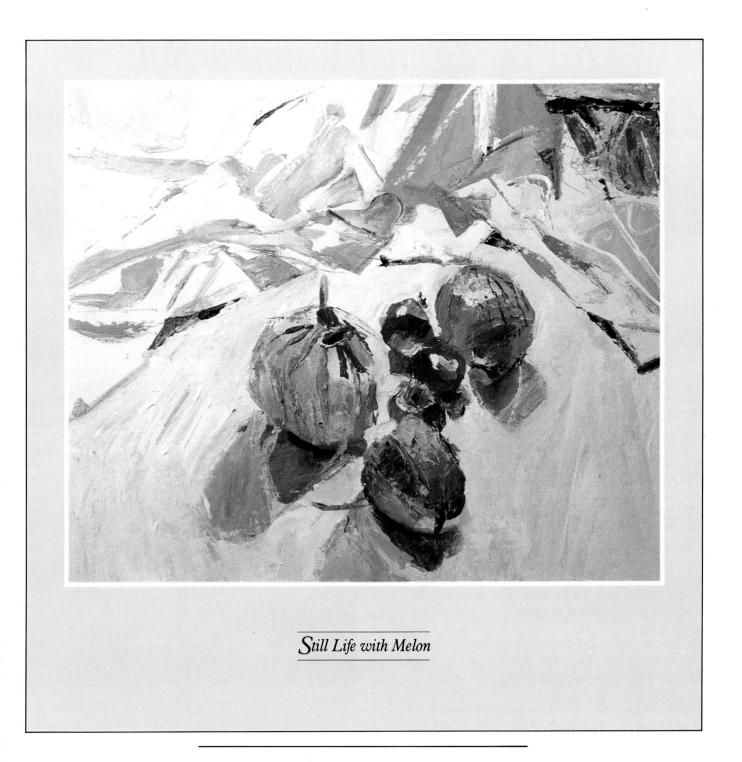

Still Life with Melon

What the artist used

His palette consisted of yellow ocher, white, Payne's gray, cadmium yellow light, cadmium red, viridian, alizarin crimson and sap green. A number 12, round, hog's-hair brush, a palette knife, a pencil and fingers were used. The support was a prepared canvas board 20in × 24in.

Tea-caddy on a Window Sill

Still life provides the artist with an exciting and infinitely variable subject, the materials for which can be found in every home. The advantage of this kind of painting is that all the elements are at hand, and you have total control over your subject, unlike a landscape or figure painter. Still life is also a very useful way of working out ideas. The objects can be reassembled day after day under exactly the same conditions, and the arrangement of the objects and the choice of the subject are entirely up to you.

Choose objects that really interest you – you need not limit yourself to the bottles and bits of cloth that seem to feature in so many still life arrangements. Here the artist has chosen to paint a tea-caddy – he was attracted by its generous curves and the decorative blue motif. He followed through the blue motif in the painting by repeating it in a small dish with a similar color. (It may help you in selecting your subject to opt for a particular range of colors – a selection of blues, or complementaries, for example.) To contrast with the curving lines of the pots, the artist placed the objects on a window sill, where the repeated verticals and horizontals of the window frame and the sill acted as a foil to the circular forms of the pots. The pots are imposed over the corner where all the horizontals and verticals meet. All the elements of the image are very sharply defined – very severe against the cool background. Beyond, a glimpse of landscape presents a soft and pleasing contrast.

The artist used a very fine-grained canvas, a surface which suited his meticulous approach and careful handling of paint. He worked slowly, using a small sable brush to build up the layers of thinned paint, developing all the areas of the painting at the same time. As you can see, the paint layer is so thin that the canvas texture still shows through. The background is an exercise in the manipulation of warm and cool grays. The sunlight shining through the window adds another interest to the painting, the patches of light fall across the sill and onto the inside of the window frame, catching the raised areas, dissolving the forms into patterns of light and shade, drawing attention to certain areas and camouflaging others. Light and shade creates another area of interest, superimposing another level of pattern. The shadow areas and the spaces they delimit are important and interesting areas of the picture.

In a technique such as this the mark of the brush is unimportant. Compare some of the details of this painting with some of the more expressive approaches illustrated elsewhere and you will be able to see how oil paint offers the artist an infinite number of roads to the creation of successful images.

1 *Right*, this simple subject is a study in geometric forms, with the circular shapes of the pot and dish set against the straight lines of the window.

2 Working with thin, washy paint and a soft sable brush the artist establishes the broad areas of the painting, *below*.

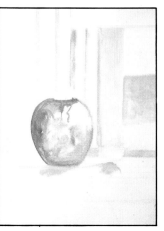

3 The composition is simple and the main elements are soon laid in. At this stage the paint is very thin, *left*.

4 With a mixture of ultramarine and a little white the artist continues to develop the blues of the tea-caddy and the dish. Payne's gray mixed with white is used for the darker tones of the window sill and the frame, *right*. The artist is using a slightly thicker consistency of paint and therefore uses a stiff bristle brush.

USING MASKING TAPE

In the detail *right* we see the way in which the artist has used masking tape to mask off part of the painting so that he could work freely into a particular area. Masking tape has a variety of uses in the artist's or designer's studio. It can be used to fix paper to a drawing board, for example, and can then be removed without damage to the paper, thus differing from some other tapes which can destroy the surface of any paper to which they are attached. A piece of masking tape can also be used when you want to achieve a straight line in a painting.

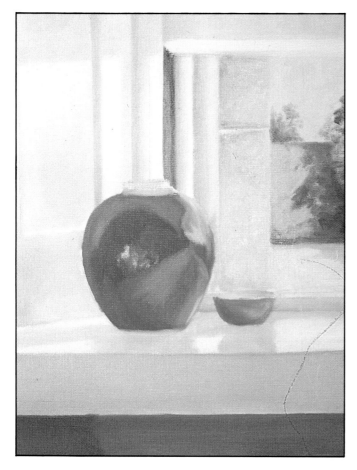

5 The artist's approach is careful and meticulous, and the thin paint surface builds up slowly, *left*. Because the paint is thin it dries quickly and he can apply discrete layers, one over the other. A mixture of ocher, Payne's gray and white are used for the brickwork, and viridian and white for the foliage seen through the window.

6 This detail, *above*, shows just how meticulous the artist's technique is. He uses a very fine brush to describe the hairline cracks in the wooden shutters that frame the window.

7 Using the same brush, the artist uses undiluted paint to paint the decorations on the glazed surface of the jar, *below*. The realism of the final picture, *opposite*, is contradicted by its cool, almost abstract, quality.

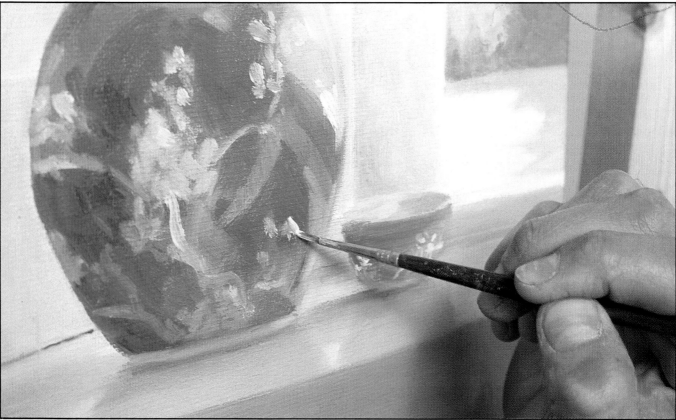

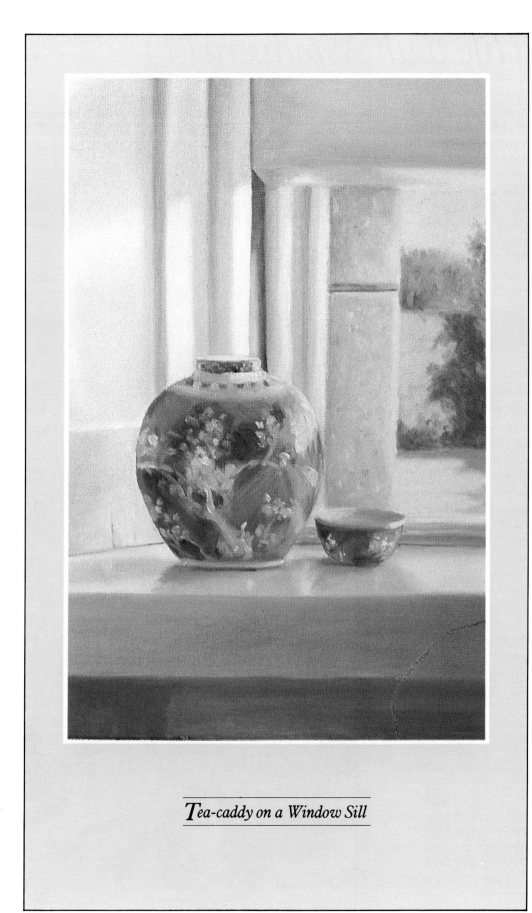

Tea-caddy on a Window Sill

What the artist used

The support was a small canvas measuring 12in × 10in bought ready-stretched and primed. His colors were Payne's gray, black, yellow ocher, Prussian blue, ultramarine and cadmium yellow pale, and he used a small sable brush and a number 8 round.

Still life with Aspidistra (1)

The artist was attracted by the rich dark colors of the subject. He cropped in to the center of the composition – laying in the objects in the center and working from the center outward. He was short of time and wanted to get as much of the subject as possible down at one sitting, so he worked with a painting knife, laying down the paint in small, separate patches. This is the 'alla prima' method of working, in which the paint is applied directly to the picture surface in one layer. It contrasts with the classical techniques which built up the painting in layers of glazes and scumbles. This way the paint builds up a richly textured surface. It is a very rapid technique, but you will find that you get through paint very quickly. Here it is used unmixed, directly from the tube, in small dabs laid down side by side as areas of pure color. Each dab of color has a specific shape, and the raised edges reflect and deflect light in a very different way than would flat, matte color. This creates a bright, light-scattering effect, which makes for a lively paint surface.

The way in which areas of tone are disposed across the surface of the painting is an important underlying current in the composition of any painting. One of the best ways to identify these areas of light and dark is to look at the painting through half-closed eyes, which will reduce it to its main components; you will see it almost as an abstract. Some paintings are divided into a few large areas of light and dark, the strong simple images creating an impression of stillness and calm. Other paintings are a mass of small elements leading the eye in a more agitated way in and across the picture surface.

In this painting natural light has been excluded by drawing the curtain. The subject is lit artificially and a soft light falls over the objects from one direction. The artist observed the subject carefully, assessing the minute changes of tone around the forms, putting down the color, working first on one area and then another so that the painting was built up, and gradually the white of the canvas was covered. He stepped back from the painting at regular intervals. This is important, especially when the artist is working with areas of broken color (optical color mixing), because the image only really begins to emerge from the picture surface as you step back.

1 *Right* This still life is dominated by the spreading foliage of the potted plant, which is balanced by the small but bright-colored fruits in the lower part of the group.

2 The artist is pressed for time but wants to make a record of this pleasing still life. He sketches in the broad shapes in paint and then starts to apply thick paint using a painting knife, *right.*

USING A KNIFE

Below we see some of the range of marks that can be made with a painting knife. In the first, the flat of the blade is being used to spread thick paint over the support. In the second, the artist uses the side of the knife with a sweeping motion. In the final picture, a palette knife is used to scrape paint from the canvas. The sgraffito marks were made by removing paint with the tip of the blade.

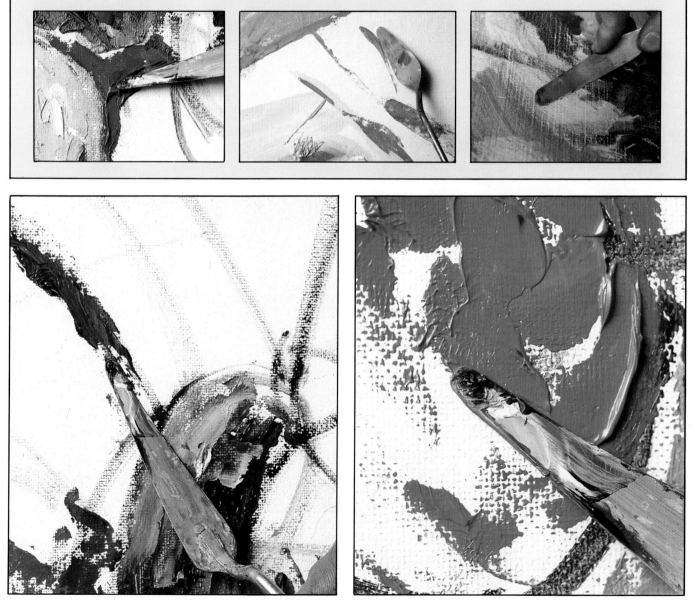

3 Using a long, narrow-bladed painting knife the artist applies the paint, *above*. He mixes color on the palette, matching the tones as closely as possible by constantly referring to the subject.

4 *Above*, paint is smeared onto the surface with the flat of the knife, creating a rippled and ridged effect which adds interest to the paint surface.

5 Using a painting knife and an 'alla prima' technique, the small discrete dabs of color are soon built up into an image, interlocking in the way that the pieces of a jigsaw do, *left*.

6 The complementary reds and greens enhance each other, making the colors sing, *above*. The paint, which is used unmixed from the tube, has a rich, glossy sheen.

7 Paint used in this way has a three-dimensional, tactile quality, *below left*.

8 The grainy texture of the support is allowed to show through the creamy knobs of the cauliflower florets, *below*.

What the artist used

The initial drawing was done with a small synthetic brush, number 8, and thereafter the artist worked with a palette knife. His colors were cadmium yellow pale, cadmium orange, sap green, chromium oxide, crimson, cadmium red, cobalt and white, and the support was a ready-primed canvas board measuring 18in × 14in.

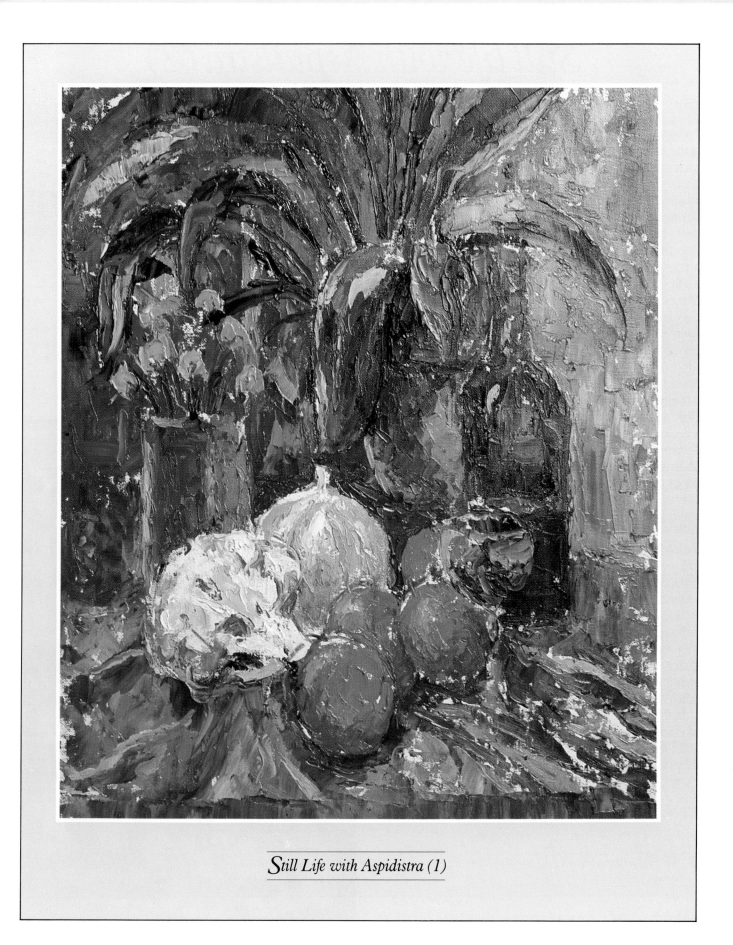

Still Life with Aspidistra (1)

Still life with Aspidistra (2)

This painting contrasts rather well with the previous painting of the same subject, which was executed 'alla prima'. Here the artist started with an underpainting in the manner of the Old Masters. A monochrome underpainting was traditionally used by artists to establish the basic tonal areas of the painting. Having done this the artist then worked up the painting with layers of glazes, scumbles and even impastos.

In this painting the artist laid in a series of glazes, mixing various mediums with the paint to create transparent skins of color. Oil paint is ideally suited to this method of working. Glazes have different effects according to the underlying paint. They can be laid over a monochrome ground to build up thin layers of local color or to develop subtly modulated tones. Glazes can also be used to modify an area of impasto. The effect achieved by laying one glaze over another is entirely different from the colors that would be achieved by mixing those two colors together. The paint acquires a special inner glow as light passes through the transparent layers and is reflected back from the opaque layer beneath.

Paint for glazing must be thinned sufficiently for the underlying colors to be seen through the glaze. It it also important to allow each layer to dry before you apply the next layer of color. The artist used the alkyd-based medium Liquin, which is added to the paint to change the consistency, improve the flow and at the same time keep the body. It also speeds up the drying process, which means that the artist can progress to the next stages. He also used another medium called Oleopasto, which helps to build up richly impastoed paint surfaces.

To achieve the range of effects possible with a glazing technique the artist should work from light to dark, starting with light colors and laying darker colors over them. Thin glazes are very useful, however, for modifying part of a painting, for infusing a pink glow into an area of sky, or toning down a sky if it looks too fierce when you return to the studio.

In this painting we can see some of the richness and depth of color that it is possible to achieve by using a controlled build-up of color, each new layer subtly modifying the previous layers.

1 *Right* This is the same subject as in the previous painting but here the artist has used a layered technique, completing the painting over several days.

2 The artist starts with a monochrome underpainting and then blocks in the local color. He mixes Win-gel with the paint to speed up drying and heighten the gloss, *below.*

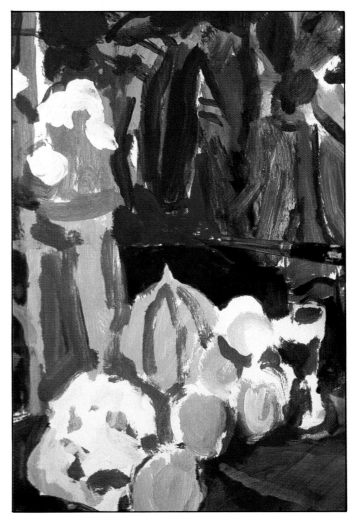

3 *Below*, the artist tries to keep the darker tones thin, retaining impasto for the highlights. He uses Liquin mixed with powdered titanium pigment.

4 *Below center* The technique of building up glazes is slow because each layer of paint must be allowed to dry before the next is applied.

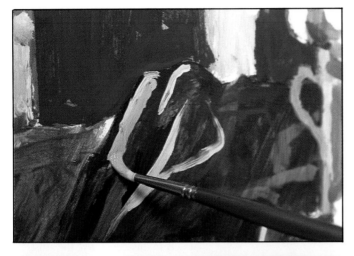

CREATING A MONOCHROME UNDERPAINTING

At this stage the artist is not concerned with the rendering of detail but with establishing the broad masses of color. With a thin solution of raw umber the artist first laid in all the darkest tones, then the middle tones, leaving the white of the canvas to act as the highlights. In this way all the important areas of the painting are established, and the forms can be fully perceived. The artist then 'drifts' the local color over this. Here he has used a dark underpainting, and has had to work from dark to light, using very thin layers of color. In the past the underpainting would have been lighter, and the artist would have worked from light to dark, but the dark underpainting gives the final work a unity that permeates the subsequent layers, binding the whole together in a satisfying and harmonious way.

5 In this detail, *left*, we see the variety of effects that can be achieved by using different mediums. Liquin is an alkyd-based medium which thins the paint, helping flow without any loss in substance. Oleopasto holds brushmarks — this can be seen in the plant pot where the artist has added it to olive green and cadmium yellow.

6 *Left*, the artist uses a creamy mixture of white and Oleopasto tinged with raw umber to create the textured head of the cauliflower. In the oranges on the right, the underpainting shows through the glazes, these translucent areas contrasting with the opacity of the cauliflower.

7 *Below left*, the artist reduces the range of tones by laying in a glaze of ultramarine.

What the artist used

His colors were cadmium orange, cadmium red, olive green, viridian, ultramarine, cobalt, cerulean, Winsor violet, raw umber and white. He also used white pigment, Win-gel, Oleopasto and Liquin. The support was a small piece of particle board measuring 16in × 12in prepared with an acrylic primer, and the brushes used were a synthetic, number 8, flat brushes numbers 8 and 10, and a number 16 round brush.

8 In this detail, *left*, the artist uses a rag to work the glaze into the lightest tones.

9 *Below*, viridian is mixed with Liquin and used to glaze the melon and the shadowed side of the jug. The artist completes the painting by glazing the leaves and darkening the deep shadows under the table *opposite*. The final picture has a rich jewellike quality which contrasts with the 'alla prima' version of the same subject.

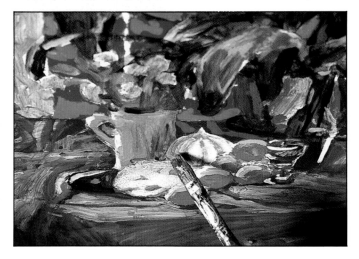

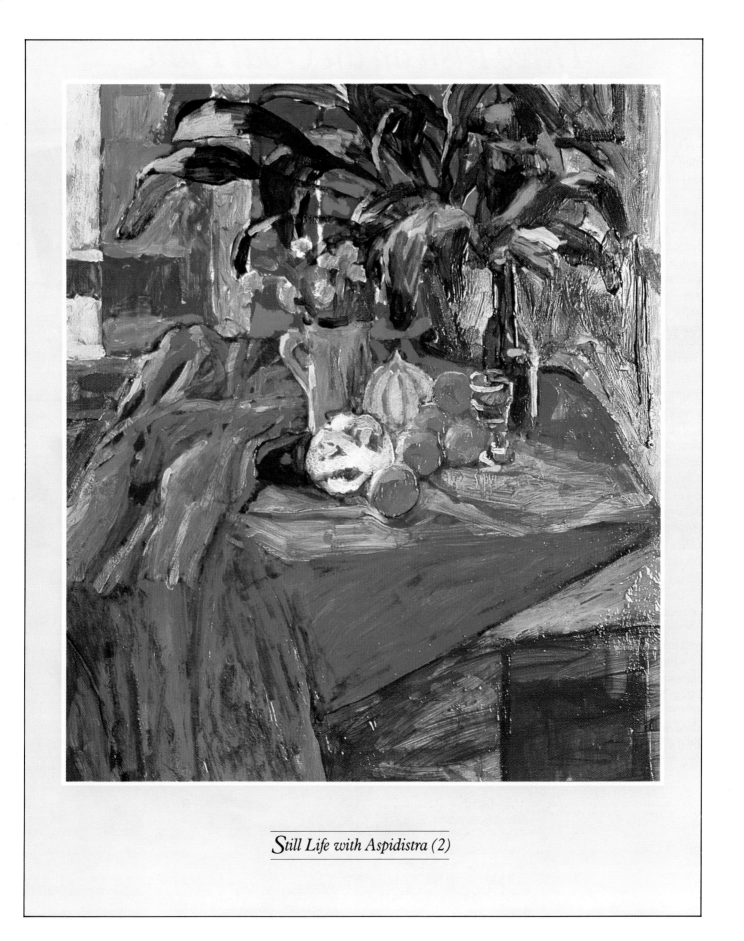

Still Life with Aspidistra (2)

Three Fish on an Oval Plate

Fish provide a wonderful subject for the painter, with their sleek shapes, shimmering colors and the delicate tracery of their scales. You can keep them fresh by arranging them on a bed of ice, and if you paint quickly enough you can eat them afterward.

The composition is very simple – three diagonals transect an oval, and these forms are enclosed within a rectangle constructed from the verticals and horizontals of the chair on which the plate is resting. The artist has exaggerated the geometric pattern-making qualities of the subject by tilting the surface slightly, by choosing to see the subject from this particular angle and by emphasizing the negative spaces – the spaces between the chair legs and the spaces contained by the chair back.

The fish are a combination of descriptive and compositional lines. The images are seen as areas of light against dark, so that it is the dark of the background that describes the chair, for example.

The artist started by making a simple but accurate drawing directly on the canvas board, which was fairly strongly textured. He started to depict the fish first, then he established the background, designing and adjusting the composition in his mind as he worked. Painting is not just a matter of copying what you see. In order to paint you must study a subject very closely, and the more you look the more you see. What you see raises other possibilities; thus, for instance, you suddenly become aware of the shimmer of pink on the side of the trout, which then becomes an important color accent.

The way you use color does not have to be complicated in order to be interesting. This painting is really very simple in composition and in the range of colors used, but the vigorous and imaginative handling of the paint, with the exciting splash of salmon pink, creates an image that is both exciting and refreshing. The eye constantly returns to that warm splash of color. Thus all the elements of the composition work together to create a particular effect. The bold sweep of the dish leads the eye around the central image, but each time the shape is cut by the line of the fish, it is halted and led back into the image and then to the bright color accent.

1 Colour, shape and texture combine to make fish a stimulating subject for the artist, *right.*

2 Using ultramarine and Payne's gray thinly diluted with turpentine, the artist starts to block in the broad shapes of the subject, *below,* with a flat bristle brush. The bright splash of pink was created from alizarin crimson mixed with white.

3 The background color is mixed from yellow ocher, white and burnt sienna, *right.* For the chair the artist uses a mixture of ocher and white and adds a little Prussian blue for the darker tones on the plate.

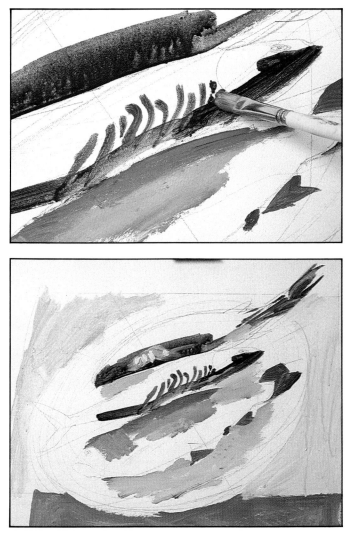

MEASURED DRAWING

Drawing is fundamental to all art and design —
and as such has many functions. Drawing may be
investigative, or it may be made for its own sake.
Here the artist is using a drawing in order to
organize the material of his painting. With a very
few lines he can establish whether the image is
going to fit within his support.

Children often draw what they know — a ball
is round, a brick is square — but the artist must
look hard and adjust constantly. The most
successful results are achieved by seeing your
subject within an environment — that is, seeing
the subject of the drawing and the objects that
surround it as part of a whole. Here the artist has
drawn the object and its background at the same
time, relating each point to others. He used a
soft pencil, and with a ruler constructed the oval
of the dish by drawing the lines that cut through
its two widest dimensions and cross at
right-angles. The rest of the drawing was
constructed by measuring the distance between
points and by dropping verticals from one point
to a point directly below.

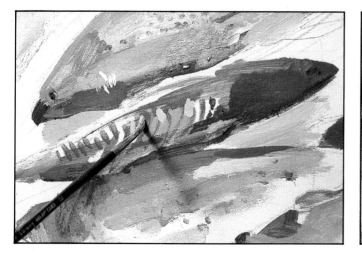

4 The artist is aware of the
decorative aspects of the
subject, and uses cerulean
mixed with white to portray
the repeating patterns on the
side of the mackerel, *above.*

5 The texture of the trout is
developed in a variety of ways.
The artist uses a dilute mixture
of paint on a stiff brush, and
draws his thumb across the
bristles to create a splattered
effect. In addition, dabs of
color are applied with a small
painting knife, *above.*

6 *Right* As the paint layers build up the artist is careful to maintain the unity of the composition by developing all areas of the painting at the same time. The colors used are very close in tone but they are carefully modulated to suggest form.

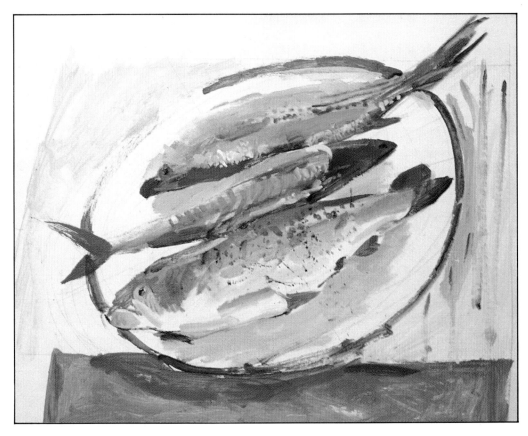

7 With a small painting knife the artist lays in slashes of black paint to define the tail of the trout, *below*.

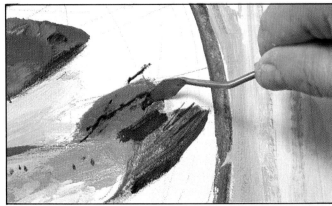

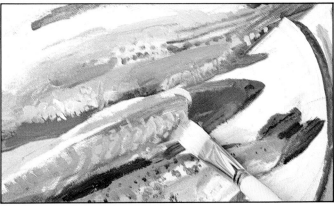

8 Using a mixture of cerulean and white the artist applies paint using a stabbing action with the very tip of the brush, *above right*. The methods of creating texture with oil paint are limited only by your imagination.

9 *Right*, the artist uses a soft black pencil to create the delicate pattern around the edge of the plate. The final picture, *opposite*, is an accurate representation of the subject but the artist has brought out the underlying abstract qualities of the composition and draws attention to them by very slight adjustments and emphases.

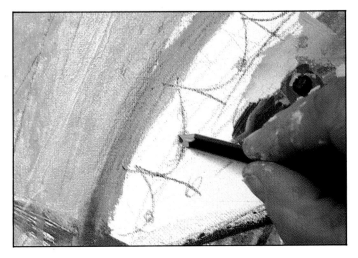

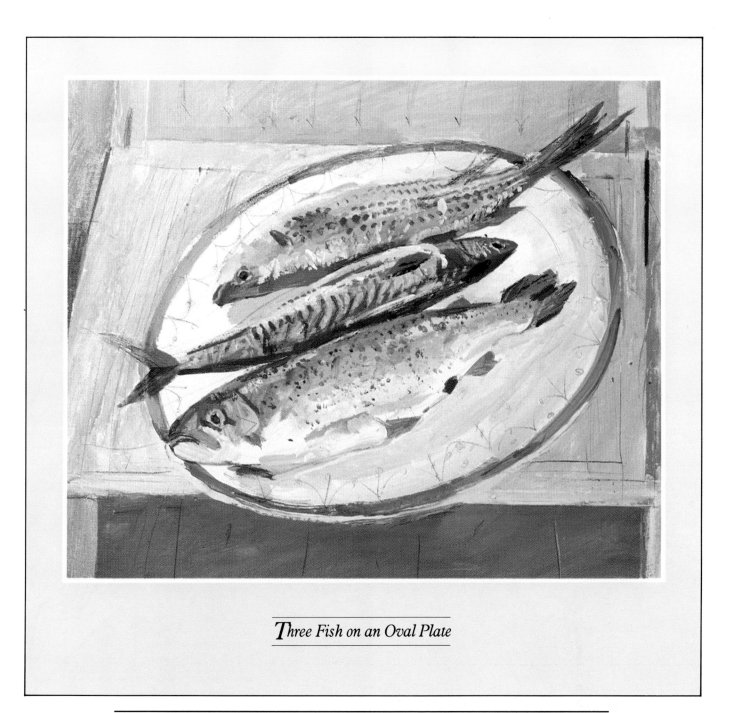

Three Fish on an Oval Plate

What the artist used

The picture was painted on a canvas board measuring 20in × 24in. The artist used a 4B pencil for the initial drawing and for adding texture and detail to the final drawing. His colors were a selection of Artists' and Students' colors: Prussian blue, cerulean, viridian, black, alizarin crimson, yellow ocher, cadmium yellow pale, Payne's gray, ultramarine blue, burnt sienna and raw umber. His brushes were a number 10 flat and a small sable. He also used a small painting knife to build up texture.

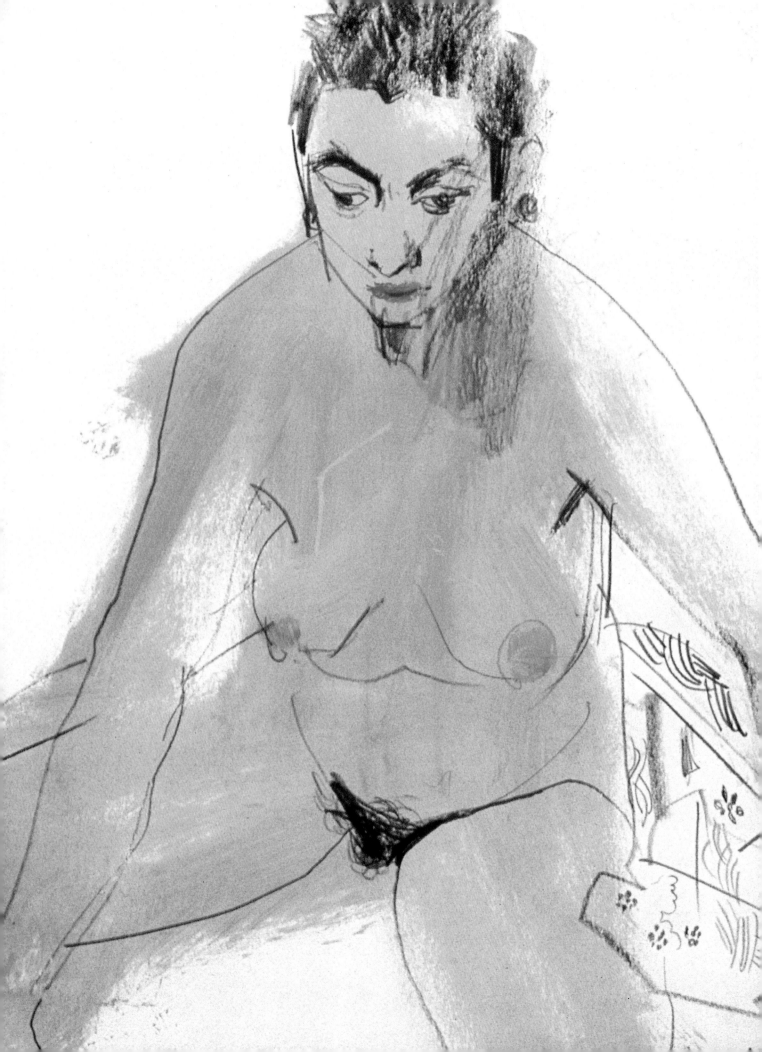

Painting
THE
Figure

The figure provides a marvelous subject for both the experienced and the inexperienced artist. The human body can be arranged in an infinite variety of attitudes, and the artist studies these shapes and forms in order to improve his powers of observation and extend his technique. The human figure is also a powerful means of expressing emotions — an aspect that is most obviously exploited in dance — and this can provide the artist with stimulating material for compositions. The problems of perspective, the representation of form and movement and the complexities of anatomy can all be explored in studies from the figure. You should paint and draw from life whenever you can — friends and relatives may be persuaded to act as models, or you can attend life classes or hire a model. In this chapter we look at both the nude and the draped figure and explore the use of oil as a sketching medium.

Woman in a Green Blouse

The seated figure is a very simple pose – but a simple pose is no easier than a seemingly more complex one. The artist must pay attention to the subject in order to maintain the quietness and the symmetry of the pose. The three-quarter view is a particularly difficult one for the head.

Are there any rules to help you make a drawing such as this and get it right? According to the rules propounded by the ancient Greeks the ideal male figure is eight 'heads' high, four for the head and torso and four for the legs, and the ideal female is seven and a half 'heads', three and a half allocated to the legs. In fact very few of us conform to these ideal proportions, but like any rule of thumb it gives us a useful clue – make a quick survey of the passengers next time you travel by bus or train.

You may feel that, faced with the diversity of human shapes and forms, you cannot possibly be expected to adhere to a set of rules. It can be helpful in such cases to think of the figure as a set of cylinders or volumes occupying space. You are dealing with a two-dimensional art form, but the human body in front of you displaces a particular amount of space, and it is important that your painting or drawing convey this feeling of volume, of bulk, if it is to have any conviction.

A pose like this could be seen as a series of blocks – the lower legs which articulate with the upper leg at the knee, on top of that the pelvis, above that the torso, then the neck and the head. All are attached and all are capable of a certain range of movements one against the other. As soon as the model adopts anything other than a strictly upright pose you are faced with an added complexity. At this point think of the directional lines – the direction in which each part of the body has moved and their angle of inclination to each other.

These methods can provide you with clues, but in order to draw you must, as always, look. Looking is the most vital, the most important, learning process for the artist and 'cross-references' can be very helpful in giving you a visual assessment of the proportions and formal relationships. To make such references, use your eye as a measuring device. Imagine that as your eye travels between the model's chin and her left hand a line is drawn, similarly between left hand and right hand, between hand and foot and so on. Each of these lines will have a particular angle in relationship to each other and will.be in a particular proportion. Verticals and horizontals are particularly useful for this exercise because they can be checked against walls, doorways and the floor.

In this very simple charcoal drawing the artist has done just that – with a very few simple lines he has blocked in the main subdivisions of the figure. He started to lay in the broad areas of color with very thin acrylic paint, which gave him a rapid start as it dried very quickly, and he could work oil color over this. The model took several breaks during the painting session and each time her pose changed minutely. Also, as she sat she gradually relaxed, and the angles and proportions changed almost imperceptibly. The artist noted these very small changes and accommodated them as the painting progressed.

This study has a very definite color slant – the painting is cool, with blues and grays placed over the warm neutral tint of the support. The head and face emerge strongly as the only warm areas in the whole painting.

1 In the seated figure, *right,* the angles between limbs and torso create an underlying geometry which adds interest to an apparently simple pose.

2 The support (hardboard covered with muslin) provides the artist with a useful middle tone. He lays in patches of color in thinned acrylic paint and sketches the outlines with thin willow charcoal, *right.*

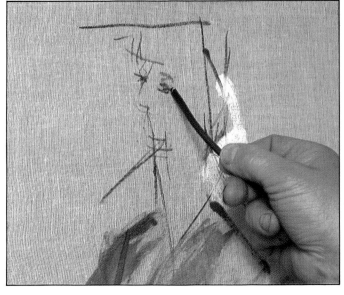

REDRAWING

Only a very few artists would claim to have learned all there is to know about their art, and thus each project is both a new challenge and a new learning situation. Even the most accomplished artist will have to make adjustments to the painting or drawing in progress. This may take the form of changing the composition for purely aesthetic reasons, or accommodating a change in the position of the subject, or even adjusting an inaccurate drawing. As soon as you see that something is wrong, change it, no matter how far the painting has progressed. It is very easy to make adjustments, especially with oil paint. In the detail *right* we see the artist redrawing by working into wet paint with charcoal.

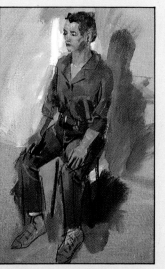

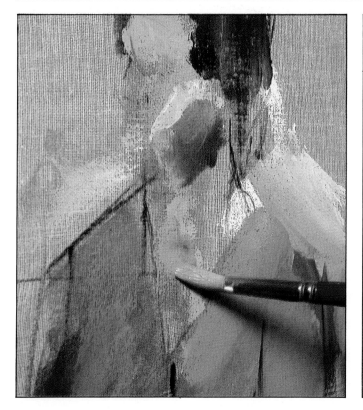

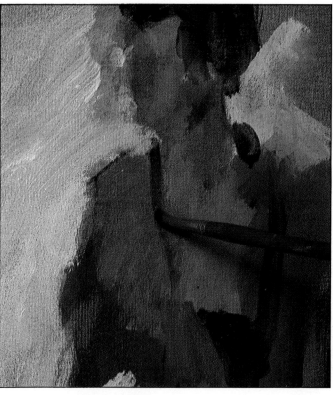

3 Working in acrylic paint, *above*, the artist continues to block in the main areas of the figure using cobalt blue and white for the torso and trousers, and black for the hair. He works fast, because acrylic paint dries quickly, especially on a textured surface that absorbs and holds the pigment.

4 Still using acrylic paint, the artist scumbles in the background with cobalt blue mixed with a little white. At this stage he redefines the forms using a soft, synthetic brush loaded with fluid black paint, *above*.

131

5 *Right*, the artist paints what he sees, measuring angles and comparing dimensions by eye, by stepping back from the easel.

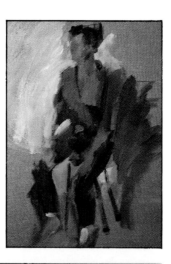

6 *Below*, the acrylic paint is dry and the artist now starts to work in oil paint. Having established the broad tonal areas, he now develops them.

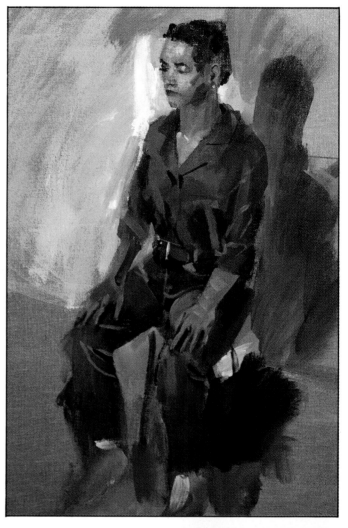

7 *Above* the color scheme is predominantly cool blues, greens and white, with the warmer tones being restricted to the head, arms and hands.

8 *Left*, a small brush is used to establish the darker tones in the crease of the elbow. This detail shows the carefully modulated tones used for the blouse and the way the fine texture of the muslin contributes to the paint surface.

9 The artist puts in the finishing touches; a slash of red for the socks, and white scumbled over the upper of the shoe, *above*.

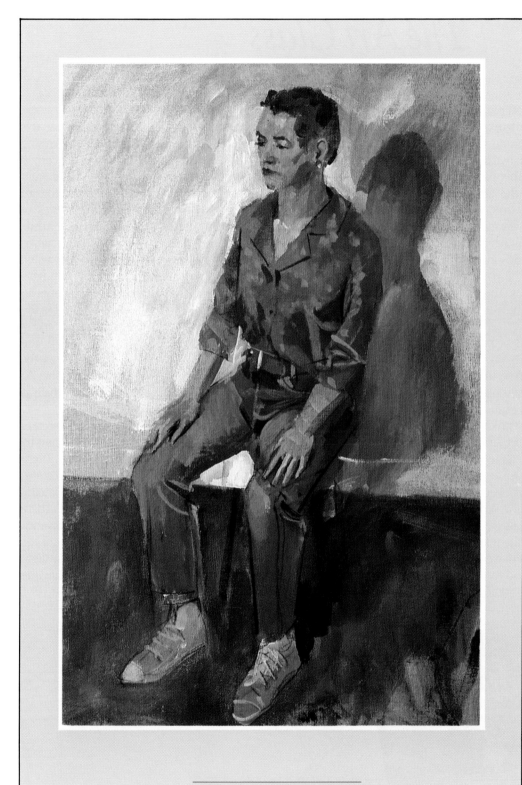

Woman in a Green Blouse

What the artist used

For the initial drawing and for making adjustments to the drawing the artist used charcoal. His colors were white, cobalt blue and black acrylic paint, then Prussian blue, Payne's gray, black, ultramarine, raw umber, viridian, yellow ocher, cadmium yellow and cadmium red oil paint. He used a $\frac{1}{2}$in house-painting brush, and a number 8 and number 10 synthetic brush. The support was a piece of hardboard 28in × 20in with scrim fixed to it by means of glue and size.

The Art Class

The artist was attracted by the complexity of the subject and the opportunity that it offered him to explore recession and the movement of different planes in and out of the picture. He wanted to create a painting which had internal movement and yet had harmony and balance. This painting was developed from a photograph of one of the artist's art classes. The photograph was a standard print from a 35mm negative, and was therefore quite small, but it was merely the starting point for the study, the raw material which the artist used to investigate a subject which he finds interesting.

The background spaces and the cool colors combined to create a pattern of receding planes. The artist had intended to restrict his palette to blues, grays, browns and ochers, but some greens crept in.

All solid forms are composed of planes, and the way in which we perceive form is by the way in which light falls on them. Even rounded surfaces can be thought of as an infinite number of small facets. Where one plane meets another the tone and color will change, because in normal lighting conditions the amount of light striking one plane will be different from the amount of light striking the other. These changes of plane are therefore extremely important to the way in which we can imply the solidity of three-dimensional forms. In this painting the artist has concerned himself with the structure, with the way in which the various elements occupy space. He is concerned with the space within the painting.

The subject of the painting is the relationship between the human figures; it also sets out to make a statement about the relationships of line and color, and to show how light affects form. The artist chose a subject he could relate to, and which in turn relates to his way of life.

All painters have to select in order to create a painting; it is by distorting and emphasizing that they create something unique and personal. In this painting the artist was concerned with two elements: the structure and depth, and the inherent sense of pattern, an approach which inclines toward abstraction. These ideas were first explored in a series of drawings which he tried out, organizing the separate elements of his composition into a cohesive whole. It is difficult to analyze the internal structuring of a group of figures fully when you have two-dimensional references only, but if you have difficulty with any of the figures you can always ask someone to pose for you so that you can study the pose and solve the problems. Placing a large figure in the foreground and a smaller one in the background helps to establish the perspective and the sense of scale. The elements within the composition overlap, one over the other. Even objects that do not actually touch in reality, here appear to touch, which is another way of suggesting space in a painting.

The painting is full of light which comes from one direction – from the studio's skylight. The artist has expressed light by painting the patterns of light on objects and forms. These recurring facets of color flicker across the picture surface, creating an energetic and repeated pattern of geometric shapes, a rhythmic movement across the picture surface. There is a constant theme of lights seen against darks and darks seen against light. This is particularly evident in the figures of the students: the faces are seen in profile against a light background, the spaces around the forms rather than the outlines being used to describe them.

1 The painting is based on a 35mm transparency of the subject, *right*, which the artist has interpreted freely.

2 This is one of a series of drawings that explores the compositional possibilities of the subject, *right*, and shows the artist's concern with structure and space.

SCUMBLING

In scumbling opaque paint is laid over another color, but loosely so that the underlying color shows through to modify the color which is overlaid. Usually the paint applied in this way is dry and opaque and the underlying color shows through in irregular patches. The paint may be applied in many ways — light on dark or dark on light. The instrument of application may be brushes, rags, or even the fingers. Titian used this technique in his mature style in combination with glazes to build up thin veils of color.

3 *Above*, the artist prepares a multicolored ground by mixing a series of colors from very pale ocher to dark gray. These are applied with a turpentine-soaked rag.

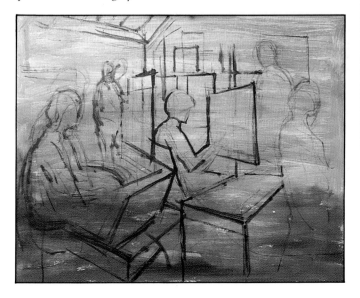

4 The underdrawing is made in charcoal because this is easy to erase. *Left*, you can see that the artist has shifted the woman on the left.

5 *Above*, the artist lays in splashes of local color and accentuates the geometric shapes of the negative spaces by painting them in black.

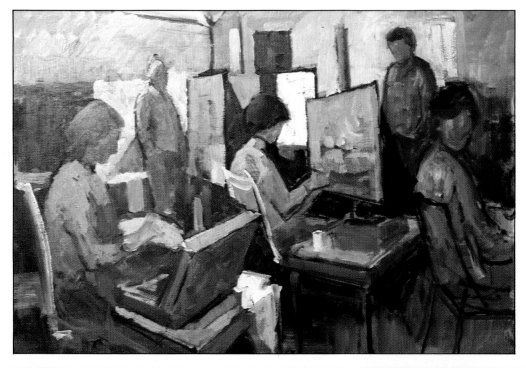

6 The painting is a complex pattern of overlapping planes, *left*. The spaces between objects contribute as much to this pattern as the objects themselves. The artist creates a tension between the spatial aspects of the subject and the pattern-making elements, which makes the viewer aware of the flat picture plane.

7 The natural illumination shed through a rooflight plays across the objects in the studio. The artist simplifies the areas of light and dark so that the painting, though realistic, has an abstract quality, *left.*

8 *Above*, the artist scumbles color onto the shoulder, where the light catches it. The final picture, *opposite*, is a complex pattern of interlocking forms in which blues and ochers predominate. The artist has managed to accentuate the geometric and pattern-making aspects of the subject, at the same time creating an accurate painting of his class at work.

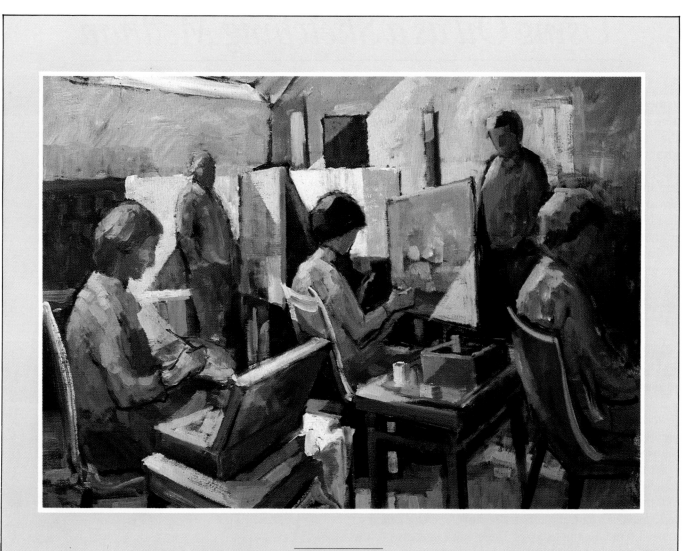

The Art Class

What the artist used

A piece of hardboard measuring 24in × 30in and prepared with Roberson's oil priming. His brushes were a number 7, flat, hog's hair and a number 8 filbert. He used a stick of willow charcoal for the drawing, and his paints were yellow ocher, burnt sienna, white, black, light red, cadmium yellow, chromium green, cobalt blue, ultramarine, raw sienna, viridian.

Using Oil as a Sketching Medium

In the series of sketches illustrated on these pages the artists were asked to make rapid sketches from life using oil paint. Oil is a very flexible and expressive medium, and one of the advantages of using it in this way is that you are working with the medium that you will be using for the finished painting. The artists here have used several different techniques. They have used thin washy colors, smeared on oil paint straight from the tube, and then worked into that with oil pastel or pencil, or anything that was at hand.

These sketches show the artist studying the figure from life and relating directly to the subject — the basis of all great art. It is never possible to say that a study of the figure, or any other subject for that matter, is complete, because each time you draw or paint from the model you are providing yourself with a new learning situation. You are not just practicing already-learned skills; you are engaged in a new and stimulating exploration. It is this freshness of approach and willingness to learn anew that marks the good and committed artist. You will find that the artists who have the most skill, knowledge and dexterity, the people whose work you really admire, all draw and sketch constantly, and do so with the same commitment and vigor as they did when they were students.

Set up your model and start with a series of five-minute sketches. If you are working with a group of people, or even on your own, set the alarm to go off at the end of the five-minute period so that you really keep to the limit. You might then set yourself some 10-minute poses. These quick studies force you to distill, to select the important elements, because you have no time to fiddle with non-essentials. At first it may seem impossible, but after a time you will become quite adept at seeing the important aspect of the pose and capturing it. These rapid sketches will tone up your hand-eye coordination in just the same way as warming-up exercises help to bring the athlete to the peak required for a really good performance.

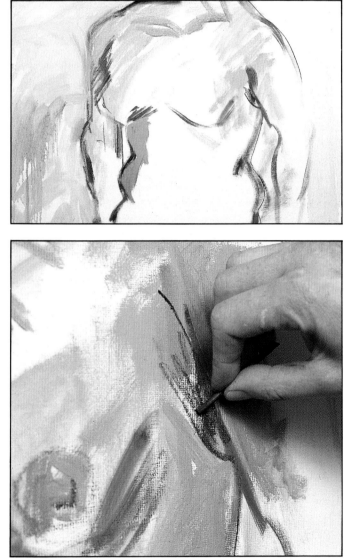

1 In this painting the artist has cropped in to the torso, *right*. This helps her to focus on the forms.

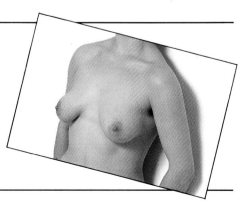

2 *Top* The artist dashes in the outlines with charcoal, works over this with purple oil pastel and washes in the background and the middle tones with diluted paint. The image breaks the frame on all sides, drawing attention to the spaces between the torso and the frame.

3 *Above*, warm and cool colors are used to define the forms; warm pinks and ochers for the curves of the breast, shoulders and hips; cool grays for the point at which the surface turns away from the light. Charcoal defines the shadows under the arm.

APPLYING OIL PAINT WITH A RAG

In the sequence of pictures *right* we see the artist using a rag to lay in an area of paint which broadly describes the main forms of the body. This is a direct method of working; the artist can move the paint in an immediate way, almost molding the forms as he would with modeling clay. He then works into the figure with oil pastel. This method is an excellent way of working in a sketch book, the artist can just pack a few tubes of oil color, a few oil pastels and a small sketch book, and return home with an image that has both line and color. The paint is used straight from the tube so it is not necessary to pack a palette or other equipment.

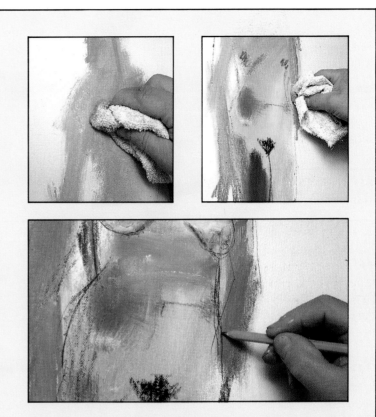

What the artist used

The painting was executed on a sheet of oil sketching paper. The palette consisted of yellow ocher, Payne's gray and flesh tint. Into these she worked with charcoal and purple oil pastel.

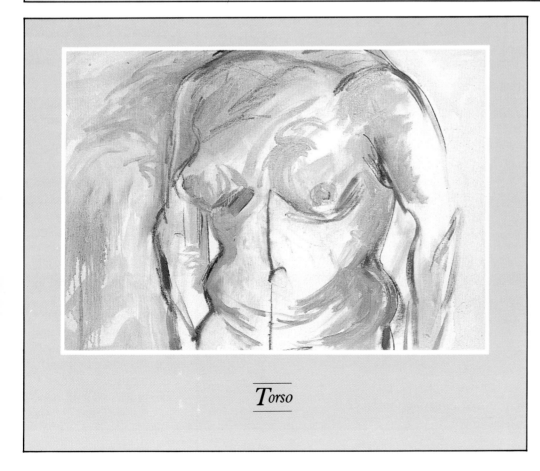

Torso

1 The semi-draped model, *right*, presents the artist with contrasting textures of flesh against fabric. The artists on these pages have adopted different approaches to the same subject.

2 Using a piece of charcoal the artist sketches the broad outlines of the figure. Then, with a large bristle brush, he lays in the flesh areas of the head, torso and the legs, *right*.

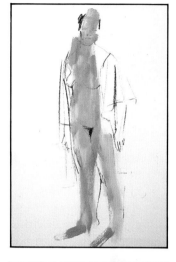

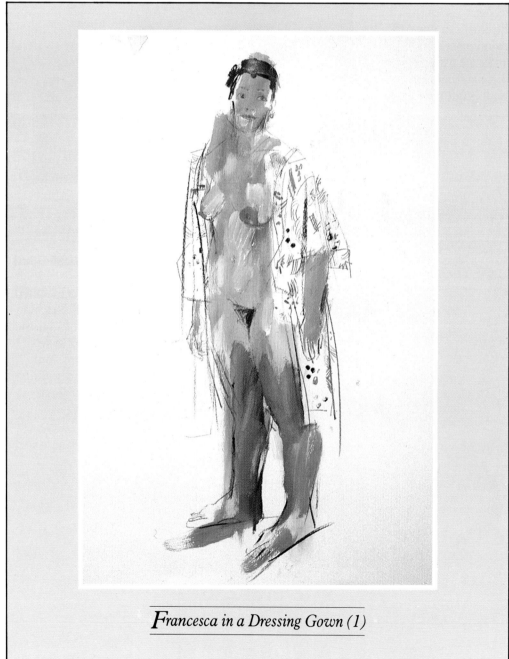

*F*rancesca in a Dressing Gown (1)

3 The details of the eyes and hands are drawn in with a pencil, *above*. The artist brushes on the darker tones of the legs, and squeezes paint from the tube for the dots on the robe, *left*.

What the artist used

A large sheet of oil sketching paper formed the support, and the colors were yellow ocher, Payne's gray, black, raw umber and vermilion. The medium used was linseed oil, and the artist used a number 5 sable brush and a 4B pencil.

1 and **2** This sketch is based on a palette of mixed ochers and grays. The artist works straight onto the support with oil paint diluted with oil, *right*. Diluted in this way the paint moves and the colors blend easily, *far right*.

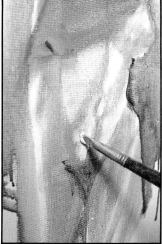

3 Using white paint the artist develops the highlights, *above*. She then uses pencil and a fine brush loaded with black paint to draw the facial features, the earrings and the inside edge of the leg, *left*.

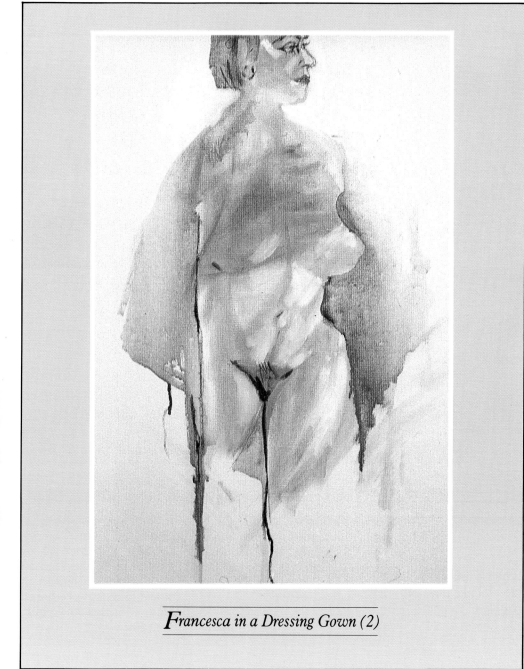

Francesca in a Dressing Gown (2)

What the artist used

A sheet of heavy drawing paper was used as the support, and the colors were flesh-tint oil paint and cadmium red. A piece of charcoal and a 2B pencil were also used.

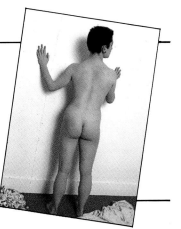

1 This pose, *right*, presents the artists with interesting forms. The outspread arms, the tilt of the head and the subtle flesh tones are captured in a different way by each artist.

2 The artist makes a quick sketch in pencil. She looks for the volumes of the figure and the angles between the parts of the body. Working briskly with a large sable brush, *right*, she lays in large areas of yellow ocher, manipulating the paint around the form so that it is denser in the darker tones and thinner in the highlight areas.

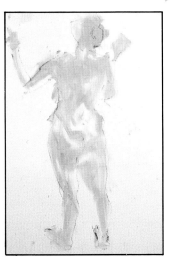

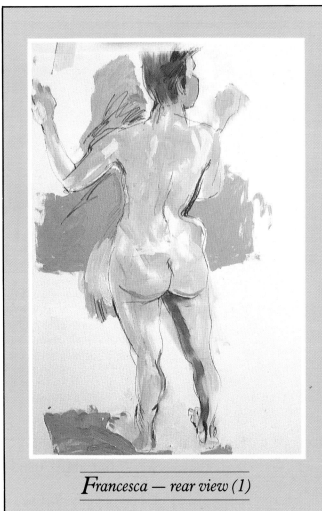

Francesca — rear view (1)

What the artist used

A large sheet of oil sketching paper was the support for this sketch, and the artist used yellow ocher, Venetian red and white, a piece of rag, three oil pastels and a pencil.

3 Flesh tint is used for the background, with a mixed gray for the shadow on the wall. The artist then draws into the paint with a soft pencil, *above center.*

4 *Above* Using washy white paint the artist lightens the highlights on the back and shoulder, so that the planes are better defined. The final picture shows how effective oil can be when used to record a short pose.

1 Another artist approaches the same subject in a different way, *right*. He mixes a flesh tint from yellow ocher, Venetian red and white, and uses a rag to scrub in the forms of the figure over a pencil drawing.

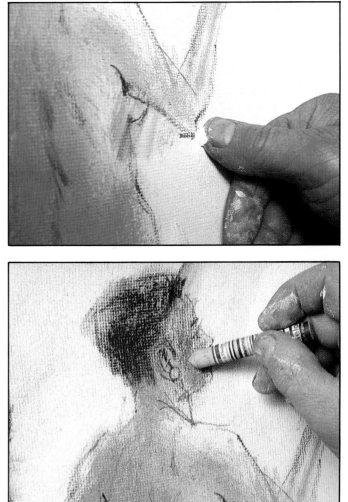

Francesca — rear view (2)

What the artist used

A sheet of drawing paper was used, and the artist's colors were geranium lake, flesh tint, yellow ocher, cadmium yellow, cerulean and white. She also used a lead pencil and a sable brush.

2 *Top*, the artist develops the forms, working with a mixture of pastels in crimson, grays and browns, and a graphite pencil. Here he works white oil paint into the background with his thumb, using the negative form to correct the drawing.

3 *Above*, stripes of colored pastels are laid onto the face, the separate colors blending optically in the viewer's eye to create the tone the artist requires.

1 This pose is the most complex in this series, *right*. The model is a dancer and drops into these poses quite naturally.

2 With thinned, flesh-tinted paint the artist establishes the broad forms, *below left*. The paint dries quickly on the relatively absorbent support, allowing the artist to work over it with a 4B pencil.

3 Fingers are used to smudge ocher into the shadowed area on the leg, *below*. The artist then uses a black pencil for definition, exploiting the quality of the line so that thicker lines are used for deep shadow.

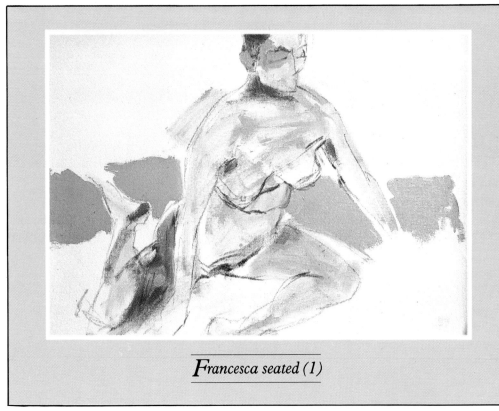

*F*rancesca seated (1)

What the artist used

A large sheet of drawing paper was used here, and the colors were Turner's yellow, yellow ocher, cerulean, white, naphthol red light, raw umber, Hooker's green. He used a number 10, round, hog's–hair brush, a small sable brush and a soft black Prismalo pencil (watercolor pencil).

1 *Right*, the artist uses a rag and flesh-tinted paint to block in the broad forms. Then, with a soft, black pencil he draws the contours that outline the turns of the form — the tips of the finger, the line of the breast and the curves of the shoulder and arm.

2 The artist works into the head with black pencil, creating a variety of marks, *below left*. The pencil, which is water-soluble, is soft and capable of creating very black marks and scumbled texture.

3 Pencil is used to describe the motif on the robe, *below*. The sketch was finished quickly because the artist is familiar with his materials and works with the confidence born of years of drawing from life.

What the artist used

A large sheet of drawing paper formed the support, and the artist used flesh-tint oil paint, yellow ocher and white, applied with a small sable brush. She also used a a 4B pencil and a black conté pencil.

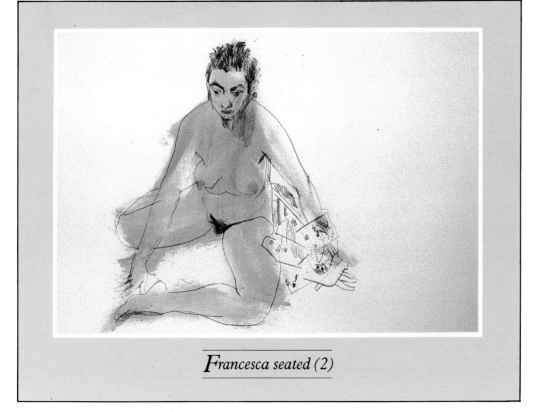

Francesca seated (2)

Woman in Black

Often what an artist leaves out of a painting is just as important as what is put in. Many compositions succeed by their clever use of large areas of the painting in which nothing happens. The works of Sandro Botticelli (*c* 1445-1510), Titian and, in our own time, David Hockney (b 1937) illustrate very well the use of empty areas in paintings. This device is often used in portrait painting, where a cool, uncluttered background is used to draw attention to the face of the sitter.

In this painting the artist has opted for a simple composition, silhouetting the figure against a pale background, creating a pattern of bold, simple forms. The painting is almost abstract in the simplicity of its geometry.

A painting that is divided into large areas of fairly flat colors creates a sense of stability and is often very soothing to look at, inspiring in the onlooker a contemplative mood. The empty spaces of a painting can be used to emphasize the more important areas of the painting. In a very busy painting, on the other hand, all the areas may have equal interest. The artist is challenging the viewer, and the eye is led all over the surface of the painting and allowed no rest. No area of a painting is ever actually empty. Even if it is left uncovered with paint, so that the support shows through, it still constitutes an area of color within the painting rather than a gap or space between things.

In this painting the artist had a very clear idea of the composition, of his intention, and of the way the color areas would be distributed over the picture surface. He had worked up some of these ideas in sketchbooks and then made a careful drawing on the canvas. He followed this drawing closely, painting each area of tone carefully, laying it down as a discrete area of thin color so that the image emerges piece by piece like a jigsaw puzzle. He has used a simple range of colors, the warm creamy tones of the flesh and the background contrasting with the rich red of the bedcover and the black of the model's hair and slip. The painting demonstrates a controlled and considered approach to the subject. It shows that a painting does not have to have streaks of wildly applied color in order to make a strong statement.

Of course, the way you handle paint depends on many things — on your intention, on the subject and even on your mood at the time.

1 The artist has chosen this simple pose *right* set against a cool, uncluttered background.

2 The artist draws directly onto the support, indicating the main outlines and tonal areas, *left*.

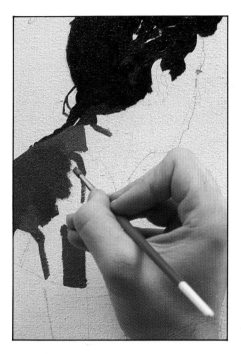

3 Using flat black color and a small sable brush, the artist lays in the hair leaving the white of the support to stand for the highlights, *above*. He mixes black and raw umber for the vary darkest skin tones, applying the paint carefully.

LAYING FLAT COLOR

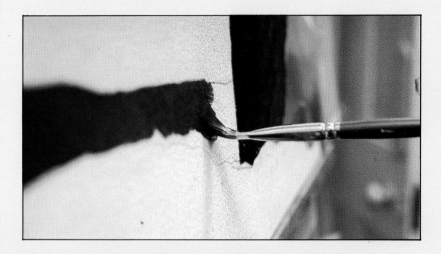

As we have already said, there seems to be no limit to the different ways in which oil paint can be handled. On previous pages we have looked at scumbles, glazes and impastos, but here we will consider color laid in a flat and untextured way. The artist uses a small brush so that the paint is laid down very smoothly. Different colors and brands of paint vary in their degree of fluidity, so the artist adds a little turpentine or mineral spirits to aid the spreading. The alkyd medium Liquin is also useful for creating flat, untextured surfaces; it improves the flow, making the paint easy to manipulate.

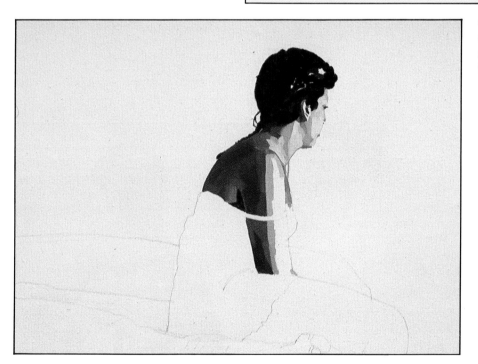

4 *Left* Working with fairly fluid paint thinly diluted with turpentine the artist works across the whole figure, dividing the skin tones into areas of lights and darks.

5 In the detail *above* the artist adds black and raw umber to the skin tones to obtain a dark brown for the very darkest areas. Notice the way in which the texture of the canvas shows through the thin paint layer, acting as a unifying factor throughout the painting.

6 Using pure black paint the artist starts to lay in the black slip, *left.* He leaves the highlight areas white, ready to receive a lighter tone later.

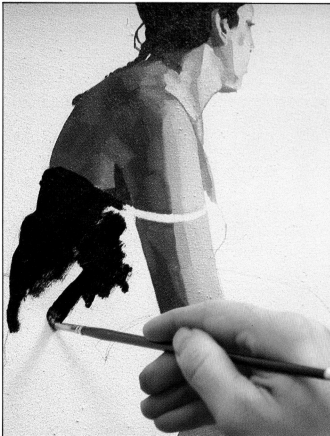

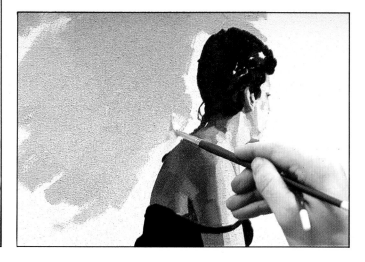

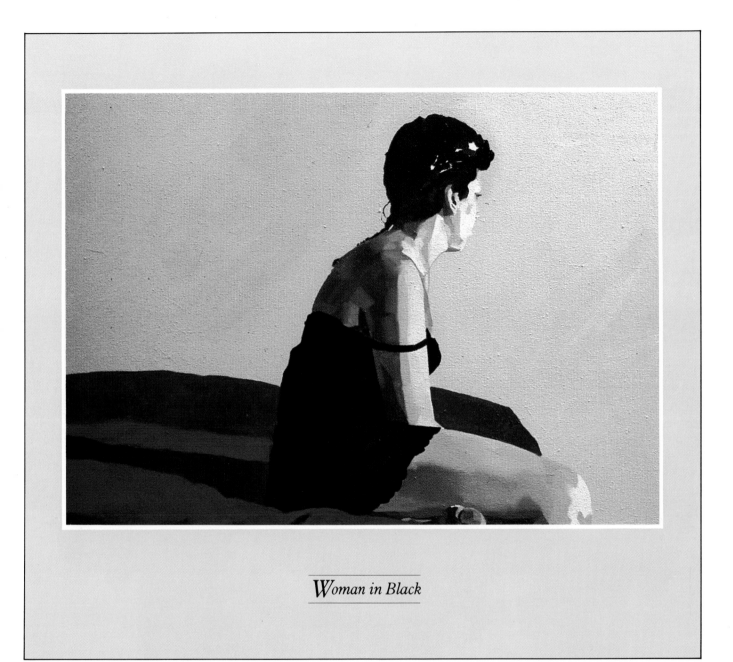

Woman in Black

7 The artist mixes creamy color from raw umber and white and starts to put in the background using a number 5 bristle brush *left*. The paint is fluid and does not hold the marks of the brush, creating areas of matte, untextured color. Using the same mixture the artist completes the background. He then lays in the reds of the bedspread and adds the finishing details *above*.

What the artist used

The support was canvas measuring 20in × 24in prepared with emulsion and emulsion glaze. The artist's colors were white, yellow ocher, chrome orange, cadmium red deep for the skin tones, cobalt blue for the cooler areas, raw umber and black. Brushes were a number 3 and number 5 sable and a number 5 bristle.

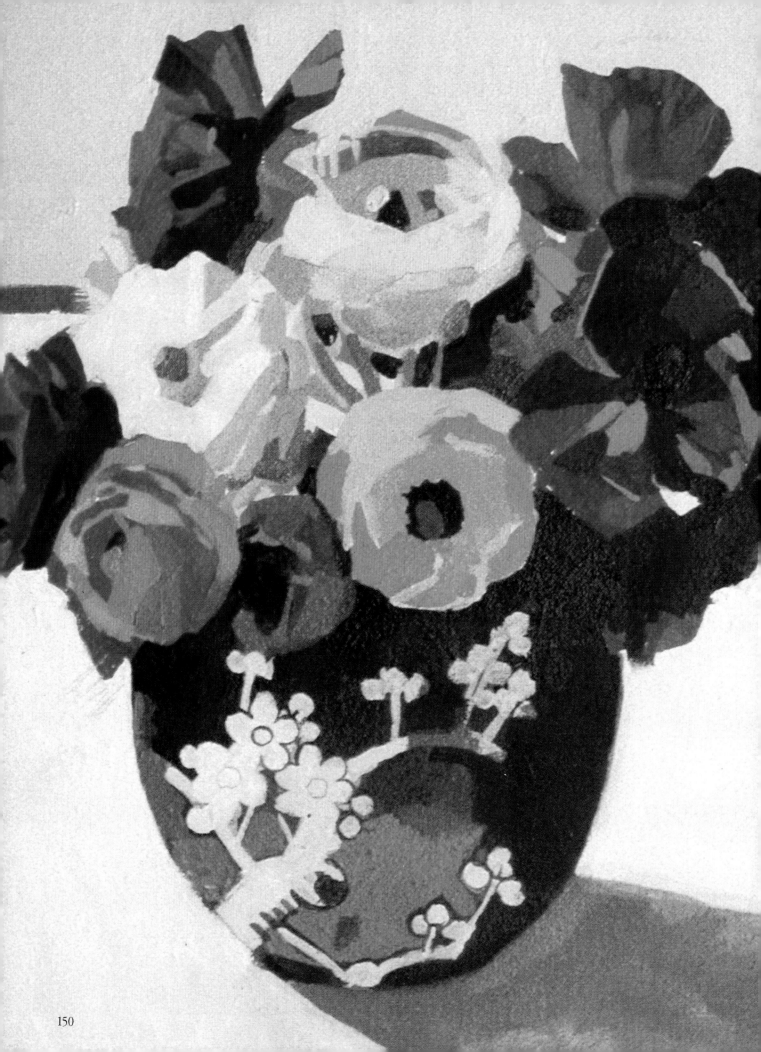

CHAPTER TEN

NATURAL HISTORY

The natural world is rich in fascinating material for the artist. Plants and flowers are obvious subjects and have the advantage of being available all year round. Your own garden will provide plenty of inspiration and don't forget that the plants and flowers make interesting compositions when painted *in situ*. The bits and pieces that you find lying around the garden or on a walk can be added to your collection — feathers, twigs, pebbles, leaves, mosses, and lichens can be assembled to create stimulating subjects rich in color and texture. Animals and birds are less accessible — wildlife tends to be shy and easily startled and you will have to be patient and develop special techniques if you wish to work from life. However, an interest in wildlife can be pursued in zoos, wildlife parks and museums, and by studying books and photographs. At your local fish market — if you're lucky enough to have one — you will find rich pickings: the multicolored carapaces of the crustaceans, the shimmering beauty of fresh mackerel, or the subtler iridescence of trout. Whatever your interests, there is always something for you to paint in the natural world.

Cactus

In this painting the artist's preoccupation was with the underlying abstract qualities of the plant, its spiky character, clearly defined edges and sharp corners. The fleshy leaves, with their gray-green surfaces trimmed with pale yellow, have an undeniably abstract geometry, which the artist has recognized, explored and exploited in his painting. He has drawn attention to these aspects of the subject in several ways; for instance, by placing the cactus low down on the picture area he has drawn attention to the starry spreading shapes. He has abstracted by simplifying the forms and removing all clutter from the background, so that the image is simple, but at the same time is rendered with relentless realism.

The artist used a canvas board with a smooth, fairly untextured surface, which suited the way he handles paint. He laid on the paint thinly, using a small brush.

As you can see, the artist decided to make radical modifications to the design by cutting a strip from the bottom of the picture. As he worked, the abstract qualities of the subject became more obvious and more important to him. He decided to crop in to the image more tightly, and by making some of the leaves 'bust' the margins he created a sense of energy, of the plant's trying to explode beyond the constraints of the picture margin. He also created a large area of blank space at the top of the painting which acts as a foil for the serrated silhouettes at the bottom of the picture. The spaces between the leaves of the plant are made more significant by this device, trapped as they are against the picture margin.

The background was added last. This too has a certain abstract quality. It is actually a fairly literal interpretation of the window sill on which the plant was resting. The beading around the window has been added in flat, untextured paint which flattens and simplifies what is there. Similarly with the pane of glass and the reflection on it, which has been rendered by leaving the blank white support as the area of highlight.

In this painting the object has acted as a starting point for the painting rather than being its true subject. Because the artist is no longer concerned with the surface reality of the object or with establishing its place in space, he can concentrate on the decorative qualities of the forms, and the balance and tensions between the different shapes.

1 The spiky, fleshy leaves of this succulent have an obviously abstract quality, *right*, which the artist has exploited in his composition.

2 The artist makes an underdrawing in pencil, working directly on the support. Using paint diluted with turpentine he starts to paint the leaves, *below*.

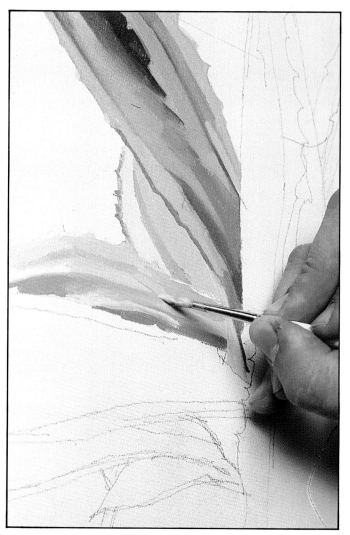

USING A MAHL STICK

A mahl stick is an extremely useful device used for steadying the hand when doing detailed work. The traditional mahl stick is made from bamboo with a chamois-covered pad at one end. Today they are made from a variety of materials including aluminium, but you can very easily make your own by covering the end of a piece of cane or dowel with absorbent cotton or sponge covered with some sort of fabric. The artist rests the padded end of the mahl stick on the canvas or on the edge of the support if he does not want to smudge the paint surface. He holds the other end in his left, or non-working, hand and leans his right, or working, hand on the cane.

3 *Left*, the leaves are painted with a mixture of sap green, Payne's gray and white, varying the proportions in order to match the subtle tonal changes.

4 The artist develops the broad spears of the leaves in the gray-green mixture, *below*. Yellow mixed with white and tinted with Payne's gray is used for the leaf margins.

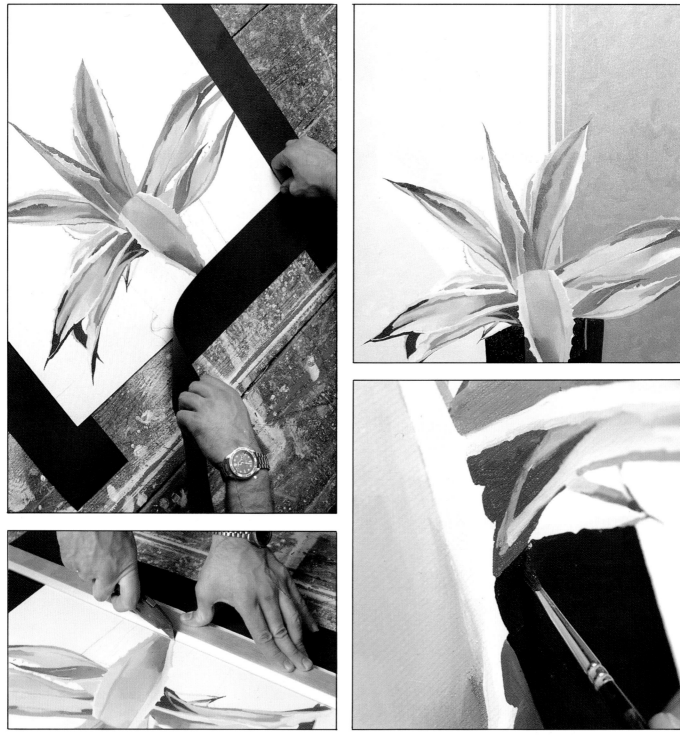

5 The artist is dissatisfied with the composition and decides to change it. *Top*, he considers the possibilities, using a pair of Ls to mask the picture.

6 *Above,* he decides to crop in to the cactus so that the leaves break the picture frame. Using a steel rule and a Stanley knife, he trims 1½in from the bottom of the painting.

7 *Top*, the background is laid in with thinly diluted paint. The artist has simplified the elements so that they have an abstract quality in keeping with the rest of the painting.

8 The plastic plant pot is laid in with thin black paint, *above*. The finished painting, *opposite*, shows how a single object can be magnified by careful composition.

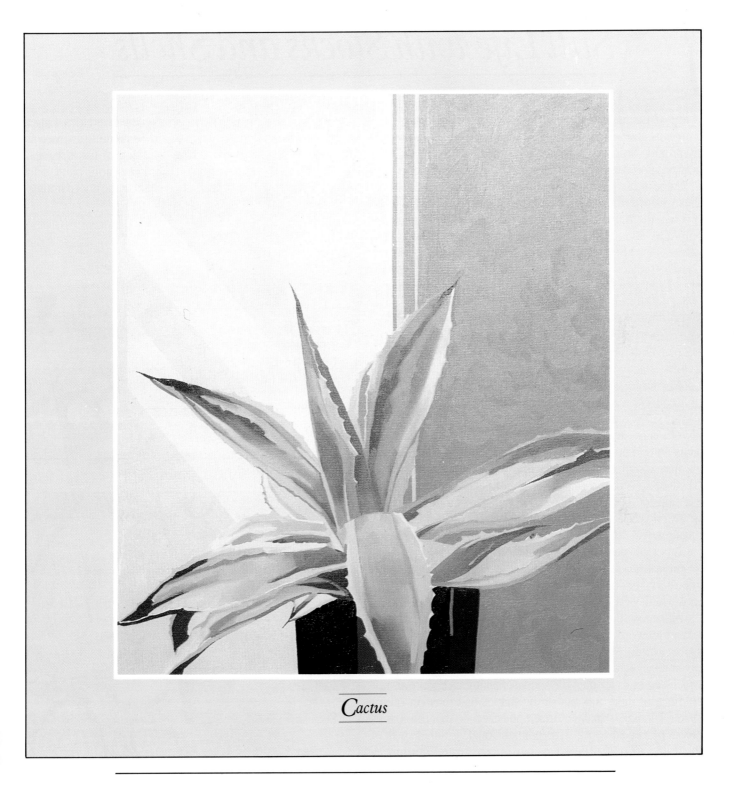

Cactus

What the artist used

His palette consisted of sap green, cadmium yellow, titanium white, cobalt blue, ivory black and Payne's gray.

His brushes were a number 3 and number 5 sable, and he used a steel cutting edge, a craft knife and a B pencil.

The support was a fine-textured canvas board measuring 28in × 24in.

Still Life with Stocks and Shells

Many artists are very aware of the rhythms within their paintings, the undercurrents that direct the eye of the viewer over and around the picture surface. The artist uses compositional devices to harness and exploit the energy inherent in his painting, and its shape and size and the way these relate to the images within all have a part to play. In some pictures the interest is focused in the center of the painting, with the corners and outer edges bare and unoccupied, whereas in others the areas of activity are scattered over the picture surface. These different concentrations of activity set up a dynamic within the painting: in the first example the eye constantly returns to the center of the painting, whereas in the second the eye wanders ceaselessly over the picture surface. The artist who is aware of this energy can exploit it for his or her own ends, and can set up disharmonies, forcing the viewer to look exactly where the artist wishes.

Most successful paintings are composed of areas rather than of a collection of images scattered indiscriminately over the picture surface, and the areas are interlocked so that a complex pattern is created across the picture surface. Small and large areas interlock, overlap and interweave in a pattern that emphasizes all parts of the picture plane, so that the shapes between objects, the negative spaces, become as important as the objects themselves. This is equally true in architecture, where enclosed spaces are an integral part of the design, and in music, where the silences and the intervals between notes play an important part in the composition.

The artist set up this still life with flowers, collecting an assortment of objects that vary in shape, color and texture. He took a high viewpoint, which emphasized the spaces between the objects, so that they are seen as shapes from above. A lower viewpoint would have created a sense of recession and of the space within the painting. He further emphasized the decorative elements by drawing lines around the objects, which serves to abstract the shapes, making us conscious not so much of their bulk but of the shapes that they cut out of space. The linear qualities are emphasized, so that the shapes are perceived as two-dimensional rather than three-dimensional. The edges have been treated not just as transitional areas between one object and another, but as important shapes. The artist had intended to use a black line, but instead used a white line scratched out of the paint.

In this painting colors, pattern and texture are all equally important. The composition is based on an all-over pattern, and the yellows used are the complementaries of the purples. Many artists have a very clear vision as they work; they know before they start what the final image will be. The composition is worked out very clearly in their heads and the painting process is merely the execution of a preconceived idea. Other artists work in a different way, in which the painting evolves on the canvas. This artist worked by blocking in his first idea, laying on color, scratching it off, applying more paint, and wiping that off. All these stages are evident in the final painting.

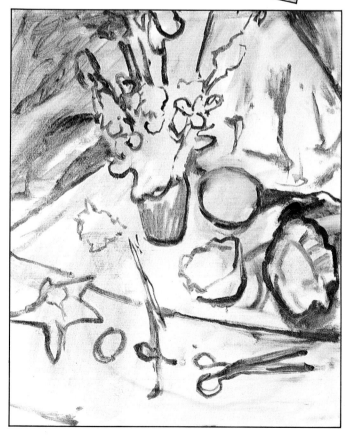

1 In this still life, the artist chose objects that varied in color and texture, *right*. The background should not be neglected when arranging such a composition.

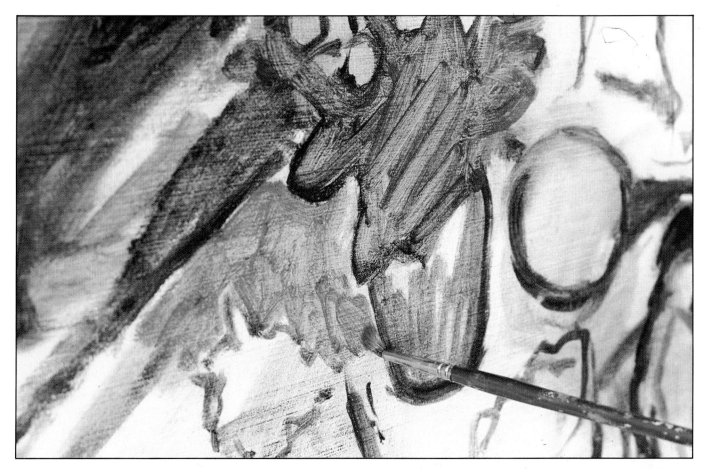

2 The underdrawing is laid in with black paint diluted with turpentine and Liquin, *left*. He loads a number 3 squirrel brush and works the paint freely over the support, using a rag to lift and erase as he seeks an accurate drawing and a harmonious design.

3 *Above*, the artist elected to use black for the underpainting, because this provided a strong foil for the subsequent colors. He now starts to lay in the local colors using viridian and Indian yellow which, are particularly transparent pigments.

4 He continues to apply paint, *right*, using a thin brush and mixing Liquin with the pigments to increase transparency and drying speed. The colors have a brilliant translucence reminiscent of stained glass windows.

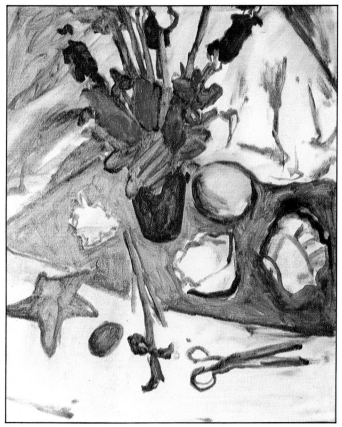

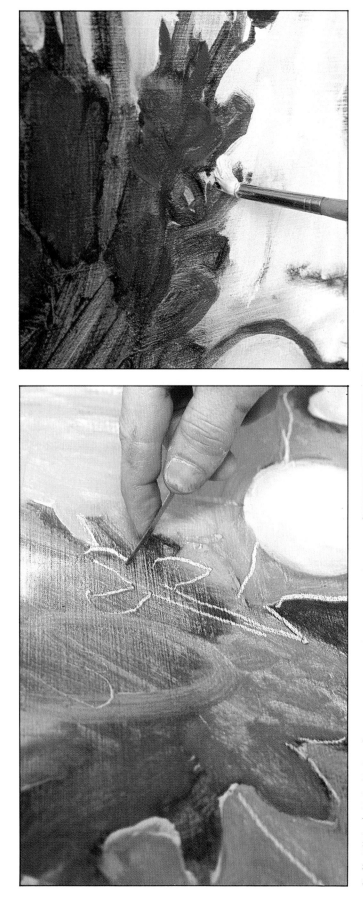

5 *Above left*, the artist lays in the background using zinc white, applying a thin veil of color through which the black underdrawing can be seen. He uses thicker white paint around the flowers so that he can work back into the forms, sharpening the silhouettes.

6 The tip of a painting knife is used to draw into the still-wet paint — the sgrafitto technique — revealing the white support and creating strong white contours. The artist is displeased with the painting and uses a piece of tissue paper to remove the paint in the offending area, *above*.

7 The artist continues with the sgrafitto technique, drawing into the now smudged and smeared paint layer, *left*. Sgrafitto is a way of drawing without introducing any more paint. This may be useful if you build up a thick paint layer and are dealing with a complex subject.

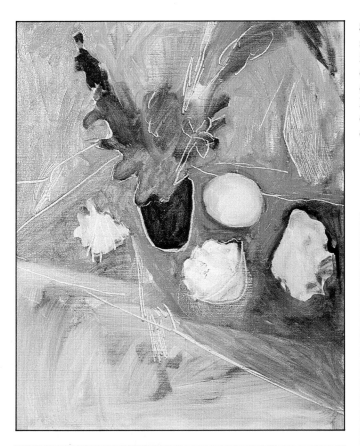

8 The picture evolves as the artist works, *left*. He is interested in the decorative qualities of the subject, the color and the pattern, and uses line as both a descriptive and a decorative element to hold the composition together.

9 Using a brush loaded with a creamy mixture of white, rose madder and yellow ocher the artist starts to paint the shell, *bottom left*. The expanse of Indian yellow in this detail shows how transparent oil paint can be.

SGRAFFITO

This is a technique in which the artist scratches through a layer of paint to reveal another paint layer beneath – or to reveal, as here, the support. Sgraffito creates a line but at the same time contributes texture. The artist sometimes uses the handle of the brush as a tool. Here in the detail *below* we see that the artist has been creating lines using the palette knife as a drawing instrument.

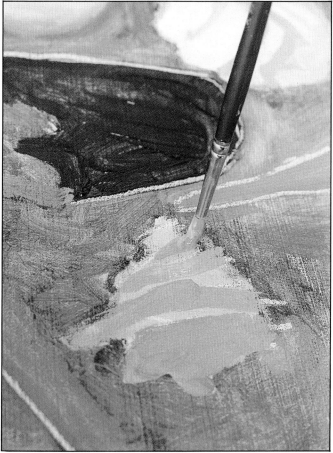

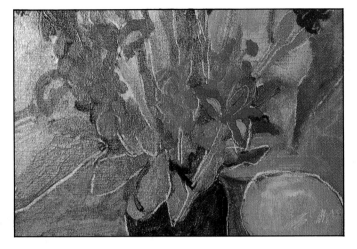

10 As the work progresses, *above*, the paint layer becomes increasingly opaque, and the individual elements more fully resolved and detailed. You can see this best by comparing this detail with earlier stages.

11 The artist has created an all-over pattern with small separate elements evenly scattered over the picture surface, *right*. The high viewpoint insures that there are few overlapping forms, emphasizing the separateness of the objects.

12 The broad tip of a palette knife is used to create texture and pattern on the surface of the shell, *below*.

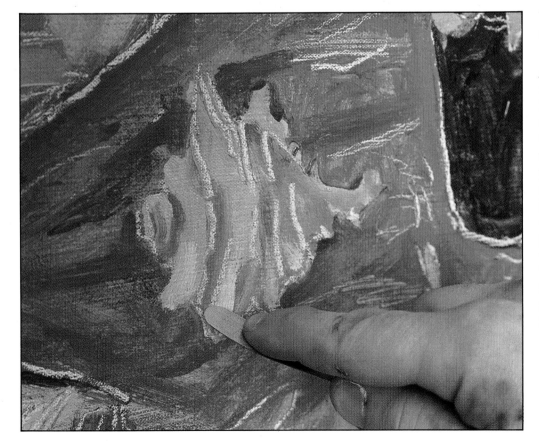

What the artist used

A finely textured canvas measuring 18in × 14in formed the support, and the artist's colors were black, viridian, Indian yellow, zinc white, permanent green, yellow ocher, cobalt blue, carmine, phthalocyanine blue, rose madder, cobalt violet hue and Hooker's green; he thinned them with Liquin and turpentine. The brushes used were a number 3 squirrel and a number 5 bristle; he also used a flat palette knife.

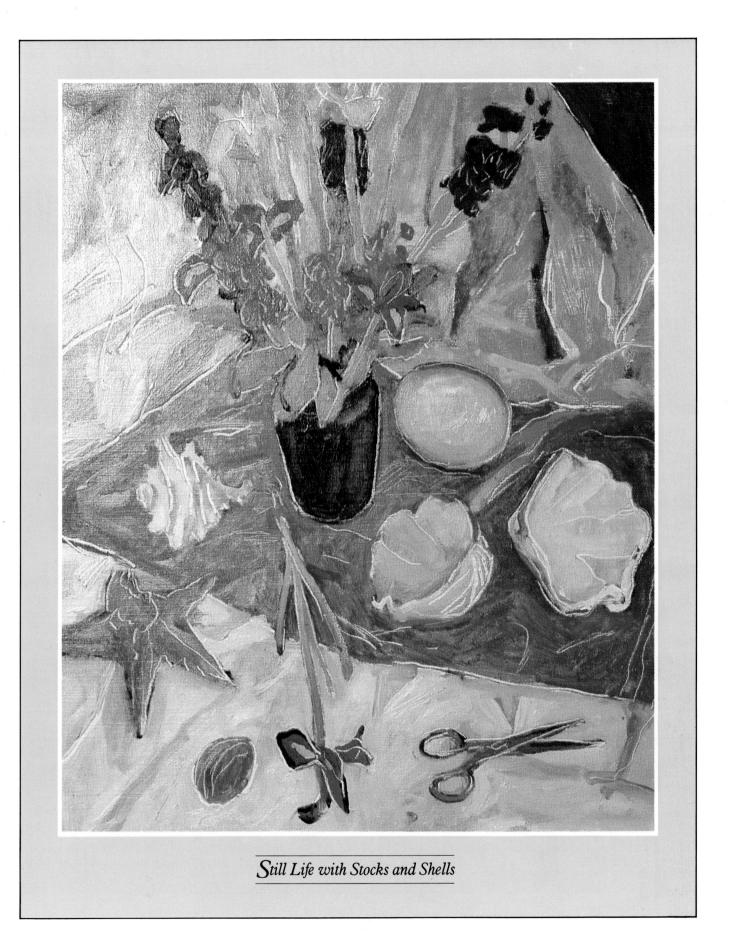

Still Life with Stocks and Shells

Peonies

Each artist has his or her own particular concerns, and though these may vary from painting to painting, themes can nearly always be recognized running through an artist's work. One artist may be primarily interested in color, for example, while another is preoccupied with light and tone. This subject was painted outdoors, and although the artist has created a realistic representation of the subject, the painting is primarily an essay in pattern and color. The more 'painterly' qualities (the involvement with the brush and its mark) are absent, yet the painting is rich in color and pattern. It is this difference in approach that makes the study of painting so fascinating, but also makes it almost impossible to lay down rules about good and bad practice.

Pattern-making is not an altogether conscious process: the artist does not generally set out to make a 'good' pattern, but rather becomes involved with a particular subject and the pattern-making possibilities intrude themselves upon the artist's consciousness. The pattern grows organically by the repetition of certain motifs. It is not just the creation of decorative surfaces but the organization of what is there, in the same way that a composer orders the notes in a composition. Patterns exist in nature, and in this painting the artist has simply taken what is there and exaggerated the similarities rather than the differences. He has, however, introduced his own element into the painting — the railings in the background. This introduces an illusion of space — we assume the railings are behind the peonies because they are higher up the picture plane. Also, the fact that the peonies overlap the railings establishes their position in space. The peonies behind the railings are less defined, their edges less definite and the colors paler, creating the sense of a space beyond. Cover the top of the painting with your hand or with a sheet of paper and you will see just how different the painting looks — without the spatial values it is pure pattern.

1 This subject, *right*, was painted out-of-doors, in the artist's garden. He was attracted by the greens of the foliage and the complementary crimson of the flower heads.

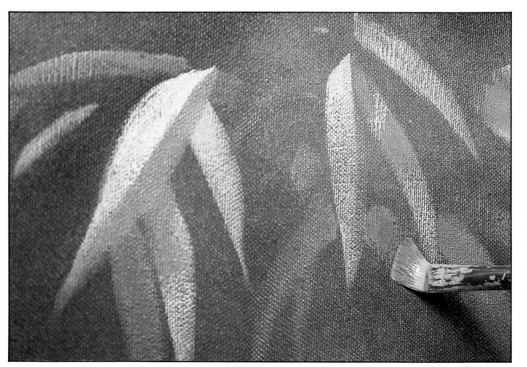

2 The support was prepared with a graduated ground. With a number 7 flat brush the artist starts to suggest the leaves, *left*, using middle and light tones mixed from viridian, sap green, cadmium yellow and white.

3 The toned ground provides the artist with his darkest tones, so that he works from dark to light, *top right*. The dry paint is scumbled so that the dark ground modifies the overlying colors.

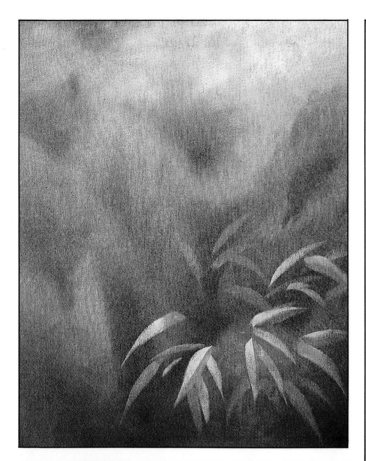

STAINING

Canvas can be stained in much the same way as paper can be stained with watercolor. Some painters use an unprimed canvas so that the stain fully impregnates the canvas — but this can limit the life of the painting, because the chemicals in the paint will eventually attack the canvas and the oil will rot it. A stain is applied directly to the support. In this it differs from a glaze, which is laid over an underpainting. In order to achieve a successful stain the artist must use a color which has good tinting powers. Here the artist has used a selection of colors — chrome green, viridian, sap green and Prussian blue — and has worked the paint well into the grain of the canvas. In this technique the texture of the canvas is very important. He graduated the colors over the whole canvas, wiping back the color with a rag soaked in turpentine to achieve lighter tones.

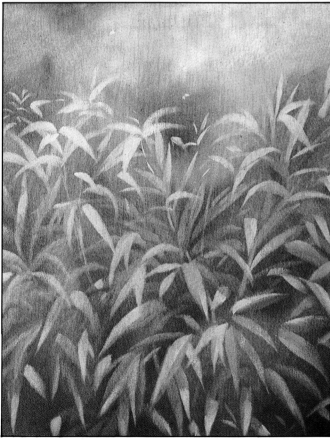

4 The artist continues working in exactly the same way so that gradually the complex tracery of the spiky leaves covers all but the very top of the canvas, *left.* At this stage the repetition of the leafy motif highlights the pattern-making qualities of the subject.

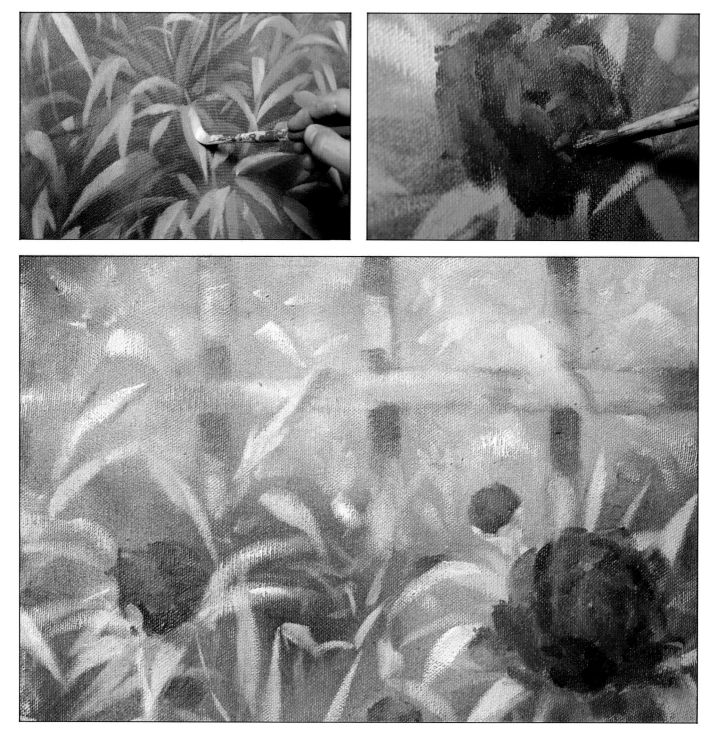

5 *Top left* The artist adds more white to his leaf-green mixture and applies streaks of highlight to selected leaves, to suggest the effect of sunlight.

6 *Top right* For the rich reds of the peony flowers the artist mixes several tones using cadmium red, alizarin crimson, geranium lake and white. He starts by establishing the darker tones and then, working slowly and carefully, adds the lighter tones.

7 *Above*, the artist introduces these railings to add interest to the upper part of the painting and to help create an illusion of space. The final painting, *opposite*, is a fine example of the way in which the decorative qualities of a subject can be exploited without sacrificing realism.

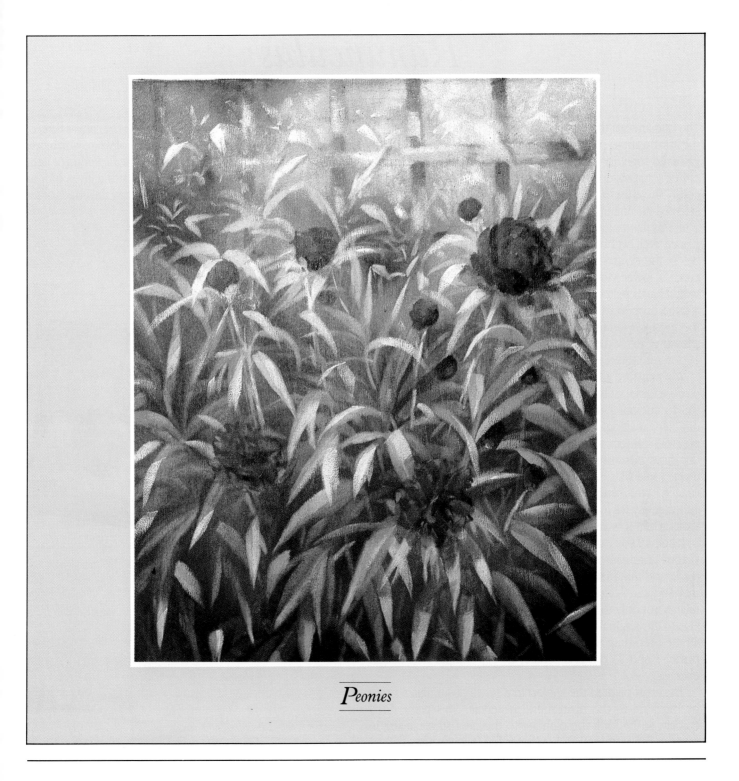

Peonies

What the artist used

A bought canvas measuring 24in × 18in was the support; it was coarse cotton duck ready primed.

The artist's colors were viridian, chrome green, sap green, Prussian blue, yellow ocher, cadmium lemon, cadmium yellow, titanium white, French ultramarine, geranium lake, rose madder, alizarin crimson and cadmium red. The brushes he used were a number 12 flat and a number 10 round.

Ranunculus

The brilliance of the colors of these flowers is what first made the artist want to paint them. Their round, attractive heads are gathered together in a tight bunch and placed in a rounded, rather squat vase which suits the flowers in both shape and color. The artist thought carefully about the composition, and selected an uncluttered background with flat areas of color.

In this painting he is concerned with spaces. The flowers are placed well within the picture area, slightly to the left and below the central point. There is space all around. If he had taken a lower viewpoint and made the flowers bigger he would have created a very different image. The flowers fill only a small proportion of the painting, but they are nevertheless the most important element. The space around the subject allows room for the shadows to fall, and these too become an important ingredient in the composition.

You may find it helpful, when setting up a still life or flower piece, to assess it by making a frame with your fingers, or better still to cut one out from a sheet of paper. If you still have difficulty making a decision you might like to try using a polaroid camera to take a series of pictures from different distances, positions and viewpoints in order to judge what the image looks like. Try out the system here: look at the finished version of this picture, cut out two 'Ls' from cardboard or paper and then lay them over the image to see just how different it looks when it is seen in various ways.

It helps if you can see the subject as a surface with colors and shapes arranged on it in a certain order. The artist makes a mark, and that first mark has a relationship with the edges of that surface — already tensions are set up. The next mark relates not only to the edges and the area of the support, but also to the original mark, and each succeeding mark relates to all the preceding ones as well as to the shape of the picture plane — and so on. It is actually a very complicated design exercise.

The artist painted the subject in a series of sittings, starting by blocking in the main areas in acrylic. This paint dried quickly, so he took the painting to the next stage, laying in areas of flat, unmodulated color for the flowers. After that he developed the painting in oil. The acrylic not only dries quickly, but also provides a good surface to work on by giving the canvas that extra bit of tooth to take the paint. The background, the wall and the piece of paper on which the pot of flowers is sitting is not completely untextured — a white wall is handled with subtle shades of gray and white paint laid over a tinted ground. In the shadow areas the light paint shows through the scumbled ground. By contrast the flowers are fairly textured, though there are no areas of thick impasto. The paint layer is nevertheless fairly thin, and on close inspection it is possible to see that the topmost weave of the canvas threads shows through the paint layer as tiny flecks of white which help to create a lively paint surface, mirroring the flickering of light. When the artist paints in the background this gives him an opportunity to use the background to redraw the edges of the subject.

1 The bright-colored flowers are an obvious subject for the painter, *right*, and the artist has thought carefully about the arrangement of spaces and colors.

2 Having decided on the composition, the artist makes an underdrawing using a soft pencil which will not damage the canvas or the ground. He then blocks in the background using a mixed gray acrylic paint, *above*.

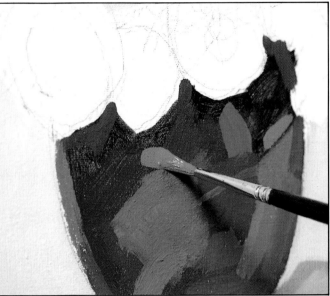

3 *Above*, the artist uses a plastic ruler as a straight edge in order to achieve the clean lines of the table top and base. The ocher browns are mixed from yellow ocher, white and chrome orange.

4 A series of blues mixed from cobalt, phthalo, Payne's gray and white are used to depict the varying tones of the blue vase, *top right*. The artist has to study the subject closely because the white motif obscures the changes of tone.

5 The broad expanse of background is laid in with a broken green-gray mixed from cobalt, yellow ocher, black and white, *right*. Again, paint is applied in a flat, unmodulated manner which reveals rather than conceals the canvas.

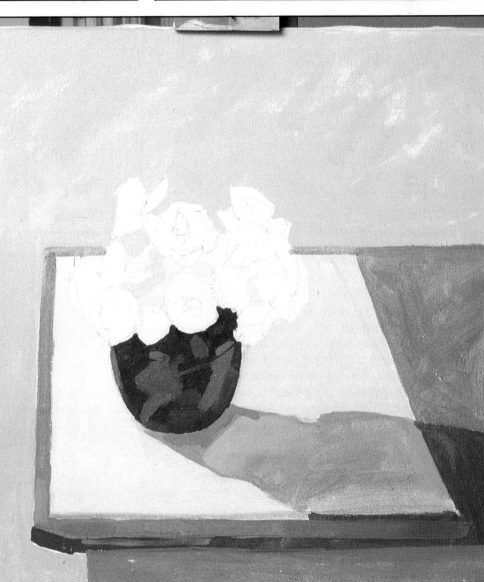

6 The flowers are blocked in freely using reds, yellows and purples, *left*. The artist simplifies the forms by looking for the darkest darks and the lightest lights. There is a temptation to try to render flowers petal by petal, and although this is possible, and sometimes desirable, it is usually a mistake. Study the subject through half-closed eyes and paint what you see. The flower will emerge from the pattern of light and dark tones.

A COLORED UNDERPAINTING

Many painters brush in large areas of their painting in thin color in order to help them organize the picture in terms of shapes and color areas. This is quite a sensible approach, because it allows the painter to break down the production of a complicated painting into a series of manageable stages. After this the painter can then attend to more detailed aspects. In this case the artist used acrylic for his underpainting, but if oils are used there should be just a little oil in the medium, with each succeeding layer having progressively more oil — a process often referred to as working 'fat over lean'. The artist progresses from the broad concept and gradually works into the details of the painting, but each layer need not necessarily cover the whole canvas and obliterate the previous layers. In this case there was more work on the flowers, so the paint there is marginally thicker. If you work fairly thickly it is advisable to keep the first layer relatively thin. If you use thick impasto on the first layer you will make it difficult for yourself to overpaint.

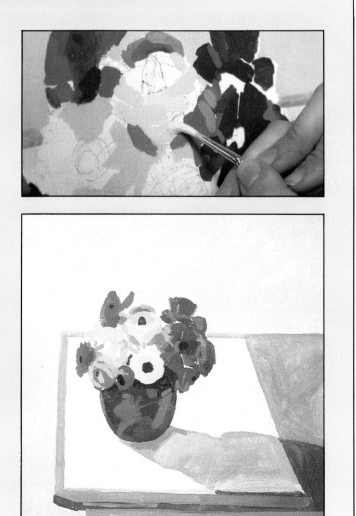

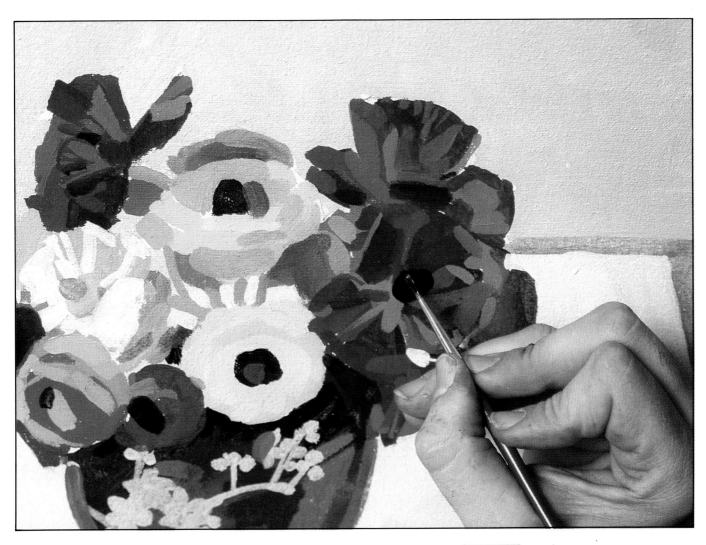

7 *Above* Up to now the artist has been using acrylic paint in order to finish the painting at one sitting. Acrylic dries quickly and provides a sympathetic surface for oil paint. He now starts to work with oils. Using white oil paint diluted with turpentine and a fine brush, the artist traces the foliage on the surface of the pot. He then works into the flower heads, refining and defining the forms.

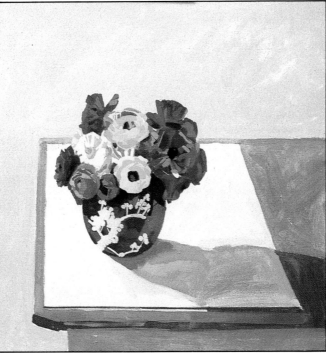

8 The artist continues to work into the flowers with diluted oil paint, *left.* As the layers of color are laid down, overlapping and partially obscuring the preceding paint layers, the tonal ranges come together, unifying the disparate forms.

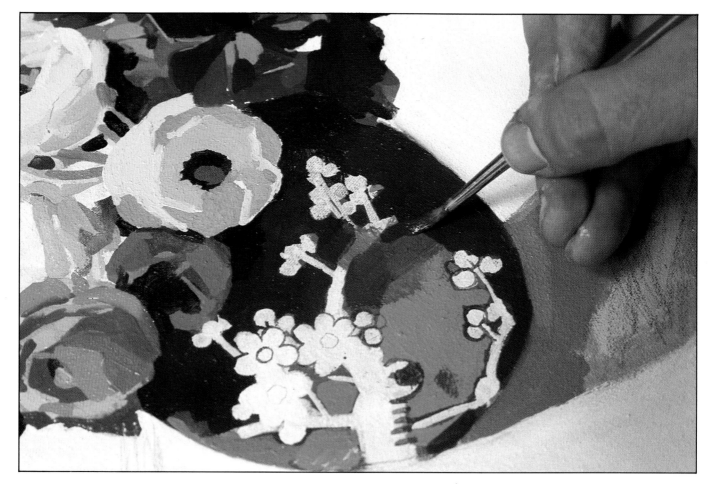

9 *Above*, the artist mixes a dark saturated blue from French ultramarine and a little black, and uses this to intensify the parts of the pot that are in shadow.

10 The artist then mixes a warm, creamy color from white and yellow ocher and uses this to describe the middle tones on the white surface, *above*.

11 The artist drifts a thin veil of white oil paint over the paper on which the vase stands, *right*. This heightens the contrast and brightens the picture and also allows him to redraw the contours of the flowers.

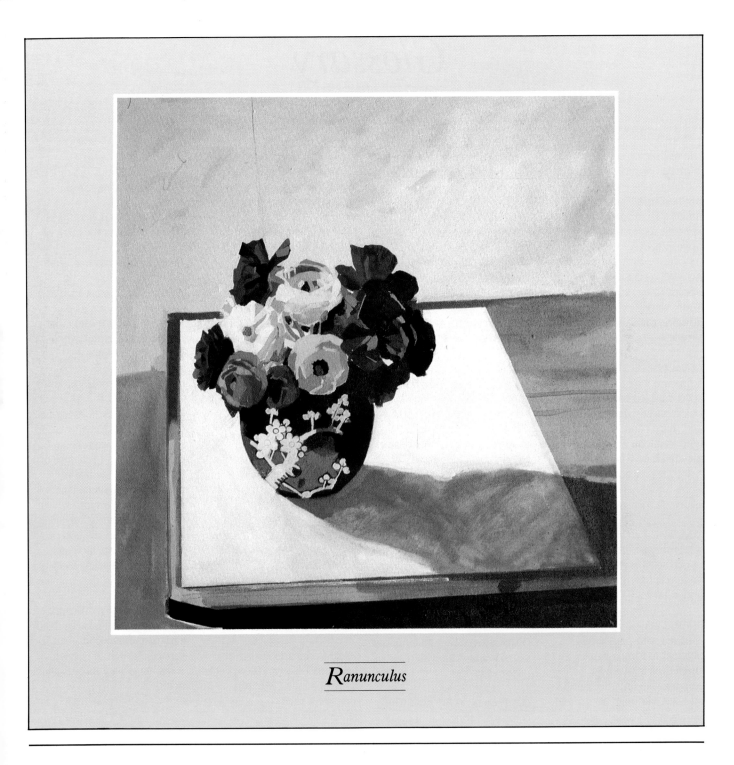

Ranunculus

What the artist used

Liquitex acrylic paints were used for the underpainting, and a mixture of Artists' and Students' quality oil paint for the rest. The artist's colors were titanium white, ivory black, Payne's gray, cobalt blue, phthalocyanine, French ultramarine, alizarin crimson, cadmium red, yellow ocher, chrome yellow and chrome orange. He used a 3B pencil, a number 4 sable brush, with a number 3 for the details. The support was a canvas measuring 22in × 20in, made from cotton duck primed with emulsion glaze mixed half-and-half with good emulsion paint, and applied in several layers.

Glossary

ABSTRACT Relying on color, pattern and form rather than the realistic or naturalistic portrayal of subject matter.

ABSTRACTION The creation of an abstract image by the simplification of natural appearances.

ADVANCING COLORS Colors that appear to be near the viewer. Warm, strong colors seem to advance whereas cool colors recede.

AERIAL PERSPECTIVE The use of color and tone to indicate space and recession. Warm colors, clearly defined forms and sharp contrasts of tone tend to advance toward the picture plane whereas cool colors, less clearly defined forms and tonal contrasts appear farther away.

ALLA PRIMA Direct painting in which the picture is completed in one session without any underpainting or underdrawing.

BINDER A liquid medium which is mixed with powdered pigment to form a paint. Linseed oil is the most common binding medium for oil paint, although poppy and safflower oils are sometimes used for pale colors. The binding medium oxidizes to form a skin in which the pigments are held in suspension.

BLENDING Merging adjacent color areas so that the transition between the colors is imperceptible.

BLOCKING IN The first stage of a painting, in which the main forms of the composition are laid down in approximate areas of tone and color.

BROKEN COLOR A term used in color theory to describe a color mixed from two secondary colors. These colors tend toward gray. It is also a method of painting in which colors are applied as areas of pure paint rather than being blended or mixed. These colors combine in the eye of the viewer to create new colors. The paint may be applied in small discrete patches, as in the Pointillist technique, or it may be applied in such a way that initial paint layers show through subsequent layers to create new colors.

CHIAROSCURO The exploitation of light and shadow within a painting. The term is usually applied to the work of painters such as Rembrandt and Caravaggio whose paintings are predominantly dark in tone.

COMPOSITION The organization of color and form within a picture area.

COMPLEMENTARY COLORS The colors that appear at opposite sides of the color wheel. Complementary pairs include orange and blue, yellow and violet and red and green. Complementary colors placed side by side tend to enhance each other; thus red placed alongside a complementary green appears richer than if it stands on its own.

COVERING POWER This term refers to the opacity or transparency of a paint. Some paints are transparent and are therefore more suitable for glazing whereas opaque paints are used for areas of dense color or where it is important to obliterate underlying color.

DILUENT A liquid such as turpentine which is used to dilute paint. It evaporates completely and has no binding effect on the pigment.

DRY BRUSH In this technique dry paint is dragged across the surface of a painting, so that it adheres to the raised areas, creating broken areas of color.

FERRULE The metal collar of a brush which secures the bristles to the handle.

FIGURATIVE ART Also known as representational art, it depicts recognizable objects such as the human figure.

FUGITIVE This term describes pigments that fade on exposure to light.

GLAZING The application of a transparent film of color over a lighter, opaque color. It is sometimes used to modify darker colors.

GROUND A ground or priming is a surface which has been specially prepared to accept oil paint. The ground serves two purposes: it isolates the support from the paint and it provides the painter with a pleasant surface to paint on.

HUE This term indicates the type of color in terms of its blueness, redness or yellowness. About 150 different hues can be recognized.

IMPASTO Paint applied thickly so that it retains the mark of the brush or the knife. Formerly, impasto was used only in small areas of the painting by painters such as Titian and Rembrandt. Later, painters including Van Gogh, exploited the expressive possibilities of impasto, applying paint 'alla prima' using a loaded brush or knife.

LEAN A term used to describe oil paint which has little or no added oil. The expression 'fat over lean' refers to the use of lean paint (thinned with turpentine or mineral spirits) under paint layers into which more oil is progressively introduced. This method of working prevents the paint surface from cracking as it dries.

LINEAR PERSPECTIVE A method of creating an illusion of depth and three dimensions on a flat surface through the use of converging lines and vanishing points.

LOCAL COLOR The actual color of the surface of an object unmodified by light, shade or distance.

MAHL STICK A cane used for steadying the painting arm when putting in fine detail. One end is covered with a soft pad to prevent the point from damaging the support.

MASK Tape or paper used to isolate a particular area of a painting. This allows the artist to work freely in the rest of the painting. Masks can also be used to create special edges and shapes. Frame-shaped masks or masks made from two L-shaped pieces of paper or cardboard can be used as an aid to composition. They are placed on a sketch or preparatory study so that the artist can select the area of the image to be used and the shape of the final painting.

MEDIUM The material used for painting or drawing, such as watercolor, pencil or oil paint. The term is also used to describe a binding substance which is added to pigment to make paint; for example, the binding medium for watercolor is gum arabic and for oil paint it is linseed oil. The third meaning of the word describes substances which are added to paint while painting or drawing to modify the way in which the paint behaves. These may be traditional mediums like poppy oil, copal oil or a varnish, or they may be commercial mediums such as Win-gel, Oleopasto or Liquin.

MODELING The three-dimensionality of objects in paintings or drawings, suggested by various methods including the variation of tones.

MONOCHROME A painting executed in black and white, or black, white and one other color.

NEGATIVE SPACE The spaces between and around the main elements of the subject – the background in a figure painting, for example.

OPACITY The ability of a pigment to cover and obscure the surface or color to which it is applied.

OPTICAL COLOR MIXING Creating new colors by mixing pigments optically on the canvas rather than on the palette. The Pointillists placed small dots of unmixed color on the canvas so that viewed from a distance the dots are no longer visible and, for example, dabs of yellow and red would combine in the eye of the viewer to create orange.

PAINTING KNIFE A knife with a thin flexible blade used for applying paint to a support. These knives generally have a cranked handle and are available in a range of shapes and sizes.

PALETTE KNIFE A knife with a straight steel blade used for mixing paint on the palette, cleaning the palette and, if necessary, scraping paint from the support.

PICTURE PLANE The imaginary vertical plane that separates the viewer's world from that of the picture. The surface of the picture.

PLANES The flat surfaces of an object. These are revealed by light and can be seen in terms of light and dark. Even a curved surface can be regarded as an infinite number of small planes.

PLEIN AIR A French term meaning 'open air', used to describe pictures painted out of doors.

PRIMARY COLORS These are colors that cannot be obtained by mixing other colors. The paint primaries are red, yellow and blue.

PRIMING Also known as ground, this is the layer or layers of materials applied to a support to make it less absorbent or more pleasant to paint on. A suitable priming for canvas could consist of a layer of size, followed by an oil ground.

RENAISSANCE The cultural revival of classical ideals which took place in Europe from the fourteenth to the sixteenth centuries.

SATURATED COLOR Pure color, free of black and white and therefore intense.

SCUMBLING Dryish, opaque paint which is brushed freely over preceding layers so that the underlying color, or the support, shows through in places.

SIZE Gelatinous solution, such as rabbitskin glue, which is used to seal the support.

STAINING POWER The coloring strength of a pigment and its ability to impart that color to white, or to a mixture. If a pigment has good staining power you will need only a little of it to impart color to a mixture.

STIPPLE The use of dots in painting, drawing or engraving, instead of line or flat color.

SUPPORT A surface for painting or drawing, which could be canvas, board or paper.

TONE The degree of lightness or darkness. The tone of a color is assessed independently of its hue.

UNDERDRAWING The preliminary drawing for a painting, often done in pencil, charcoal or paint.

UNDERPAINTING The preliminary blocking-in of the main forms, colors and tonal areas.

WASH An application of thinly diluted paint.

WET INTO DRY The application of paint to a completely dry surface.

WET IN WET The application of wet paint to an already wet surface. Used in the alla prima technique. Wet in wet allows the artist to blend colors and tones.

Index

Credits

QED would like to thank all those who have helped in the preparation of this book. We would like to thank all the artists, with special thanks to Ian Sidaway for expert advice and the use of his studio, to Rowneys, and to all the staff at Langford and Hill Ltd for their patience and generosity in lending materials and items of equipment.

Contributing artists
pp *30, 44, 47* (except *bottom right*), *48, 49* (*left* and *right*), *56-59, 68-71, 82-85, 94-97, 102-105, 106, 108-111, 124-127, 128, 130-133, 140, 143, 145,* Stan Smith; pp *47* (*bottom right*), *49* (*center*), *64-67, 76-79, 80, 90-93, 146, 150, 152-155, 162-165,* Ian Sidaway; pp *45, 50, 52-55, 60-63, 72-75, 116-119, 134-137,* Gordon Bennett; pp *86-89, 98-101, 138-139, 141, 142, 144,* Rosie Waites; pp *112-115, 162-165,* Lincoln Seligman; pp *120-123, 156-161,* James Nairne.

Other illustrations
pp *8, 9, 11* National Gallery, London; p *12* Private Collection, London; pp *13* © DACS 1985; p *15* Museum of Modern Art, New York; p *17* John Wyand.